Star Shots

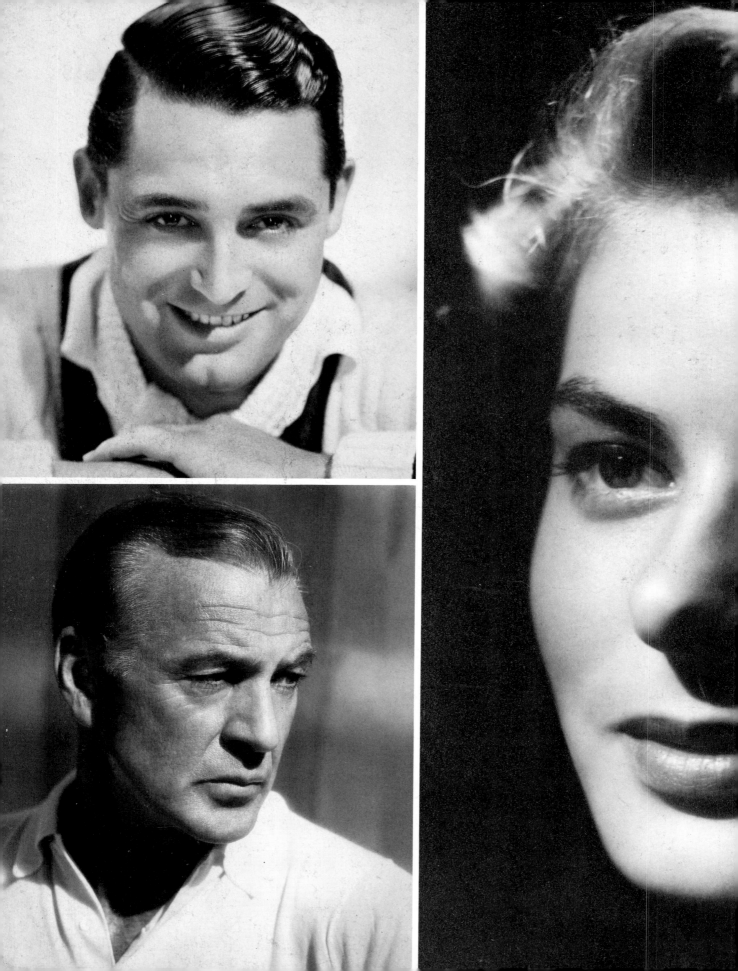

Star Shots

Fifty Years of Pictures and Stories
by One of Hollywood's Greatest Photographers

John Engstead

STAR SHOTS
JOHN ENGSTEAD

E.P. Dutton ■ New York

E 6 3

791.43028
E

Contents

Beginnings

ALL HELL BROKE LOOSE THE DAY I started to work at Paramount. It was August 23, 1926. I was seventeen years old and I want to tell you I was impressed with myself as I walked into the elegant studio lobby and up to the guard who controlled the entrances and exits to this magic city. I spelled out my name, the guy found it on a list, he released the catch on the door, and I walked into this exciting place I had fantasized about for years. As a first-day bonus, just inside, three feet from me, stood Richard Dix, Paramount's superstar of the 1920s, quietly reading his mail.

When I entered the publicity department down the end of the hall, I felt I was walking into a madhouse. The place had seemed very normal on the day I had been hired, a few weeks back; but now it was like one of those crazy Hollywood scenes from the play *Once in a Lifetime*—only wilder. Publicity men were talking a mile a minute on telephones. Other telephones rang unanswered. Messengers were running in and out. Secretaries were typing away like ants on a piece of sugar. Somebody yelled, "The *New York Times* wants to know if Pola Negri is going to New York."

Arch Reeve, the head of the department who hired me, only had time for a fast glance in my direction and a quick, "Sit down," before he dashed into his office and yelled, "Get Louella Parsons on the telephone."

I hadn't the faintest idea what was going on. A secretary flew by me several times and on

3

her third flight, seeing my bewildered face, threw out an explanation: "Rudolph Valentino just died this morning in New York."

That did it! I was sure that I had arrived too late, that the golden years of the motion picture were over. Gloria Swanson, my dream lady, had already left Paramount and now Valentino was dead. What lousy luck! Who was left? Only Pola Negri, Esther Ralston, and Buddy Rogers.

My love affair with the movies had started further back than I could remember. Although I was born in Los Angeles (a distinction few could claim at that date, except Joel McCrea and a couple of Indians), I had no contact with the studios as I grew up. I think the early part of my life would have been different if my parents had bought the $6,000 house they looked at on the corner of Hollywood Boulevard and Cahuenga. This was a couple of blocks from the original Paramount studios and I am sure that the glamour of the place and my infatuation with Gloria Swanson would have drawn me to the studio, even to do part-time work.

As it happened, it must have been a hot day when my parents scouted Hollywood. "No breeze," said my mother. "Too close to the hills." And that ended that. But as far as I was concerned, the place where we settled, on Pico near Western, had one thing going for it—the Keystone movie theater next door. I earned passes by distributing handbills for the coming attractions. When I ran out of passes, I'd stand in front of the theater until the manager let me go in free, to get me away from the entrance.

My career in the movies had its earliest beginnings when I was a teen-ager, and the person responsible was one Ann Pennington, who went from the Ziegfield Follies to become one of the greatest dancers of all time. William Randolph Hearst and his weekly scandal section kept us residents of the hinterlands informed about the loves and escapades of Miss Pennington and her playmates in New York, London, and Paris. It was seldom that these glamour ladies left their cozy little careers and wealthy playboys to come west. But to get a little extra change on a spare week, Ann took a train from New York to Los Angeles to appear five times a day at the Kinema theater. As if anyone hadn't already heard about Ann, the theater plastered billboards all around Southern California with nothing on them but two enormous words: ANN PENNINGTON. Although the movie that week was mediocre to poor, Ann's reputation saw to it that there was never a cold seat in the house.

I was dying to know what these "dancing ladies" were like, face-to-face. The only way I could devise to meet a glamorous star was to interview one and see if my high school paper would use my story. When I called the theater where Miss Pennington was to appear, the publicity man, who must have wanted every bit of exposure he could get, told me to come to the theater at noon the next day to meet Miss Pennington. I ducked school, arrived at the theater, and was ushered into a dirty little dressing room. It was so small that the publicity man had to stand outside and introduce me. The place needed a good scrubbing and a coat of paint. That was disappointment number one; the second was that Miss Pennington was completely uninterested in some young punk. What the hell could a high school kid do for her? She didn't hide the fact that she was bored stiff. The feeling was mutual because from my fifteen-year-old

perspective, this twenty-six-year-old woman was already middle-aged. Her body was incredibly small: less than five feet in height. She had a cute little Irish face—if she ever smiled. Instead of the glamorous feather-trimmed negligee that I had imagined, Miss Pennington was covered by a plain flannel robe, and she was busy beading her eyelashes. (These being the days before false eyelashes, any girl who wanted to improve on nature had to resort to mascara.) Miss Pennington kept a small pot of liquid mascara cooking over a can of Sterno. With a tiny brush she would dip into this black stuff and swab it on her lashes.

Now, for my story in the high school paper, I couldn't go the route of Hearst. I questioned Miss Pennington about where she was born, how she got started, and what advice she would give high school girls who would like to be dancers. After the interview the publicity man said I could see her show. It was at this moment that I first realized that what we see on the stage sometimes isn't "reality." With the background of some hot jazz, Ann made her entrance followed by a dozen spotlights. She was young, she was sparkling, and she was beautiful. And how she danced! The audience went wild. This was certainly a change from the dame who had been swabbing her lashes just a few minutes earlier.

I wrote the interview and took it to the office of the *Blue and White*, our daily newspaper. The journalism teacher, Katherine Carr, read the interview and the next day the front-page headline read, LA HIGH BOY INTERVIEWS ANN PENNINGTON. With this little taste of importance, I decided to do more interviews, but realized that the subjects should be former LA High pupils or very famous personalities.

A former student was Adela Rogers St. Johns, already one of the most famous newspaper and magazine reporters in the country. One evening I rang her doorbell, introduced myself, and asked if she would write a short piece for the school paper on success. She agreed and I picked it up the next afternoon. A couple of evenings later, I took the *Blue and White* with Mrs. St. Johns' article to her home. Previously we had done all our transactions on the front porch, but this time she invited me in, asking me if there was anything else she could do to help me. "Well," I told her, "I'd like to interview Michael Arlen." He was the hot writer of the year, author of the sensational novel *The Green Hat*, and was then in Hollywood writing for Paramount. Mrs. St. Johns suggested that I contact her friend, Harold Hurley, assistant head of publicity at the studio: "Tell him you're a friend of mine."

When I called Hurley and told him my request to interview Mr. Arlen, there was a very quick and decisive "No! Michael Arlen hasn't had any interviews and won't have any." But a few weeks later I read that Arlen was living at the Ambassador Hotel, only three blocks from our new home in the Wilshire district. Since we were neighbors I had to give it a try. So one morning I stayed out of school and walked over to the hotel. Never having heard of anyone sleeping after eight o'clock in the morning, I arrived at nine o'clock. The man at the desk gave me the number of Arlen's bungalow out near Wilshire Boulevard. A Chinaman answered the bell and I explained to him that I wanted to interview Mr. Arlen for the school paper.

"No. Mr. Arlen is still asleep. He is going to New York this morning. You come back in

an hour and I'll see what I can do." I walked home for the hour and at exactly the right time rang the bell again. "Where you been?" asked the Chinaman. "Well, I didn't wait in the hall," I said. "He woke up," said the Chinaman. "He said he'd do the interview. Now it's too late. He's leaving." He looked at my long face. "Wait, I'll see what I can do." Whatever he did was right because Arlen appeared in a minute, saying he was going to the desk to pay his bill; I could go along and ask any questions I wanted on the way to and from the desk and that would be all the time he would have. So I tagged along and asked the same old questions—his advice to young people who wanted to become writers. The story appeared the next day. It wasn't good, but Arlen was too important to ignore.

My session with John Barrymore was rough going. I interviewed him one morning at Warner Brothers studio as he was making up to go on the set of *Don Juan.* As far as I could tell, he had a hangover. I'd never seen such red eyeballs before or, for that matter, since.

Another Warner Brothers star, comedienne Louise Fazenda, really changed the course of my life. This charming gal with the pixie face and a high squeaky giggle was impressed with my

*From left, Cary Grant
Randolf Scott, Frances Dee, and
John Engstead in
mid-1930s.*

story about her—enough to ask if I'd ever thought of working in a studio. The idea took me by surprise. Of course I hadn't. This was beyond my imagination. I was about to graduate from high school and go to college in the fall.

"My boyfriend is Hal Wallis, the head of publicity at Warners, and I can arrange an interview with him if you want."

You bet I'd like to work in a studio! So I went to see Mr. Wallis and the arrangement was made that he'd hire me if he could get an allotment from the New York office for an increase in his budget. But he didn't get the increase and I didn't get the job. Still, Miss Fazenda had given me the idea and I was so enthusiastic about it I thought I'd better see what I could do about working at some other studio.

I took copies of my interviews (arranged so that the good ones were on top and the bum ones, such as the piece on Michael Arlen, on the bottom) and went to call on Harold Hurley at Paramount. The man at the front desk asked me my name, and who I was.

"I'm a friend of Adela Rogers St. Johns," I said. And with those magic words, the door opened and I walked in. I told Hurley I would like a job as a writer. All I got from this was a peculiar look, but before he could say anything I pushed the interviews under his nose. My favorite stories didn't impress him very much, and leafing through the others, he didn't change his bored expression. He pretended to read, but I had a feeling he was wondering how to get rid of Mrs. St. Johns' friend. All of a sudden he sat upright in his chair. He had come to the Michael Arlen headline.

"Did you interview Michael Arlen?"

I nodded.

"How?" he asked. And I told him.

"Come with me," he said.

We pushed by two secretaries and into an oak-paneled office. There behind the desk, sat a heavy-set man, Arch Reeve, head of the department. The guy was massaging the end of a cigarette as he looked up.

"You have to hire this kid," said Hurley. "He's the only person in Southern California to get an interview with Michael Arlen."

And so it was arranged. I wasn't going to college. I was going to be the first office boy in the publicity department. All the studios had the same budget problems, but Reeve said he'd manage to get the extra eighteen dollars to cover my weekly salary.

■

So here I was with my first job in the movies. And I soon found out that that first hectic day of Valentino's death was not at all atypical of life in the publicity department.

My job was to keep the file room in order, clip all the Paramount publicity from the local papers, and deliver copy to the seven local newspapers and magazine offices in Hollywood. For six months I was the happiest, hardest-working office boy you could imagine. Most days I didn't have time for lunch. My desk was in the office of a good-natured publicity man, bright and lazy—bright enough to knock out an excellent fast story, and lazy enough to sit for long periods with his feet up on the desk reading the trade papers or maybe just dreaming. During one of his meditations, he watched me clip and paste.

"Hey," he opened up, "how long are you going to clip those damned papers. All your life?" (That was his delicate way of saying, "Why don't you get the lead out?")

"No," I said turning to look at him. "I'm going to write."

"Well, what are you waiting for?"

I got the message. That afternoon I talked to the head of the studio commissary to find out what the stars like to eat. Clara Bow, I discovered, loved hot dogs. Wallace Beery liked crepes. There was a long list of likes and dislikes to make up my story. The copy editor corrected it and the secretaries made copies that I delivered to newspapers.

I always thought I had more to offer than just delivering messages, so I would go to an editor's desk with the written material out of the envelope and say, "Here are some stories for you." Sometimes the busy editor would take them and I'd leave. Other times he might read them and I'd always ask if there was anything he needed from the studio. This way I became acquainted with the editors, and quite often came back to the department with requests for photographs or information. When I had my own stories to plant, I gave them an extra plug and many times they were printed. If they weren't, the editor would tell me why and I'd rewrite until they did appear.

My task of keeping the file room in order kept me in close touch with all the photographs of the studio, the most effective way of publicizing motion pictures. Our stills consisted of photographs made on the sets during production, portraits of the players, fashion stills, and an occasional home sitting of a star. There were no pictures utilizing beautiful gardens or breathtaking sleek yachts or ranches with cows and horses as backgrounds for pictures of our actors or actresses. And I wondered why.

At one of the staff meetings, photographs came up for discussion. Mr. Reeve was raising hell because the publicists weren't supplying the New York office with enough pictures. "If you guys are too busy writing your copy," he barked, "just set up a session with one of your players and let the photographer take over and do the sitting by himself. We have to have more pictures."

A bell rang inside my head: I could arrange a sitting of a star in a garden if it didn't require the guidance of a publicity man. I could go along and might even help, even though I was totally ignorant about producing photographs.

In my eyes the best girl for any sitting was Clara Bow. My first glimpse of this star had definitely put Gloria Swanson on the back burner as far as I was concerned. Clara breezed

into the publicity department one day after returning from the *Wings* location in Texas. I'd never seen anything like her. Red tousled hair, a knee-length dress, beautiful teeth, a lovely face, smiling and laughing and talking to everyone. All this love of life just bubbled from inside Clara Bow. No actress trying to impress people, she was absolutely natural. The publicity writers stopped work and came out to see her. Even Arch Reeve emerged from his oak panels and Clara jazzed over to him and put her arm around his fat shoulders.

"Hi, Arch!" He smiled, a little embarrassed.

Why shouldn't I take Clara Bow to a garden with bathing suits, dresses, and shorts? I could take her anywhere and pose her with anything and get great pictures. Barney Hutchison, her publicity man, thought it was a good idea. It would take some work off his shoulders. "Get Otto Dyar," he said. "He's the still man who has been working with her on *Wings.*" And he gave me Clara's telephone number. I called her. Of course she didn't know me from Adam, but was very nice and thought the pictures a good idea and agreed to do them the following Tuesday afternoon.

Now all I had to do was find a garden. The best ones I'd seen were out on San Vicente Boulevard, where there were two- and three-acre estates. I found one that had a pool, statues, garden gates, and beautiful trees. Luckily the owner was home and gave me permission to use the place.

Edith Head helped me select some dresses and bathing suits for Clara to wear on the big day. Nobody worked as fast as I did on that Tuesday morning. I clipped all the papers and made

John Engstead showing Crosby how to pose with F. Gaal for Paris Honeymoon.

all the deliveries by 12:30, just in time to gather the clothes, the cameraman, and the grip (he's the man who works the reflectors), and off we went to Clara's house at 512 North Bedford Drive in Beverly Hills. She was ready almost on time and everything clicked along. On location, Clara was in great form. She was hanging from the trees, reclining by the pool, coming through the gates. Nobody had to tell her what to do. All that was necessary was for Dyar to focus the camera and be sure that she was in the frame.

I returned to the studio just after closing at six o'clock. One secretary who was still there asked, "Did you take Clara Bow out on a sitting this afternoon?"

"Yes," I said.

"Boy, was there a lot of hell being raised around here! Mr. Reeve found out and was he mad! He got ahold of Mr. Hurley and said, 'Who let the office boy of our department take out the top box office attraction of the screen?' Nobody knew where you were so they couldn't do anything. Finally Hurley said, 'Just wait until tomorrow morning and look at the proofs.' "

The next day, after clipping the papers and going downtown, I returned to my desk and found an orange staff memo from the boss's office. It read, "Staff, it may interest some of you high-powered publicity men to know that the best sitting of Clara Bow was made yesterday by our office boy, John Engstead."

I hadn't seen the pictures, but Mr. Reeve took me into his office, smiled, and said I could make more sittings if I had an idea, but reminded me that I was still the office boy. "You must have all your work done first and check with Hurley next time, before you arrange a sitting."

After a few months Mr. Reeve decided to hire another office boy and I became a full-fledged publicity writer, assigned to handle my own productions. The first, Josef von Sternberg's *The Case of Lena Smith* with Esther Ralston and James Hall, was a tough one, but the next, *Stairs of Sand*, was even worse. It was an inexpensive Western, made to use up the last few weeks of Wallace Beery's contract. If you don't think a star about to be dropped from the contract list can be disagreeable, you should have seen Beery. He acted like an angry bull toward everyone in the studio, including me. The love interest was provided by Jean Arthur and Phillips Holmes.

In 1928, when I had been in this job about six months, Mr. Reeve again called me into his office and said that several of the fan magazine editors had asked that I be their Paramount contact. During my year as a delivery boy I had met the editors and relayed messages, the same as I had done with the newspapers. So now they asked that I be returned to work full-time with them. Reeve agreed, on one condition: "You have to wear a coat and tie every day, so you won't look so young."

With this promotion I had my own office for the first time. The editors were very cooperative and gave our studio considerable space, but the job had one aspect that was a pain in the neck. I was supposed to think up answers our stars would give to such sloppy symposiums as "How to Manage Famous Wives," "Can You Type Love?" and many more. I couldn't dream up this stuff so I had to go around and ask the players for answers. This took time, but I got some very good original copy.

The part I liked best about the magazine job, though, was filling requests for photographs. Once a group of our stars were to pose in roles they would like to play. Each was to occupy a full page in *Screenland* magazine. Claudette Colbert did Juliet, Kay Francis was Cleopatra, Jean Arthur was Peter Pan, Jack Oakie did *Merton of the Movies,* Gary Cooper dressed as Sidney Carton from *A Tale of Two Cities,* and when I asked William Powell what he would like to play, he smiled and said, "A wealthy retired motion-picture actor on the French Riviera." So I found a big easy chair and set it in front of a large window through which could be seen a painted backdrop of the French Riviera. Bill sat there contentedly smoking a pipe and his picture was the last in the layout—the topper to the series.

Working on these layouts, I no longer had to check with Hurley before every sitting. I could do whatever I wanted. And I wanted desperately to work with Louise Brooks, the beautiful, raven-haired, chic, former Follies girl under contract to Paramount. I wasn't much younger than Louise, but she was years beyond me emotionally. She had a great figure, and was always dressed like a million. In those days actresses would come to the studio in suits, hats, and furs, looking sensational. Louise was the first woman I ever heard swear. I caught up with her walking across the lot one day. We were talking about something or other and all of a sudden out of that beautiful mouth came the damndest profanity—and she wasn't actually angry about anything. This was true sophistication, I thought.

Facing camera, from left, Jackie Coogan, Betty Grable Gail Patrick, and John Engstead at Grace Bradley's hayride party, 1934.

Finally my chance to work with her came along. She was about to play the title role in *The Canary Murder Case*, the best feature of which was the costume Travis Banton had designed for her. Yellow canary feathers (they could have been dyed chicken feathers) covered a very small portion of her exquisite body like a skin. On her head was a skullcap of more tiny yellow feathers and on her feet were high-heeled yellow sandals to set off her glorious legs. I knew photographs of this would hit all over the world so I arranged the sitting. During the session I had an idea to pose Louise, looking terrified, stretched out on the floor with the shadow of a menacing hand (mine) on the background above her. The still became the basis for advertising the film.

Arch Reeve decided to take me out of the fan magazine department and in 1929 created a new job for me: art supervisor, in charge of all stills. I was to arrange sittings to keep our two portrait men busy and when a still man from the sets was unassigned, find sittings for him to do. I was also in charge of production stills, making sure our set photographers made the right kinds of shots. Each morning a new assistant publicity chief and I would go over the proofs of the preceding day's work. We'd kill the bad stills, and then I would mark the proofs with retouching instructions, ordering the right number of prints, depending upon where each photograph would be used: as a production still, as a magazine exclusive, for syndicates, or for general publicity.

The most monotonous part of this work (and one that ruined my already ordinary handwriting) was the issuing of requisitions each night for the next day's work. Every hairdresser, makeup man, grip, piece of wardrobe, every background, each painter, delivery truck, and each part of every sitting had to have a separate written order and charge sent to the operations desk, the twenty-four-hour heart of the studio, for expediting You can believe I did all this pretty fast.

At that time all studio photographs, except pictures, were taken on 8 × 10 film so that main offices of distribution and publicity in New York could mass-produce contact prints for theaters and newspapers throughout the world. The big negatives required cumbersome cameras and tripods and slow film that needed exposures from one tenth to half a second, depending upon the light on the set. After every scene was filmed, actors posed for photographs depicting the key action of what had just been shot. A few concerned directors such as Josef von Sternberg and Cecil B. DeMille posed their own stills, but usually the set photographer was left to do the best he could while the director lined up the next shot.

Paramount's number-one portrait gallery was operated by Eugene Robert Richee, and the other by a succession of photographers including Bill Walling and Ray Jones. In these galleries we did the portrait sittings, fashion layouts, and advertising stills. Sittings were also made at the stars' homes, on the beach, playing golf, and so on.

Clara Bow, who had lit up the Paramount office that day, was always available. I could snag her off the lot and get a picture at any time. She wasn't one of those who needed a three-hour hair and makeup treatment before she could be photographed. She'd check her lipstick, run a comb through her hair, and be ready.

Clara was second only to Carole Lombard as the most exciting subject I ever worked with, but the two were totally different. Where Carole completely planned a sitting in advance and knew what she was doing at all times, Clara worked by instinct. Whether you gave her a chair, a ladder, or a lounge, she'd immediately go into the right pose and the right expression.

I thought Clara could do anything—and she could—but once I got into hot water over her. I had seen a striking picture in some beauty ad of a model with her head tightly bound, suggesting a nun's habit. The next time I had Clara in the gallery I got a fitter from the ladies wardrobe to come down and drape her head in silver cloth. By the time it had been wrapped around her head and sewn, Clara was completely in the mood of the nun for the Easter picture. As Mr. Richee photographed, tears rolled down her face, and we got some marvelous pictures.

"My God," yelled Hurley when he saw the proofs. "Clara Bow as a nun! For Christ sake, are you out of your mind? She's just about to be sued by the wife of a Texas dentist for alienation of affections!" So all our great photographs ended up in the wastebasket.

In 1928 I was to escort Clara down to the World's Fair at Long Beach, where, I believe, it was Clara Bow Day. On the way, Clara showed me a letter she had received from a little boy who, with his mother, had a popcorn stand at the Fair. He asked if she would stop by and help him. And did she! With her help he sold out all his popcorn in fifteen minutes.

When talking pictures arrived, it wasn't Clara's happy voice that was the problem; there was just no incentive for her to go on. The studio had forced her to make practically the same picture over and over again for five years and she was fired.

"I used to love to come to work—couldn't wait to get here," she once told me. "Now I hate it."

I'll give you Walter Huston's idea of Clara. Walter, who had come to Hollywood to be in Clara's first talking picture, stuck his head in the window of my office as he was leaving the studio one night. "How's Clara going to be in the picture?" I asked him. "How will she stack up against all these other stars from the theater?"

He thought a moment and tapped his heart, "She begins where the others leave off."

■

For all the stars of the silent screen, radical changes came with the talkies in 1928 and '29. Dialogue directors appeared overnight. Performers had not only to cultivate their voices, but to learn to sustain scenes without the director's constant instructions, as well. At first little rooms resembling isolation booths housed the noisy cameras, but sound stages were rapidly built. Another important change during the advent of talkies was the recruitment to the screen of stage personalities. Unlike the glamorous silent stars, many of these actors and actresses were not very photogenic. The days were gone when great beauty alone could guarantee stardom, and this

meant some changes in my work as well. I always had first crack at these people—to arrange the best makeup artists and hairdressers and lure camera-shy characters to the still gallery. Until they were signed for pictures, stage actors never gave a great deal of thought as to how they photographed, which seemed to have been all that the silent stars had cared about. A face could look presentable across the footlights twenty-five feet away and yet not be very attractive when enlarged perhaps a hundred times on the big screens. Without brains, talent, and unusual voices, for instance, I doubt that people like Mae West, Miriam Hopkins, and Ruth Chatterton would ever have made the grade.

Glamour
and Hard Work

SOME OF THE LADIES FROM THE NEW York stage brought a new type of problem to the portrait sitting, because a Broadway star usually sat for portraits only once every few years. One good pose was selected and this was used in front of the theater and in newspapers until the next sitting. It could have been that Ruth Chatterton, a middle-aged woman with great charm and a marvelous voice, didn't think her face was as photogenic as, say, Joan Crawford's. This was in spite of the fact that our studio gave her Marlene Dietrich's great makeup woman, Dot Pondell. When Miss Chatterton did pose it was almost always with the dignity of an Eleanor Roosevelt: "Leave all thoose extreeeme poses to Miss Dieeetrich." When Florence Lawrence, the motion-picture editor of the Los Angeles *Examiner*, who had been one of the first important stars of the silents, saw the ritzy Miss Chatterton's photos, she said, "I want actresses to look dramatic on my pages—the dignified dames are for the society pages." And she threw Miss Chatterton's picture in the wastebasket.

My task of jazzing up our photographs and making sure that nothing went in the wastebasket was a little like walking on eggs. All the photographers were older than I and had a great deal more experience. Gene Richee, for many years the head portrait man, had worked very successfully with Gloria Swanson, Pola Negri, and all the contract list. It was difficult to get him, and also the set photographers, to take directions from me. I realized that if we had more ideas behind our portraits, more of them would be published. I clipped photographs by Edward Stei-

17

The cast of Double Door. *2nd from left: Lona Andre. 4th from left: Buster Crabbe, then Barbara Fritchie, John Engstead, Ida Lupino, and Gwendolyn Gill. Far right: Ann Sheridan.*

chen, Cecil Beaton, and the other photographic greats and showed them to our people. This went over like a lead balloon. But I kept pushing. I would arrange for curtains to be set up and have new pieces of furniture delivered. On my trips to the stages and the back lot I was constantly on the lookout for statuary, latticework, columns, or anything interesting and small enough to move to the gallery. One important preparation for a setting was persuading makeup wizards, such as Wally Westmore and Miss Pondell, and the best hairdressers, whose time was usually monopolized by the big stars, to work on the young actresses for our sittings. And I learned to suggest lighting effects whenever possible.

As if technical problems and the challenge of dealing with all these eccentric personalities didn't make my job difficult enough, in 1934 the studios set up the Hays Office to police and maintain high moral standards in films to appease the ladies clubs about our wild Hollywood. Every photograph from every studio had to be approved by the Hays Office and its stamp of approval put on the back of a key set. The rules were strict. No man and woman could be photographed in any way so that the still could be cropped or turned to suggest the man was on top—even if both participants were fully clothed. Cleavage had to be retouched. No one could point a gun or dagger at anyone. No woman's navel was ever exposed. An actor could never kiss an actress on the ear (too much like nibbling). If an actor was behind a woman and put his arms around her, his hands and arms had to be absolutely clear of her bosom.

18

Besides those, our studio had ideas about certain restrictions. I learned how they felt about hair on a man's body when I brought in some proofs of Buddy Rogers in tennis shorts. "Get him to shave his legs or bleach them," Mr. Hurley said. "Women have all these hairy guys at home and they don't want them on the screen. Do you realize that John Gilbert is the mental father of half the children born today?" No romantic idol was to be photographed in any lovey-dovey pose with his wife. There was no escaping the fact that Fredric March was married to Florence Eldridge, but I was instructed never to pose them looking romantically at each other. Freddy had to stand and look footloose while Florence was seated, to give the impression to any lovesick fan that he might not be too happy at home and could take off at any time.

The worst part of my job as art supervisor was the terrible gag pictures. Publicity men would sit in a meeting thinking up these silly ideas, which were only excuses to show off the charms of our pretty starlets. Once, for example, poor Jean Arthur and Lillian Roth were forced into playing football on the studio lawn in shorts and football helmets. I was given a list and was told to execute the damned things. I am sure the policy of forcing new actresses to pose in these undignified photos helped to foster their rebellious natures when they became stars.

Every holiday of the year called for art for the newspapers. A starlet would jump through

John Engstead and Gail Patrick

an enormous paper calendar for January. If we had a kid under contract, he was dressed as the New Year. Girls had shamrocks painted on their knees for St. Patrick's day. The favorite Fourth of July pose was of a starlet in a bathing suit with a five-foot firecracker: she would have one finger in her ear and the other hand lighting the fuse. There were loads of ideas for Easter and Christmas, but I once devised an Easter pose I thought a little better than most. It was a shot of a beautiful actress holding dozens and dozens of fake Easter lilies. Sometimes I'd have it photographed in a meadow or on a hill or with her seated in the gallery. The girl always wore a soft white dress with a long full skirt. Every year after that the Los Angeles *Herald* published a full page of the same photo with different actresses in different places, but always the beautiful girl in the beautiful dress with the same Easter lilies. After five years, I didn't have the nerve to do it again and, believe it or not, MGM did it that year with Ilona Massey and grabbed the same cover of the same newspaper.

Understandably, persuading stars to pose for sittings was difficult. One reason was, as the old saying goes, "Nobody appreciates anything free"; and it was the studio that paid for all the

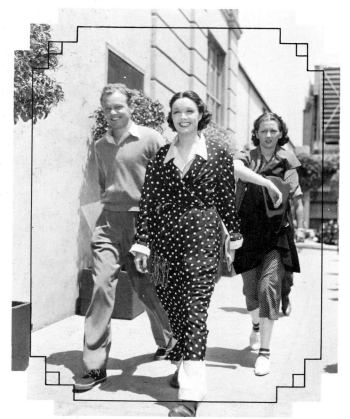

John Engstead and Gail Patrick

photographs thought necessary to promote and sustain a major player's career. Another reason was the obvious one: making one film after another, working six days a week, if a performer had a few days off between productions, he or she would rather vacation than pose for stills.

With new players it was a different ball of wax: they were eager to pose at any time; in fact, it was sometimes difficult to get them out of our hair. But as they became more important, the scene would change. It wasn't until they were feee from long-term contracts and needed stills for publicity and to help their agents get them other jobs that the players would again see things differently.

Gail Patrick, 1975

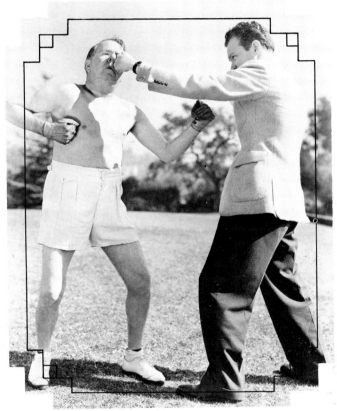

W. C. Fields and John Engstead, 1936

Gail Patrick was one of the most cooperative young actresses at Paramount in the mid-1930s. Although the usual cheesecake art wasn't up her alley, her beauty and brains made her an ideal subject for many photographic sittings. Gail was always invited to dinner parties when studio executives entertained bankers, exhibitors, or statesmen from around the world. After studying law in Alabama, Gail could talk to those men on almost any subject and she proved that girls in Hollywood weren't all dumbbells. In 1936, RKO studios made a survey of leading newspapers and magazines to find out which stars and which studios were receiving the most publicity. To everyone's surprise, Gail Patrick topped the list with more space than anyone in the industry. And when she retired from acting, she became producer of the very successful "Perry Mason" TV series.

There was one photographic sitting that all stars were required to do. This was a session where we posed the principal players of a film for special photographs used on billboards and in front of theaters. The advertising department would supply sketches they wanted photographed, and I would read the scripts and think up other ideas. The actual shootings were rewarding: I could explore the dramatic effects possible with two or three stars. But arranging the sittings was another matter: scheduling the stars and making sure the costumes and backgrounds were ready. To help me out, the studio brass made it the duty of the assistant director to find time out of the production for these important photographs. Of course, filming the movie always came first so it took a great deal of checking and prodding to schedule the session. Bing Crosby, for example, was so fed up with the antics of Miriam Hopkins and she was so elusive that we never made photographs of the two together for *She Loves Me Not.* I soon found that the executives of the studio would not back me or our department if a lazy star refused to be

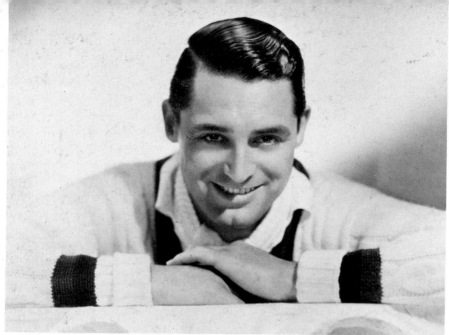

Cary Grant, 1933

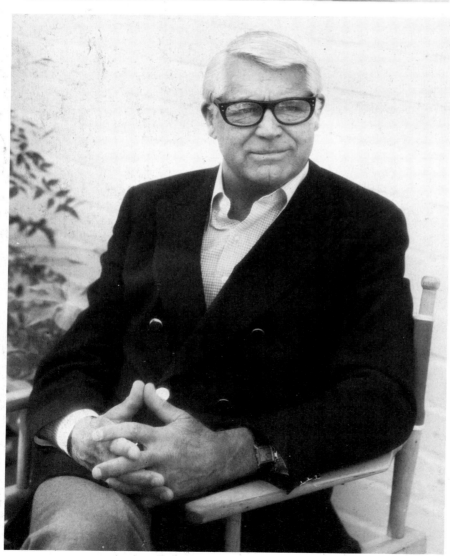

Cary Grant, 1977

photographed. So it became necessary for me to pin them down for sittings, by hook or crook. Sometimes we would set up a gallery on the sound stage where an actor or actress was working and grab shots during the pauses between scenes. My friend, nice old W. C. Fields, was always obstinate about coming to the gallery, but once I discovered that he was agreeable to posing between scenes, all my worries with him were over.

■

One morning in 1933, like the understudy who went on at the last minute, I suddenly became a photographer. When the still cameramen went on strike at all the studios, there was a mad scramble to find men to shoot stills on the sets. In what seemed like a rash moment, the

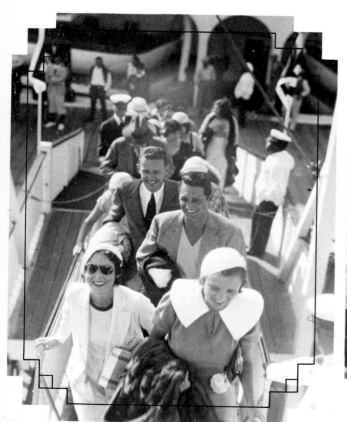

From left, Frances Dee, John Engstead,
Cary Grant, and Janet MacLeod, 1932.

From left, Martha Sleeper, Cary Grant, Janet MacLeod,
John Engstead, and Frances Dee at Paramount picnic 1932.

head of publicity pointed to me: "You're going to take over the portrait gallery." Knowing that I had never exposed a piece of film in my life, he said, "Get someone in tomorrow and practice—on your sister, on anybody."

I knew about lighting from watching our photographers and the experts from the magazines. The head of the still department was not on strike, and he explained how one should squeeze the bulb like this when you have the lens stopped to 11 and then you squeeze thiiis long for a stop of 16. I was ready. With no doubt in my mind that I could make good pictures, I decided to start with a Paramount player.

A woman would require the extra expense of a hairdresser and a makeup man, so I called a very good-natured friend, Cary Grant. He was agreeable and we worked for two hours. I tried everything—crosslight, flat light, and backlight. Cary, who was as eager as I was to see the proofs, was in the publicity department at nine o'clock the next morning. It was decided that the sitting was a success. Before I shot another picture, I was called into the chief's office and was told that he and the New York office had decided that I would be the new permanent portrait

From left, George Raft, Mack Gray, John Engstead, and Mayor Rossi of San Francisco, 1935 (Credit: Phil Stroupe Photography)

George Raft, 1933

Fred MacMurray, 1960s

Fred MacMurray, 1939

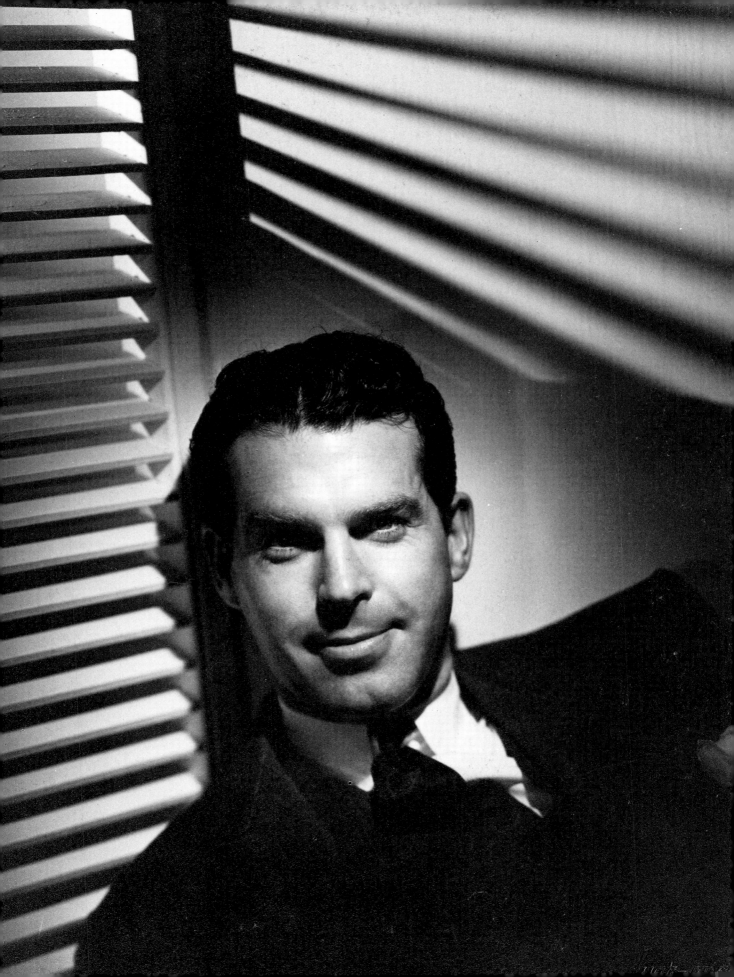

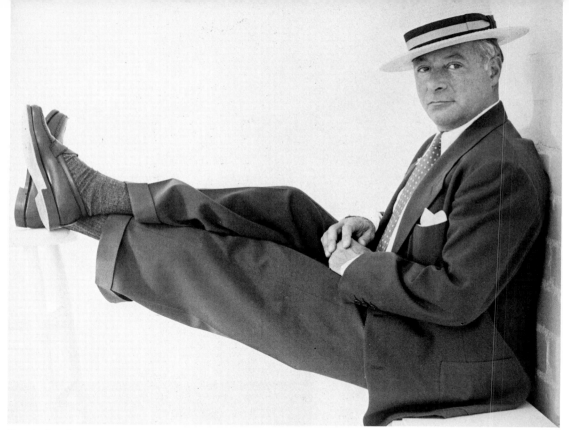

Georgie Jessel, 1953

man of the studio and they would increase my salary from $90 a week to $125—which was a very tempting figure for the Depression era. But I refused. It would have put one of the men I had been working with out of a job. Also I couldn't fancy myself sitting in the gallery by the hour waiting for someone to bring me a subject to photograph. The realm of my work was the entire studio, working with hairdressers, makeup men, directors, writers, and producers.

During the strike I arranged the sittings as well as operating the camera. But after the photographers came back to work a month later, I returned to concentrate on simply managing the sittings. And I continued in this job for the next five or six years. On every sitting there was always some product sent to the gallery to be photographed with a player for an endorsement—pool tables, lamps, beds—you name it and we shot it. Today we hear about the astronomical sums actors are paid to do television commercials, but in the 1930s the studios saw this as another way to promote a film. As an incentive the players were usually promised one of whatever product they endorsed, but when it came time to collect the loot, the stars often never received it. Either it was never sent or some sticky fingers along the way annexed it.

Paulette Goddard, a sharp number in anybody's book, may have been fooled once, but she was very wise by the time they asked her to pose with a large console radio. Paulette did her pose and she said nicely that she would take her radio then and there. "You can't have this one," the advertising man said. "We have to shoot it with other actresses." "No," said Paulette, "I'm taking it now. Open the doors, boys." Waiting outside was a truck she had hired to haul it home. And out it went.

The most important advertising campaign to come out of Hollywood in the 1930s and '40s was for Lux soap. Sooner or later almost every top female star posed for the account. A

Michele Morgan, 1942

full-page photograph of, say, Claudette Colbert posed holding a cake of soap in a luxurious bathroom with credit to her new film was an excellent way for the studio to latch onto some free advertising. The actresses were supplied with Lux soap for twenty years—but no money. However, the same actresses were often chosen to appear on the "Lux Radio Theater," for which they were paid $5,000 for several hours' work. George Hurrell, ace photographer formerly with MGM, took the pictures.

One night at a party, Danny Danker, West Coast head of the J. Walter Thompson agency, who handled the Lux ads, told me that Hurrell had been signed by Warner Brothers for their portrait gallery and had given up the Lux account.

"How would you like to do the Lux ads?" Danny asked.

"I can't. You know I don't photograph," I said.

"Do just what you do at Paramount. Get a photographer to work with you, but you manage the sittings. I have to have someone the stars know—and they know you."

"But I work at Paramount. They won't let me take time off."

"Don't worry about that. I'll arrange it."

And he did. This was too much money to turn down, so I made an agreement with Otto Dyar, who worked with me the first year. After the series was completed, Otto wanted to continue the arrangement so we rented half a small studio on Sunset Boulevard. I was still at Paramount so I could only work at night and on weekends.

In 1941 this happy existence collapsed. Dyar decided to go back to the studio and shortly after that I was fired. A new boss had a friend he wanted in my job. Well, I had done fairly well: eight heads of publicity had been fired while I was there. But where do you look for a job as

31

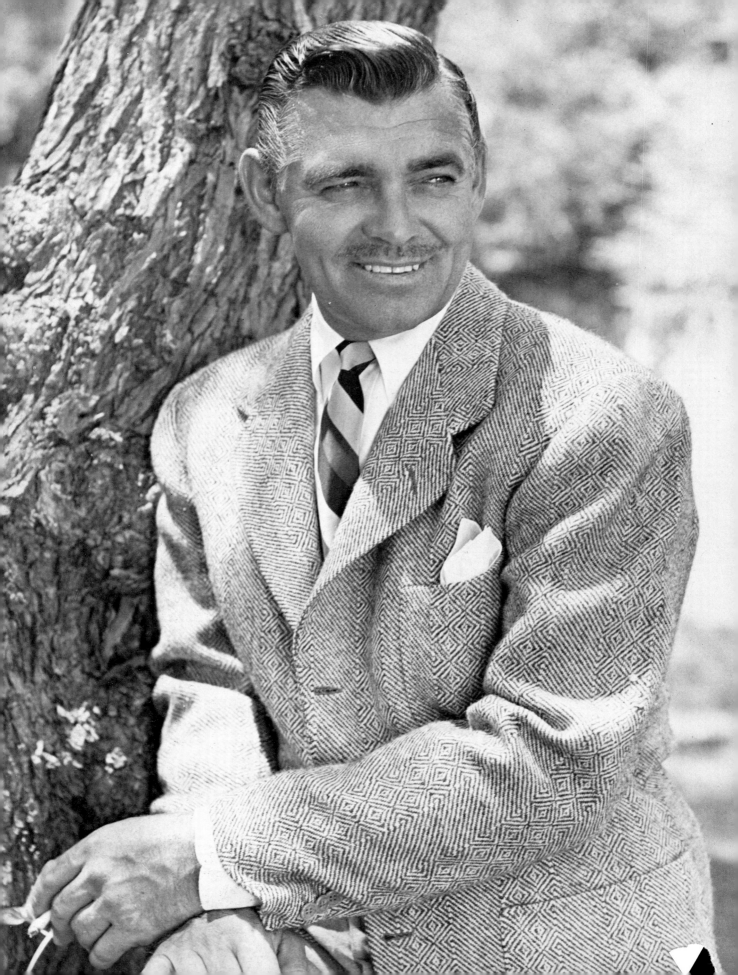

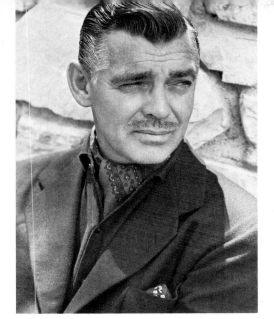

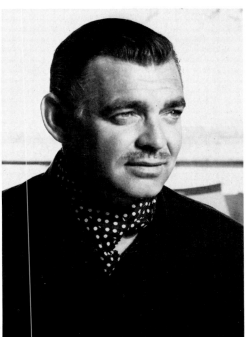

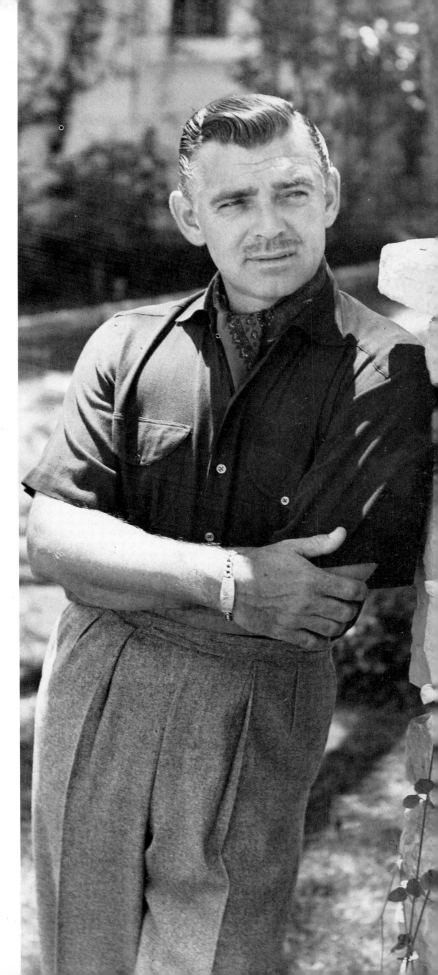

All photos of Clark Gable taken in 1947

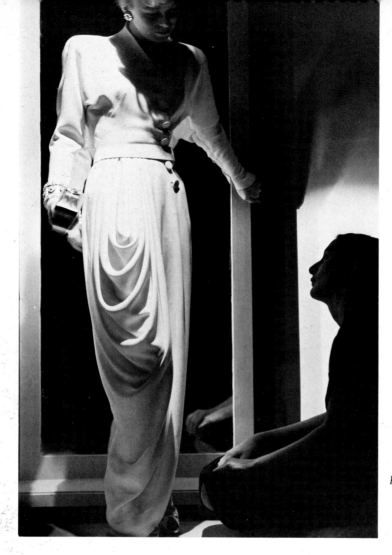

Fashion shot of an Irene creation, 1940

specialized as mine? I was living in a house in Beverly Hills with five lights and a camera sitting in the corner of my living room. There was no alternative but to become a photographer—if I wanted to eat.

Two marvelous guys, Christy and Shepherd, took me under their wing. They showed me how to load film and read a meter. They developed, proofed, and printed what few pictures I made. There weren't many. But no job was too small for me. I scoured the papers every morning to see if I could find a prospective bride who might need a picture or two. The first ad I did featured a model in a sports dress, photographed on location, and for it I received twelve dollars.

One way to give my new career a lift would be to have a few pictures published in either *Harper's Bazaar* or *Vogue*. In response to my letters, *Vogue* definitely wasn't interested, but a nice editor from *Harper's,* whom I'd met on a job at Paramount, said that if I wanted to photograph on speculation, I should shoot the new collections of Adrian and Irene. If the magazine liked them, they would be published. Adrian's manager turned me down, but Irene was extremely cooperative. My friend Carole Lombard (I'll tell you more about her later) had introduced me to Irene with such enthusiasm that I had already made some portraits of her. One night Irene held open her salon at Bullock's Wilshire and I photographed for several hours. The dresses were beautiful and the models perfect. I rushed the pictures to the magazine and they all came back in a

34

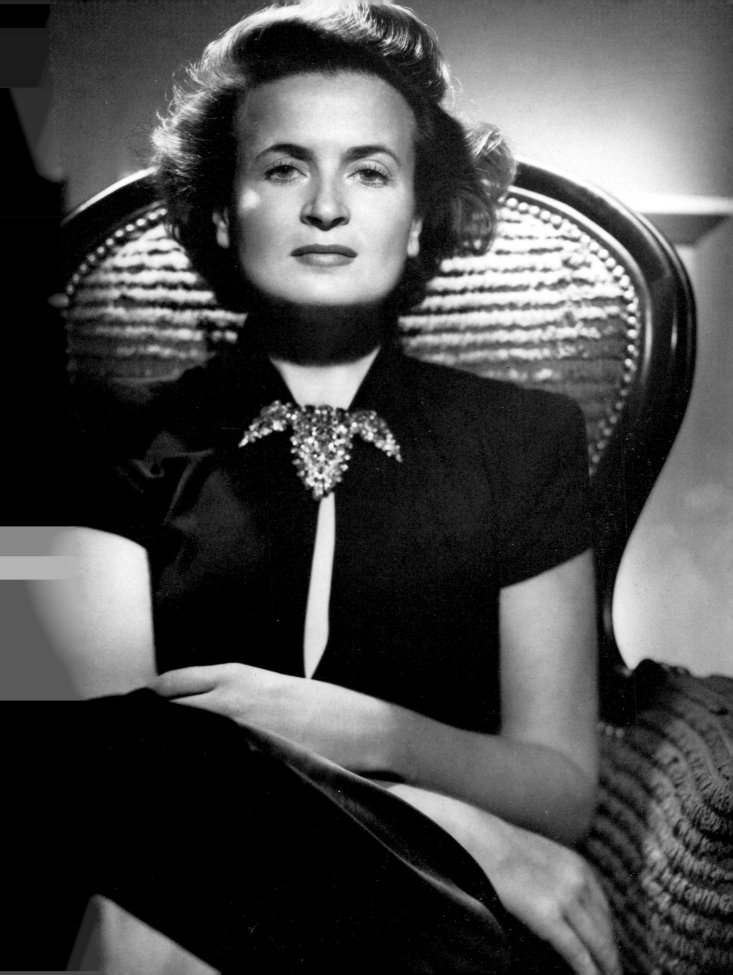

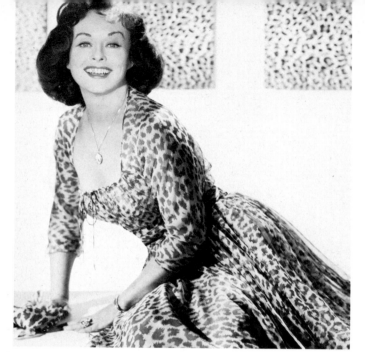

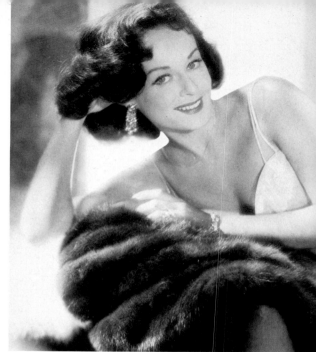

Paulette Goddard, 1965

week. There was a note congratulating me on the photographs, but saying there were no new ideas in the designs. I thought they were just letting me down nicely and went out looking for more twelve-dollar ads. To my surprise, in two weeks I received a wire from Carmel Snow, editor of *Harper's Bazaar*: PLEASE CONTACT WESTERN FASHIONS [that was a local manufacturer] GET NUMBERS 35A, 18B, 6B, AND 40 AND PHOTOGRAPH ONE ON EITHER JUDY GARLAND OR MICHÈLE MORGAN. I didn't call MGM for Garland because I knew the studio would allow me about twenty minutes to do the job. So I called RKO, which had just brought Miss Morgan from France to make a movie. I picked her up at her home in Benedict Canyon (which years later was to be the scene of the Sharon Tate murder). Wearing almost no makeup, Miss Morgan was beautiful. There was no studio entourage to interfere and I had the whole afternoon to work.

Driving over Coldwater Canyon, we stopped and shot pictures in some tall dried weeds and then proceeded to a ranch in San Fernando Valley, where we used bales of hay, turkeys, and horses. All these rural props added interest to some rather dull shirts and slacks we photographed. Mrs. Snow wasted no time in wiring that she thought the pictures were "divine" and would give us two pages instead of one in the May 1942 issue. From then on, almost every month Mrs. Snow gave me assignments and published my photographs of Ann Sheridan, Alan Ladd, Veronica Lake, and others. With this endorsement, designers in California and advertising agencies asked me to photograph for them.

In 1943 Mrs. Snow came to Hollywood to work with me on a series of photographs which ended up on twenty-six pages of the July and August issues of the magazine.

With this exposure, the kind and talented Adrian called and asked me to photograph for his imaginative collections. Studios invited me to previews and sent presents. Best of all, assignments came unsolicited from *Ladies' Home Journal, Woman's Home Companion, Life, Look, Collier's, Esquire, McCall's, House Beautiful, Mademoiselle,* and even *Vogue,* who a year before had treated me like a bad odor. I even got a tempting offer to work in *Vogue's* New York office, but decided to stay with my roots in California, with *Harper's Bazaar.* Suddenly there was more to do than time allowed. And I've been a busy independent photographer ever since.

36

Pros

THE DAY OF MY FIRST ENCOUNTER with Barbara Stanwyck, Gene Richee and I were dragging our feet as we prepared the gallery for a two o'clock sitting. Actresses are usually late, anywhere from fifteen minutes to four hours: "My hair didn't curl right. The makeup was a problem. An interview took longer than I thought."

But it was 1:45 when Barbara Stanwyck walked into the gallery, made up and carrying several changes of clothes. We were caught, let's say, with our preparations down. During the thirty-five years since then, Barbara has arrived for each session at least a quarter of an hour early. Another asset to a Stanwyck sitting is that she never schedules another appointment after a photographic session, so we can continue working until we are both satisfied that we've taken every photograph that is needed.

Barbara prefers to work with professionals, and once she is convinced they know what they are doing, she takes direction and works fast and smoothly without giving a lot of static. She doesn't want the mirror next to the camera that many actresses insist upon. She wears very little makeup, only an occasional pat of powder. She knows very definitely what Barbara Stanwyck is; there's no indecision about that. She's exactly the same offscreen as she in on; a very definite lady—no coy looks, no phony allure, no drooping eyelids. Her approach to sex has always been honest, without a lot of beating around the bush.

39

Paul Muni, At the Grand, 1958

I photographed Barbara in 1942 for *Harper's Bazaar* and from then on did regular sittings. An event that tells a great deal about her code of fair play and friendship occurred when she was making *To Please a Lady* with Clark Gable in 1951. For many years a fine black woman named Harriet had worked for her as a maid and companion. As the film company was preparing to leave for location at Indianapolis, a business manager called Barbara to find out what type of hotel accommodations she required. Barbara told him she wanted a bedroom and bath for herself and the same for Harriet, with a sitting room between. When the business manager explained that this was the best hotel in Indianapolis, where Mr. Gable wanted to stay, and blacks were not allowed, Barbara told him she wanted Harriet close to her, that he should fix it up because that was the way it was going to be. Later that day the producer called to soothe Miss Stanwyck by assuring her that Harriet would stay at the best "colored" hotel in Indianapolis.

"Well," said Barbara, "I'll tell you what you can do to solve the whole thing. You make a reservation at the best colored hotel in Indianapolis for two bedrooms and baths and a sitting room between, and that's where I'll stay with Harriet."

Barbara Stanwyck, 1942

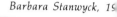
Barbara Stanwyck, 19

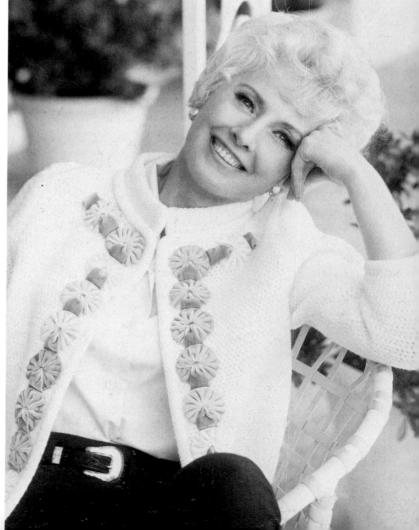

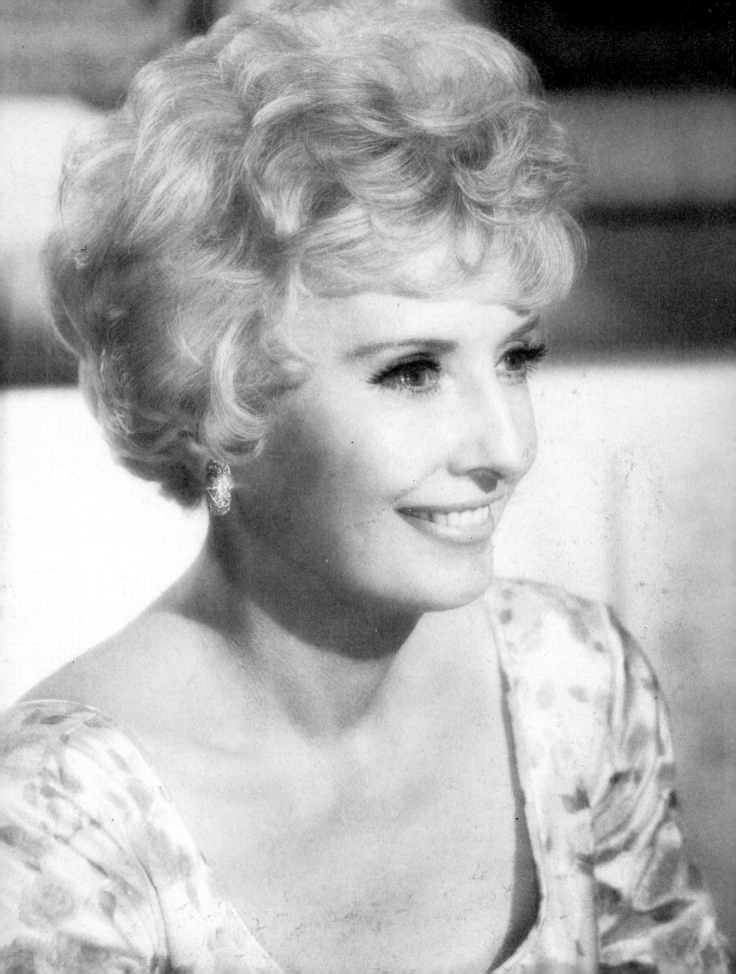

Bob Hope, George Burns, John Engstead, Gracie Allen and Ben Blue, The Big Broadcast, *1938*

"Oh, Barbara, you can't do that!" argued the producer.

"The hell I can't," she said, and hung up. With many telephone calls the room for Harriet was arranged next to Barbara in the hotel with the rest of the company, and when the stars arrived at Indianapolis, the manager personally came down to meet them and thank Barbara for taking her stand.

When Barbara went to work on her television series, "The Big Valley," she became more popular than she'd been in the movies. For a layout at her home in Beverly Hills, Barbara was wearing one of the striking costumes from the television series. As we worked in the front yard, car after car of tourists, with the Guide to the Movie Stars' Homes map in their hands, stopped and gawked. "You know how long I've been in this business?" Barbara said. "I've never had these hundreds and hundreds of people searching out my house and following me down the street until this television series. People wait out in front until I come home. I go out back to dump trash in the alley and they are there. The other day I came home and a family group was having a picnic on the front lawn." Barbara had to move and this time she kept her address a secret.

This is one lady I'd call a real pro. There are many of them in our business. I've worked with some of the best, and will only be able to mention a few of them here. The pros come prepared to do the very best they can and are considerate of their co-workers. And when they squawk, it is nearly always justified, make no mistake.

George Burns and Gracie Allen were certainly real pros, and of course George still is. I had a small part with them in *College Humor* in 1933, worked on all their photographic sittings at

42

Paramount, and later did publicity shots for their television series at my studio. They always cooperated completely. While Gracie wasn't really the zany character she portrayed, she did have that marvelous lilt to her voice, a warm personality, and a zest for life.

Fred Astaire, like Barbara Stanwyck, always arrives at least fifteen minutes before a scheduled sitting. He comes dressed and ready to work and nothing seems to stir his calm temperament—even the times we both had a long wait for his dancing partner, Barrie Chase. At one session she completely forgot the appointment. All Fred said was, "Poor Barrie, she's so insecure," and made another date for the next day.

The partner most associated with Fred in his dancing films is, of course, Ginger Rogers, the same bright, dedicated, hard-working lady in real life that she is on the screen. Her movie career began at Paramount in 1929, first in short subjects and then so-so parts in feature films at the Astoria studio on Long Island. I met her briefly in 1933 when she came to do a couple of sittings in connection with the film *Sitting Pretty.* Later she went to RKO where she made the fantastically popular films with Fred Astaire, and in 1940 won an Oscar for *Kitty Foyle.*

The first time I shot Ginger was for a fashion piece for *Harper's Bazaar.* She was studying painting at the time, so we used her equipment to add a little realistic touch to the shots. For the last twenty years we have done sittings whenever she needed them to publicize a new film or a stage appearance such as *Dolly* or *Mame.*

Ginger is one of the few actresses who prefer to pose for a sitting with a well-scrubbed,

John Engstead with Gracie Allen, 1938

Fred Astaire, 1955

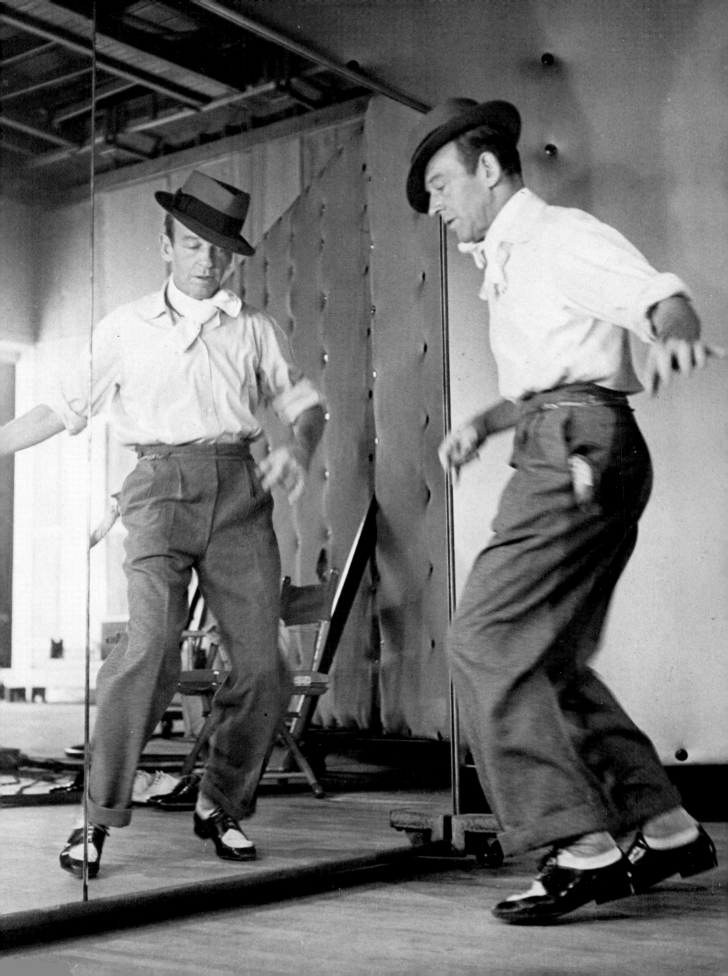

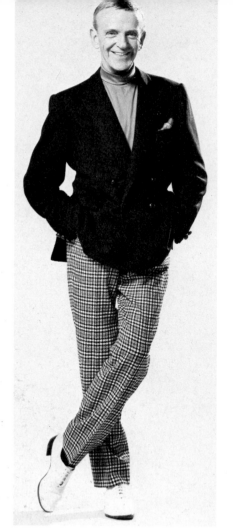

Fred Astaire, 1970

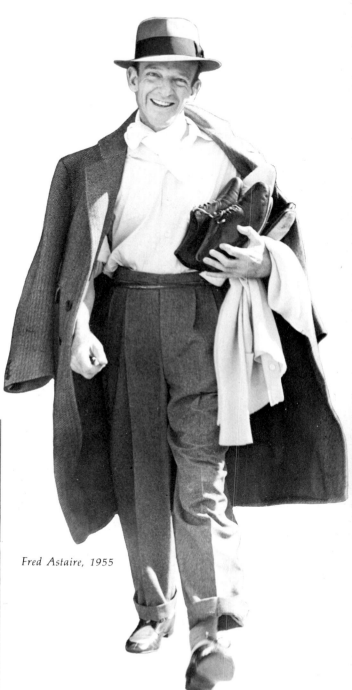

Fred Astaire, 1955

Fred Astaire, 1955

Fred Astaire, 1955

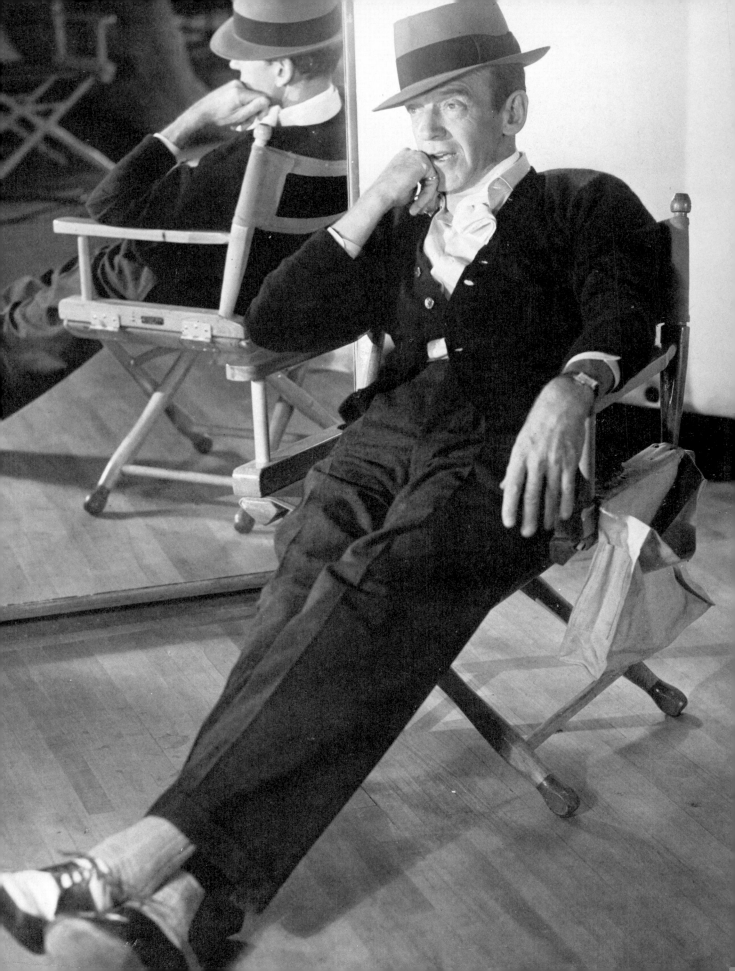

healthy, shiny face. For her first sitting at my studio in the early 1950s, she came with a tanned and well-oiled face, which would have looked appropriate with a track suit but was certainly not in the mood of the silks and sequins she was to wear. When she gave complete agreement to powdering down her face, I realized that Ginger would always be open to suggestions and never turn a sitting into a struggle of wills.

Like most pros, Ginger is very considerate. In 1970, she arrived for a portrait sitting on time and explained that her face was a little swollen on one side from a session with her dentist that morning. The swelling was small and we began to shoot. As the afternoon advanced, the tooth began to assert itself and after a few hours it looked as if she had a walnut stuck in her cheek. I knew she must have been uncomfortable and when it became too large to hide in any way, we stopped the sitting.

"Why didn't you call and tell me you had been to the dentist?" I asked. "We could have made another appointment."

"No," she said, "your time is valuable. I wouldn't do that."

Another nice thing about Ginger is her body, which she keeps in top form—waist, legs, midriff—none of which requires retouching. Just a year ago we were working in the alley behind our studio on a picture of Ginger in a tennis outfit. She was leaning a shoulder against the wall and facing up the alley. From behind her in a little sports car came two young men in their early twenties who stopped beside us to see what this chick looked like from the front. "Out of sight!" one of them said, before it dawned on him that this was Ginger Rogers.

When it comes to cooperation, Helen Hayes is the champ among pros. She's smart enough to know that by being agreeable to any reasonable request, instead of being a pain in the fanny, she is really helping her own career. And that's one of the reasons why hers has lasted for more than three quarters of a century. I first met this special lady when Paramount brought her out to costar with Gary Cooper in Ernest Hemingway's *A Farewell to Arms* in 1932. She had come by train and was driven directly to the studio. About noon, Arch Reeve called me into his office to meet her. He was telling her that the first thing we needed was a portrait sitting and that I would call her to set up an appointment as soon as possible.

"I really don't know when I can do it," said Miss Hayes. "I've just met with the director, Mr. Borzage, and I start tomorrow morning on fittings and tests." She sighed, "I just don't know." She was obviously tired from her five-day train trip, and you could have floored me when she came up with, "Unless we do it this afternoon." I would never have had the nerve to suggest that—but she did.

"If I could go to the hotel, unpack, and find a few things to wear—just take a bath, I could be back here by 2:30." And that's what she did. A hairdresser and makeup man started to work on her and at 4:30 we began her sitting. It was finished by 6:00 and we had some beautiful photographs.

When it came time to make the billboard stills a week later, I was in luck. The costumes (nurse's outfit for her and a uniform for Cooper) were finished. Frank Borzage and his assistants

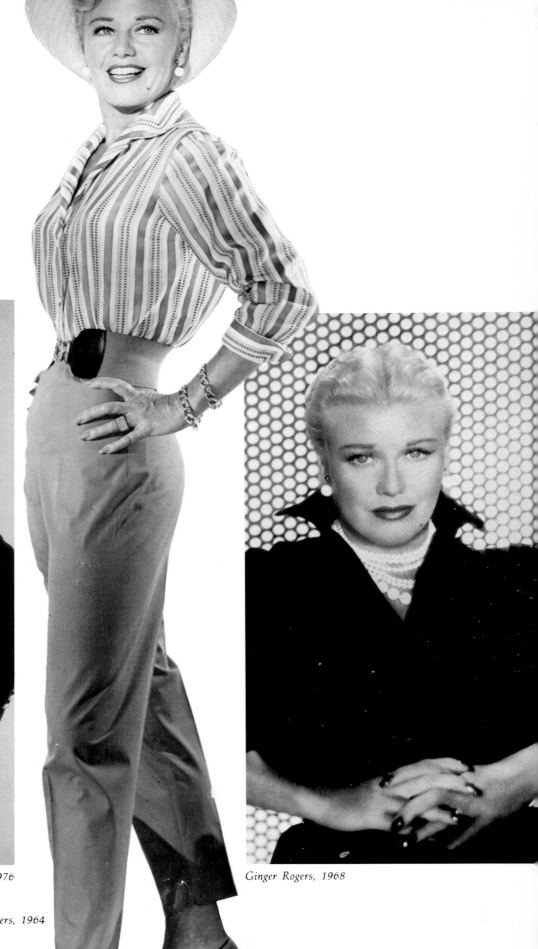

Ginger Rogers, 1976

Ginger Rogers, 1964

Ginger Rogers, 1968

Helen Hayes, 1976

gave me an afternoon before the filming began. Everyone knew *A Farewell to Arms* was a beautiful love story and the advertising department wanted only romantic shots of Hayes and Cooper, with considerable sex. Now, Helen is one of our great actresses, but nobody ever called her sexy, in the Hollywood Garbo-Crawford-Harlow way. I decided the best way to start the sitting was to ask the two stars to lie down on the gallery floor. That would certainly break the ice, so to speak. Coop was surprised, I think, not for himself, but at the idea of Helen Hayes on the floor! A minute later Helen was on the floor and Coop followed her. It didn't take them long to get in the mood of the picture, and we made some really marvelous, romantic stills. They were good enough for Borzage to ask for a set of proofs as a guide in filming some of the love scenes for the picture.

Forty-four years later, in 1976, I was able to make a few photographs of Helen during a busy trip to the West Coast. Her friend Laura Mako arranged the appointment and told me Helen's plans. She would read the Declaration of Independence at the Battery in New York on the Fourth of July and welcome the tall ships as her part of the Bicentennial. On the fifth she

50

Charles Laughton as Captain Kidd

would come to California; on the sixth she would receive the ANTA gold medal of achievement; and on the seventh, she would be present in Washington, D.C., at President Ford's state dinner for Queen Elizabeth of England. Somehow she managed to find time, in the midst of all that activity, for the shooting.

■

In spite of his careless way of dressing, his rumpled suits, and unruly hair, Charles Laughton carried with him an air of unmistakable professional genius. For years he used to kid

Charles Laughton, 1960

Charles Laughton and model, 1960

me about how I tried to take away his character when he first arrived in Los Angeles. Paramount had been impressed enough with Laughton's success in the New York stage play, *Payment Deferred*, to sign him to a contract, but not impressed enough to send anyone but me and a photographer to meet him.

It had been raining and Charles had on a wrinkled raincoat from under which I could see a tie that was edging its way over toward his ear. He was accompanied by his wife, Elsa Lanchester, whose outstanding features were large eyes and loads of red hair—which was naturally very, very curly and with the added encouragement of the wet day looked as if it had been hit by a bolt of lightning (shades of *The Bride of Frankenstein*). I straightened Laughton's tie and gave Elsa a comb, which only served to increase the violence of the red mop. My idea was to make this couple as presentable as possible for their first-arrival photograph in Los Angeles.

Taking a tip from the New York critics, who had gone on record that Laughton was an

Charles Laughton, 1960

acting genius, I made it a point to befriend him, find out what made him tick and how he had gone from a hotel clerk to a great actor. And Charles wasn't stingy about giving out information about his craft. His number-one rule: every actor should read Constantin Stanislavsky's book *My Life in Art,* and keep it on his dressing table—as a bible.

Charles found that acting for the screen required a new technique of preparation, since scripts are never shot in sequence. He explained to me a scene from his first film, *The Devil and the Deep.* He hears that his wife, Tallulah Bankhead, is having a few very private sessions with Gary Cooper. As he walks home to confront his wife, Laughton developed a bit of business to strengthen the scene. He would be tossing a small ball in his hand as he came along the street. When he reached his home the tempo and the height of the toss would increase. Inside the house, looking for his wife, the ball would go even faster. The only trouble was that the interior scene was filmed two weeks before the exterior shots, so it was up to him to remember the tempo of the toss.

Charles once said that part of acting was mental telepathy. When the accomplished actor or actress concentrates strongly and completely believes in his character, these thoughts are projected to the audience. As an example he spoke of Ruth Gordon, for whom he had great respect, who at the time was playing the leading role in the New York production of *The Little Church Mouse.* In the first two acts she is an insignificant little thing and in the third act becomes a great beauty. Miss Gordon has never been accused of having the physical attributes of, say, Elizabeth Taylor, but Charles said that when she made her entrance in the third act, the way she carried herself, the height she attained—everything about her gave the aura of great beauty.

■

The late Joan Crawford was a meticulous professional. I first heard about her regimented life from Allan Vincent, a New York actor under contract to Paramount in the early 1930s. For his first few weeks in Hollywood, Allan stayed at the Brentwood home of Joan and her first husband, Douglas Fairbanks, Jr., and he told me their routine. Joan and Doug would be up every morning at 5:50 to go through a series of physical exercises. At breakfast they would read the news sections of the morning paper for at least a half hour. There was a full day's work at the studio, and when they returned home an instructor would be waiting to give them a French lesson. After dinner they learned their lines for the next day's shooting. At 11:30 they would be in bed.

In 1943 I photographed Crawford for *Harper's Bazaar.* The sitting was done at her home in Brentwood and when I arrived she came from the region of the garage, her face flushed and with very little makeup.

Joan Crawford, 1945

Joan Crawford, 1945

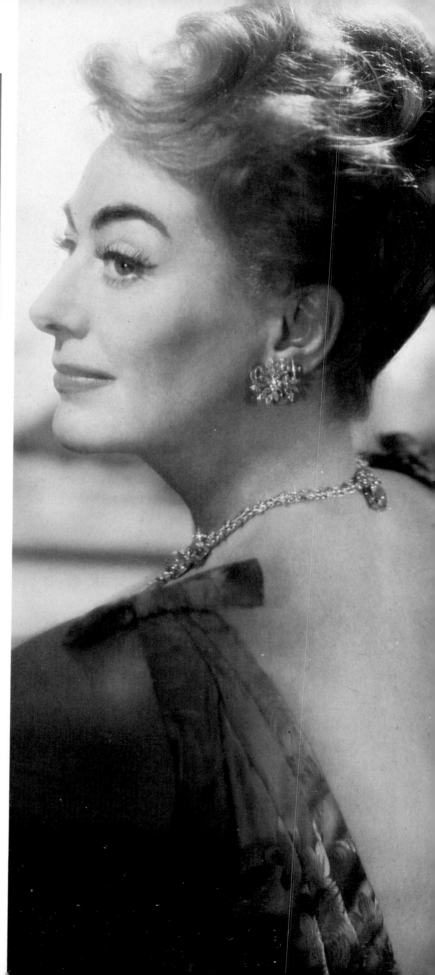

Joan Crawford, 1955

"Excuse my appearance," she said. "I've been ironing. It's impossible to get help. So I do my own work."

Since then I've done four or five sittings of Joan. One summer a publicity representative called to say Miss Crawford wanted me to make a sitting of her and asked if we had air conditioning. Miss Crawford wanted the room kept at sixty-five degrees. The appointment was made for ten o'clock in the morning—a very early hour for an actress if she is not working on a film.

Joan has never done a portrait sitting with me that has lasted more than an hour or an hour and a half. We both work fast. One unusual session occurred during the 1960s when she called to ask if she could stop by my studio late one afternoon and make a quick sitting on her way to dinner. She came in at five o'clock in an extravagant aquamarine evening dress and cape and loaded with emeralds—necklace, earrings, and bracelets—big rocks, too. In an hour we were through.

In recent years Joan grew to loathe Hollywood, preferring to live in New York. Notes and messages from mutual friends would come from her to please call her when I was in New York: she wanted to make photographs.

It was late summer 1976 before I was able to oblige. I arrived at her apartment at 12:30 for a one o'clock appointment. Not only was Joan ready but so was the apartment. She had covered all the carpets where we would work with heavy white canvas, and the chairs with plastic. Joan answered the door (there was no maid), barefoot. Her hair had turned gray

Joan Crawford, 1976 (her last portrait sitting)

Julie Harris as Emily Dickinson, 1977

Christopher George and Julie Harris
in "The Hand of Mrs. Lincoln," 1976

since I had seen her last, but her strong black eyebrows were a little at war with the new gray hair. The apartment was in lively colors of green, yellow, and white. The place was immaculate—not a thing, even, on the counters of the all-white kitchen. At 2:30 I left, since she had other appointments.

This year I'll miss Joan's Christmas greeting—always the first to arrive, and written by Joan herself.

■

The extraordinary Julie Harris is a new addition to my list of professionals. What talent she has! I've taken two sittings of her: one for The Last of Mrs. Lincoln and the other for The Belle of Amherst. After she had rehearsed for a week for Belle, the photographs were scheduled to be

taken after a dress rehearsal. I didn't see how she could look or give her best at the end of such an exhausting day. But after a couple of pretzels to sustain her, she was absolute perfection, doing exactly as directed and giving completely of her energy for two hours.

Then there are Lynn Fontanne and the late Alfred Lunt. (Why is it that the greater the stars, the more professional they tend to be?) In 1949 when this pair did *I Know My Love*, where they played an old couple who become progressively younger as the play develops, the road tour started before the New York opening. Lunt had been ill with ulcers and was only allowed by his doctor to perform in the play if he promised to do absolutely nothing else during the tour. Consequently, there were no photographs of the play. *Harper's Bazaar* hoped to scoop every other publication by asking me to take pictures when the Lunts reached the Biltmore Theater in Los Angeles. I kept in touch with their secretary as they slowly crossed the country, city after city, and was told that Miss Fontanne would pose but Mr. Lunt was out of the question. The night of the appointment, I arrived early at the Biltmore Theater. As they entered the stage door, I introduced myself and she, hesitating a moment, said, "I'll see if I can get Alfred to pose with me." Half an hour later they both came onstage, made up as the old couple, ready to be photographed. The sitting took twenty minutes.

In 1959 I had another encounter with the enchanting Miss Fontanne. When the Lunts were appearing in the pre-Broadway tryout of *The Visit* in New Haven, the fashion editor of the *Ladies' Home Journal*, Wilhela Cushman, made arrangements for me to take eight fashion photographs of Miss Fontanne. Permission was given us to use a rather small room on the Yale campus as our studio. Mrs. Cushman had set up beautiful backgrounds of antique screens,

John Huston and his wife, Evelyn Keyes, 1947

Bing Crosby, 1933

Bing Crosby, 1974

Alfred Lunt and Lynn Fontanne, Speak to Me of Love

paintings, tables and chairs, and large vases of real flowers. No matter who photographed for her, all Cushman photographs were flooded with light. We had a generator (because the wires of any ordinary place would not take this enormous voltage), 2,000-watt lamps, cords all over the place, and great heat. At this time Miss Fontanne was having a severe bout with arthritis and the heat was probably rather welcome to her, but she moved very slowly. We were allowed only two minutes at a time with her in front of the camera, and then she rested.

Miss Fontanne is not hep to the twists and tricks of the fashion models, so I arranged her pose. "Turn your hips away from the camera . . . bend your left knee a little . . . put your hand on the chair . . . point your toe out a little . . . pull yourself up from the chest . . . think about smiling but don't." Now she had to rest. We helped her over the tangle of light cords to a chair. She was given a drink of cool water, and the Elizabeth Arden makeup woman powdered the little shine around her nose. Brought back into the set a few minutes later, Miss Fontanne found her exact spot. As the lights were turned on, I could hear her saying to

Myrna Loy, 1944

Myrna Loy, 1977

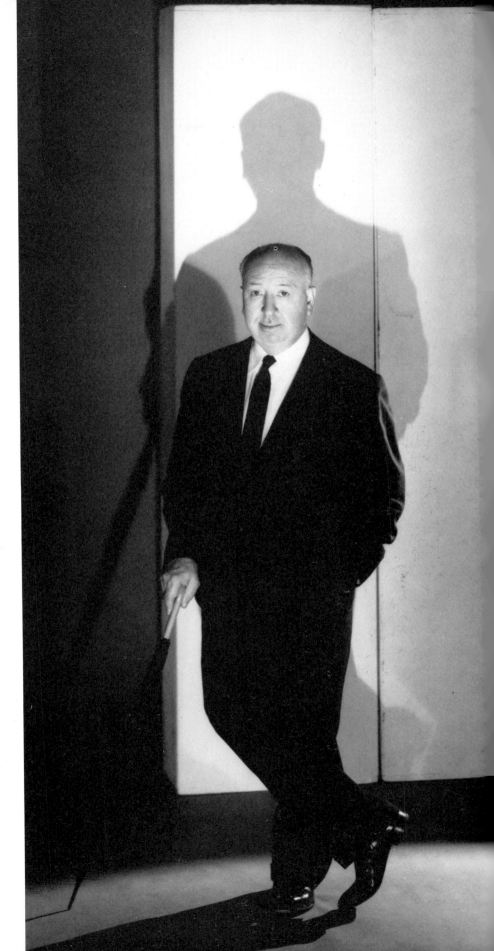

Rosalind Russell, 1955

Alfred Hitchcock, 1960

herself, "Turn your hips away from the camera [and she did it], bend your knee, put your hand on the chair, point your toe, pull yourself up, and think of smiling." And we shot the picture. Everything was right. This was a great performer working her mind and body with perfect discipline.

We saw *The Visit* that night. Between acts, Miss Fontanne tripped over a cable in the darkened backstage and took a hard fall. She continued her performance, which closed the run there. Back in New York the next day, in spite of her bruised and pained body, she completed the fashion layout at her apartment and at the Lunt and Fontanne Theater. Black-and-blue marks on her arms and legs had to be covered with heavy makeup so they would not photograph, but nothing would stop this lady from completing her task.

The person who could out-professional all the others in Hollywood, New York, and points west and east and turn on his enthusiastic charm like an IBM computer was Maurice Chevalier, whom I first met in 1929. Offscreen he was a calm, middle-aged, shrewd businessman, but onstage that charm was always there, whether he was sick or well, bored or not.

For his arrival in Hollywood, Paramount made sure that everyone knew they were building a new star. At the old Santa Fe station at Pasadena there were Adolph Zukor, Ernst Lubitsch, dozens of underlings, five limousines, and twelve dancing girls in shorts holding a banner saying WELCOME CHEVALIER.

A couple of days later I stopped him on the lot, introduced myself, and told him we'd like to set up an appointment to make a portrait sitting of him. For a new arrival and such a big star, I explained, we required at least four hours to ensure enough pictures for coverage in the newspapers and magazines around the world. The most I got out of him was an appraising glance before he opened up his little black date book, not more than two by three inches with a pencil attached. (How did he keep from losing this little thing?) He found the right page and said, "I can give you from 2:30 to 3:30 next Tuesday."

"Mr. Chevalier, we have to have more time than that."

"Sorry, that's all the time I have."

Tuesday rolled around and at 2:30—it wasn't one minute before or one minute after— into the portrait gallery walked Chevalier, alone, unsmiling, and carrying his tuxedo and a straw hat. After an introduction to Mr. Richee, Chevalier walked in front of the camera. Gene snapped on the lights and Chevalier turned on the charm. In an instant he shed fifteen years. The smile into the camera, click: the hunched shoulders and a surprised look, click; the little-boy look, click; the pout, click; and so on, for twenty or more poses. Then he changed clothes and slipped back into his own personality again. At 3:30 he picked up his things and left. We had a hundred great pictures.

I saw Chevalier undergo the same transformation during the filming of the "I Am an Apache" number for *Love Me Tonight*. In the early days of the talkies, there was no such thing as prerecording. There was an eighty-piece orchestra on the set behind the cameras and behind the orchestra were huge panels of acoustic material to throw the music back to the microphones.

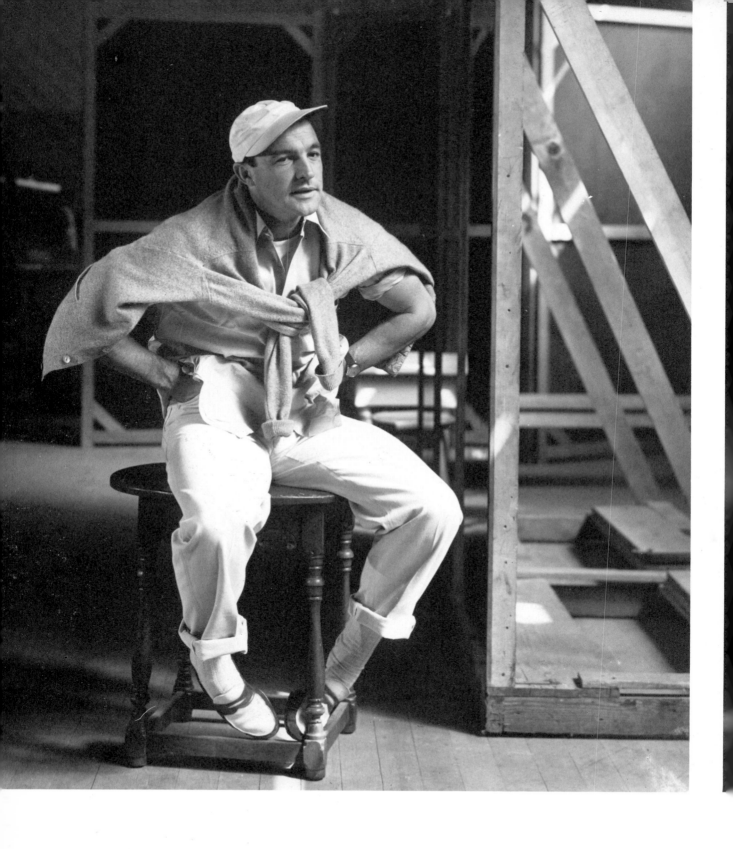

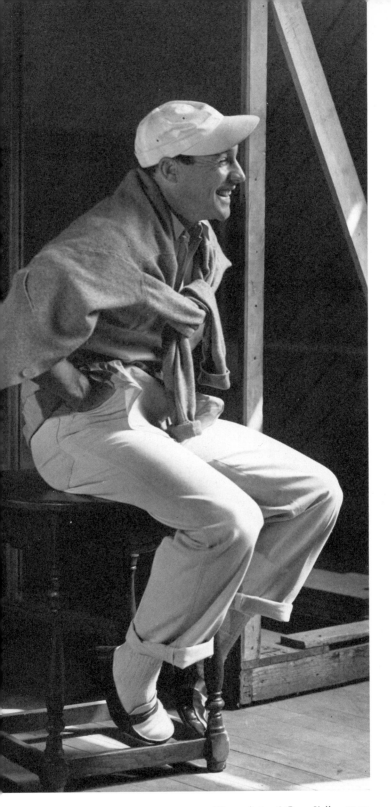

Three shots of Gene Kelly, 1945

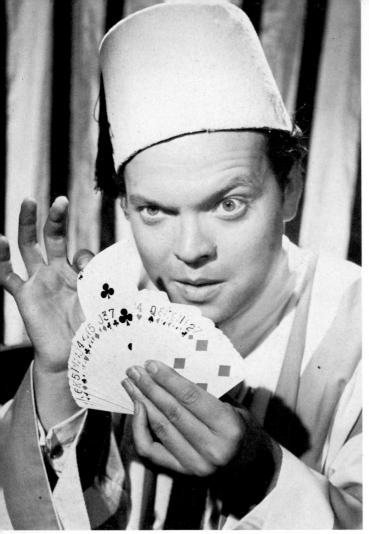
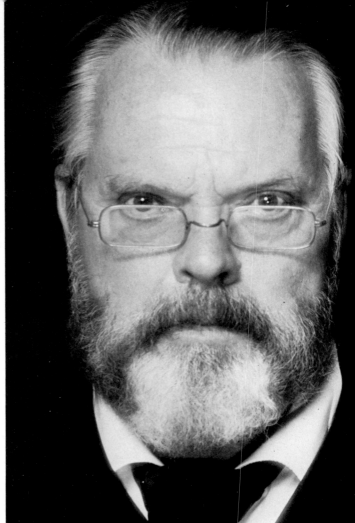

Orson Welles, 1940 *Orson Welles, 1977*

The musical numbers were filmed and recorded at the same time. This was damned exciting. When word filtered around the lot that Chevalier or any artist was recording on a stage, as many studio workers as could steal away from their jobs were there for a great free show. I went, too.

By mistake, I selected the wrong door to the stage where *Love Me Tonight* was shooting, and found myself behind the main set instead of out front with the director, orchestra, and crew. I could hear the assistant director yell "Quiet on the set! Roll 'em." I knew I didn't have time to go around to the right entrance. Then I saw that I wasn't alone behind the flats. There stood Chevalier at the entrance to the set. He had his cap on at a rakish angle and a ragamuffin suit, but he was still the tired, I've-done-it-all-before businessman. Nathaniel Finston, who was conducting the orchestra, tapped to alert the musicians. At moments such as these, most stars are extremely nervous. There's the last powder whether the nose needs it or not, the last puff on a cigarette or a mint to be disposed of. But not Chevalier. The star machinery hadn't been turned on yet. As the director yelled, "Camera!" the great music filled the stage. Chevalier stood immobile until his cue came, and then the electricity came on in an instant. He moved onto the set, bursting with personality—a completely controlled, minutely rehearsed performance that seemed entirely spontaneous.

Strong Ladies

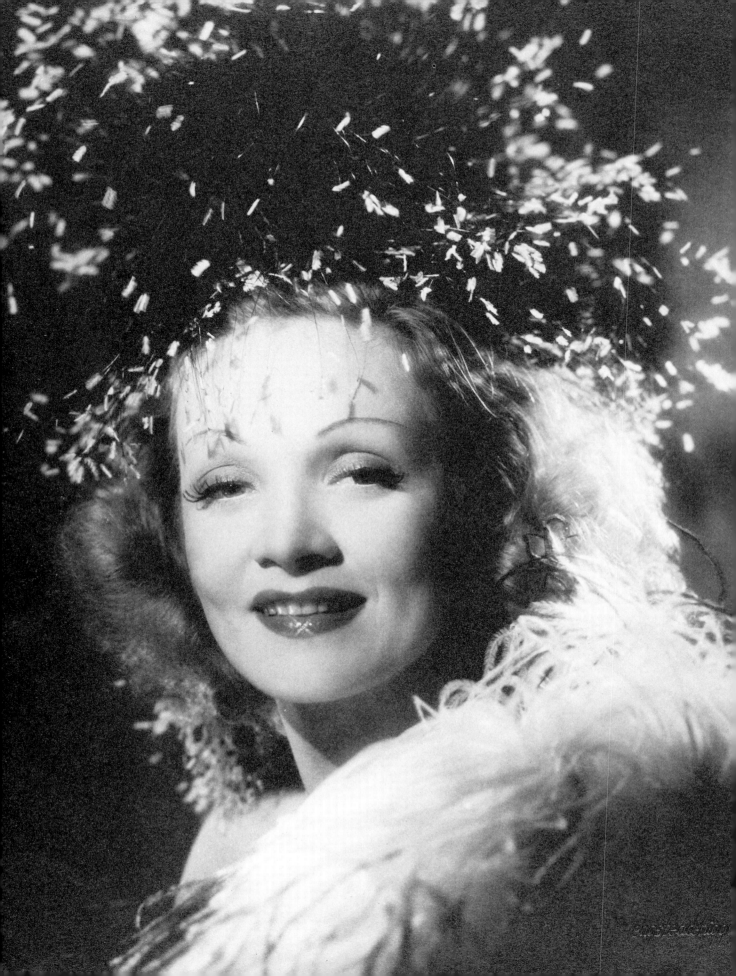

I'M THE STAR OF THIS TELEVISION SE-
ries—everyone else is dispensable," said the strong lady. In 1955 she'd been a film beauty for
twenty-five years. "I okay the scripts, the clothes, the directors, the cast—and every one of them
can be replaced."

She carried all this kind of rough stuff a little too far, but this woman was just one
of the group of stars in the 1930s and '40s who learned early in their careers that an ac-
tress who was the sweetest kid on the lot didn't make much headway in the front office. It
was only when the sweetness covered an iron glove that it was understood. And the pro-
ducers had nobody to blame but themselves for ruffling these ladies' tail feathers. A studio
would sign a promising actress to a seven-year contract at a low salary. The girl would start
posing for leg art and playing small roles, and if she caught on, she would be rushed from one
picture to another and loaned out to other studios at a big profit. If the girl, backed by a good
manager, didn't have the guts and self-confidence to demand a good contract and fight for good
roles with the best directors, she'd be pushed around and assigned unsuitable roles until the
public tired of her.

Players learned the hard way to pay attention to details of their careers. For instance, if a
designer made a bad dress for Doris Day, audiences would say "Doris Day doesn't know how to
dress." If Audrey Hepburn allowed some hairdresser to put fake jewels in her hair, women

71

Marlene Dietrich, 1940

would only say "Miss Hepburn doesn't have good taste." And so it went with directors, dialogue, and every aspect of a star's professional life. They can't let people push them into bad situations.

Nobody pushed around one 1930 newcomer to Hollywood—Miss Marlene Dietrich. After the success of Greta Garbo, there wasn't a rock in Europe left unturned in an effort to find more exotic beauties. Who remembers Sari Maritza, Gwili Andre, Lya di Putti, Tala Birell, Francesca Gall, or Anna Sten? But Paramount hit the jackpot when they signed Marlene Dietrich. With her face and equipment and Josef von Sternberg's savvy, the successful legend of Dietrich began.

Marlene had made a half a dozen German movies plus von Sternberg's *The Blue Angel* with Emil Jannings before she was signed, so she wasn't exactly a pig in a poke. Paramount had sense enough to realize that it was on to a good thing and threw an elaborate cocktail party at the Coconut Grove at the Ambassador Hotel in Los Angeles to introduce Marlene to the press. She was sexy and sultry if you like big women—there was at least 160 pounds of her. And obviously, nobody had checked her wardrobe in advance, because this fleshy lady arrived in a light, multi-colored chiffon dress with little furbelows hanging around which put every one of her pounds on view. On top she wore a big horsehair hat. For her first Hollywood movie, Travis Banton camouflaged the extra pounds by dressing her mostly in dark colors.

One thing that Marlene brought to Hollywood was a good set of brains that she put to constant use. It didn't take her long to lose weight and learn how to dress. I remember her entering my office after a day of rehearsal dressed in all beige and light tan—suit, shoes, gloves, scarf, and hair. It was a lovely vision.

Marlene also has great self-discipline and determination. Once, when von Sternberg let drop some caustic remark that Marlene was putting on a little weight, for the next week nothing went into her stomach but tomato juice and crackers. For the first five years of her Hollywood career, von Sternberg took complete control of her portrait sittings. I'd stick around to watch and learn because, added to his directing ability, he was one of the great cameramen in films. He used a high spot to bring out the shadows under her cheekbones. He would ask Marlene to move in various positions—leaning over a chair, in backbreaking contortions with nothing to support her. She would hold these positions for minutes on end while he studied the situation and spoke to her only in German. When the pose was suitable, he began to work on her face. At his command her head would rise and fall; the lids would lower; the mouth would open and sex appeal would pour from her face. When all was to von Sternberg's satisfaction, he would poke photographer Richee in the back and the shutter would click. At one point when Marlene's mind wasn't working as he thought it should, he lapsed into English, "Think of something! Think of anything! Count the bricks on the wall!"

Nothing was too difficult for Miss Dietrich to endure for her career. For a scene in *The Scarlet Empress*, she ran down an elaborate staircase in her many-petticoated costume forty-five times before von Sternberg approved the scene. It took all of one morning. And for her last

Paramount film with von Sternberg, *The Devil Is a Woman*, Travis Banton and Dietrich found an enormous Spanish comb for her to wear. To anchor this to Marlene's head, hairdresser Nellie Manley made little braids of Marlene's own hair and wired the comb to these. And if this weren't enough, a large mantilla was draped on the comb. God knows the agony she went through each day with no time to remove it at noon. I was there in her dressing room one night and watched Nellie with wire cutters and loud crunches snip the bands and release the comb. Marlene fell forward, arms and head resting on her dressing table, exhausted from pain. When she came up, tears were running down her face.

Travis Banton knew firsthand how well Marlene had learned to dress. He told me that one scene in *Desire*, produced by Ernst Lubitsch, required Marlene to wear a hat. So forty of the latest models from Lily Daché and John Fredrics were sent to Hollywood. Marlene arranged to have an advance peek at the forty hats and selected the one she wanted to wear. The next day, meeting with Lubitsch and Banton to decide which she would wear, Marlene first modeled her

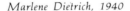

Marlene Dietrich, in Las Vegas, 1950s *Marlene Dietrich, 1940*

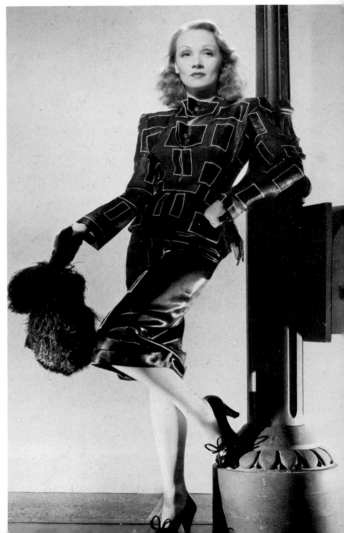

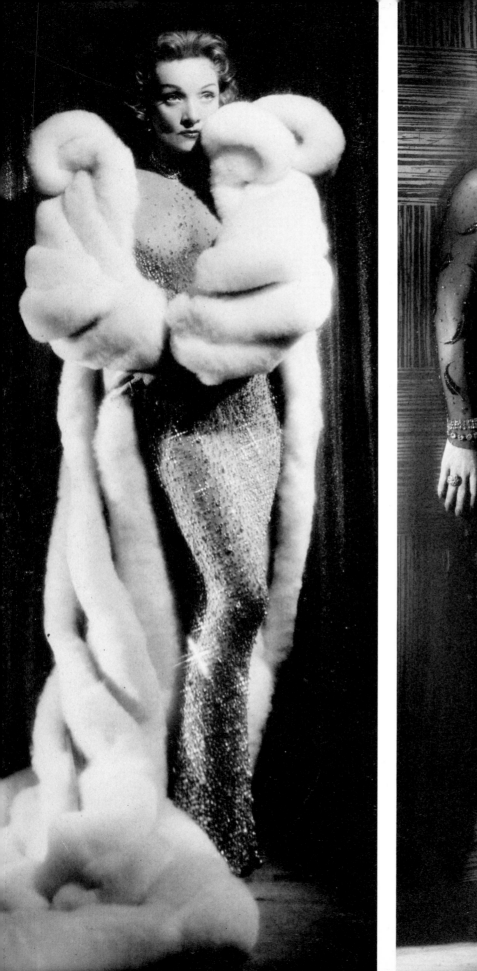
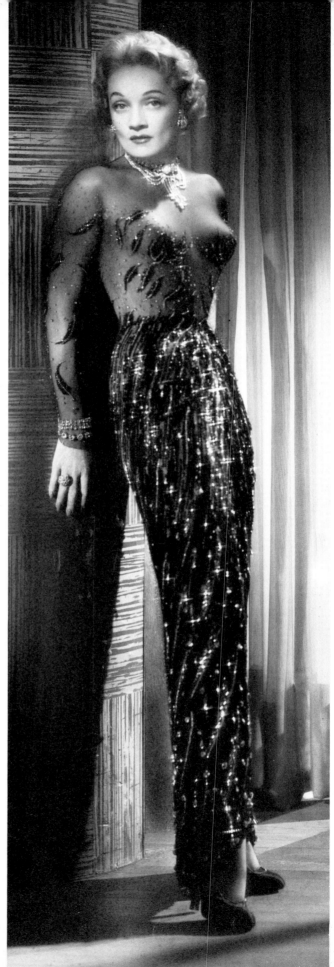

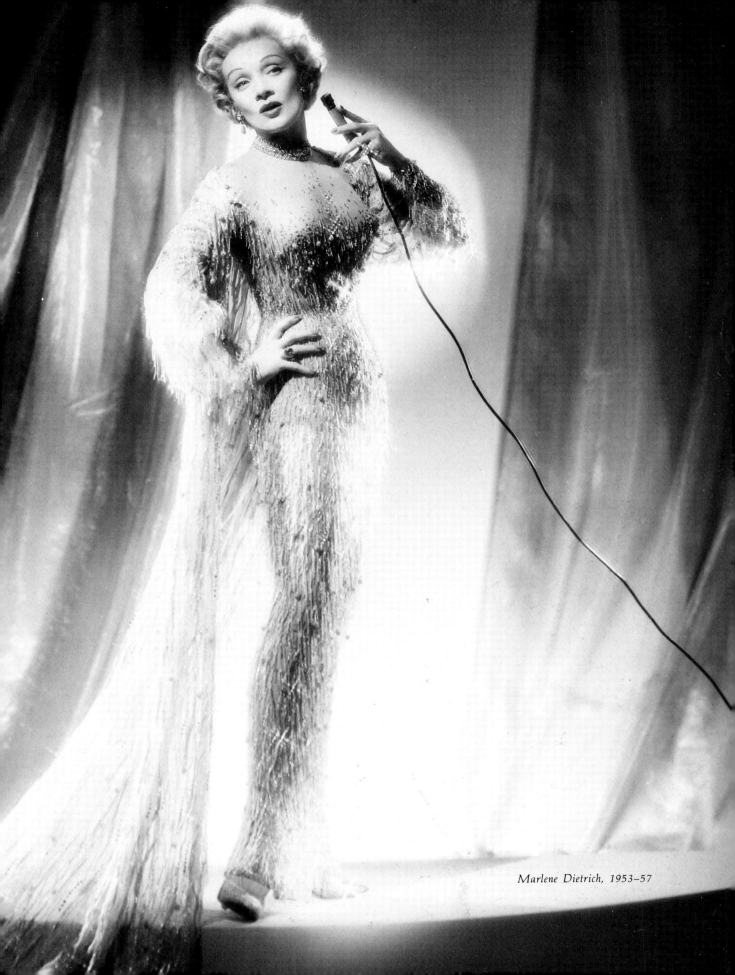

Marlene Dietrich, 1953–57

big black favorite. "Not right," said Lubitsch. "It's too big for the scene and will shade your face. Try on some of the others."

She tried on at least twenty more—all at just the wrong angle because she was determined to wear her black hat. The arguments grew a little more heated as hats flew on and off her head. Finally, Lubitsch, a marvelously good-natured man, gave in and Marlene wore her favorite hat. When they showed the rushes of the first day's shooting with her hat, Marlene realized that Lubitsch had been absolutely right, and she had to admit it. They went back to Banton and selected a new hat for retakes.

From watching von Sternberg, Marlene gained great knowledge of lighting. And she makes no bones about telling any photographer if she thinks he is making a mistake. How far she'd go to put on a good show is illustrated by a little incident that happened when I went to her home late one afternoon to show her some proofs. I was ushered into the library where director Fritz Lang was also cooling his heels. There was only one light in the room, situated in the ceiling, its tiny beam shooting down at an angle to illuminate a painting over the fireplace. After a few minutes, in glided Miss Dietrich. She moved directly to the fireplace, leaned against it and arranged herself in this lovely light, and raised her head until she had the perfect von Sternberg illumination on her elegant cheekbones.

Falling into exciting and sinuous poses is second nature to Marlene. Come to think of it, I have never seen her in an awkward pose. Nor does she have any compunction about letting her public in on the fact she has a great body.

One afternoon I had to see Miss Dietrich about some small matter and knocked on the screen door of her dressing room at Paramount. One look inside told me I shouldn't be there. About eight feet from me, clearly visible through the screen door, was Marlene, languidly

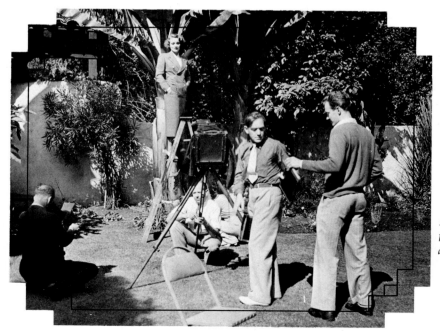

Marlene Dietrich being photographed by Gene Richee, assisted by John Engstead

draped against the doorway to the next room. The reason for my surprise was what she didn't have on. She was wearing a little thing that looked like a net bikini with a tiny reinforcement where it should be reinforced. On top there was a white shirt that was cut straight across the bottom and ended a little below her navel. So there wasn't much to stop a guy from taking in Marlene from her navel all the way down those beautiful legs to her high-heeled sandals. I guess the reason she was in this position was the fact that Travis Banton, who made those extraordinary designs for her, was sitting there on the floor talking about some dress.

Before I could excuse myself, Marlene purred "Come in." And I did. And I was just sitting there taking in the whole thing again when I heard a jaunty little whistle coming down along the sidewalk. In a few seconds I saw that the whistle belonged to the comedian Joe Penner. The sidewalk was only three feet from Marlene's screen door, so Joe had seen just about the same view of lovely Marlene as I had. You've seen these comics in the movies give big double takes. Well, when Joe got a load of what was standing there to be seen through that screen door, he gave a take that would put Laurel and Hardy and Dick Van Dyke to shame. Even his whistle took a deep breath. I don't know where he was going but he didn't go there—in about ten seconds he was passing the door again in the opposite direction. This time there was no whistle and the jaunty walk had slowed down to an amble. As if he hadn't gotten enough of the situation, he came back for a third look. Marlene didn't move a muscle.

The sexy German, like all those lady superstars of the 1930s and '40s, is a perfectionist. She gives great attention to detail and can do almost anything herself. She could have been a top public relations person, a cook, a hairdresser, a makeup expert, a charwoman, a camerawoman, a film cutter, a director, a designer, or a carpenter. Her housekeeping talent always came to light when she stayed at the apartment of Madame Spanier, directress of Balmain in Paris, who always sent her maid on vacation when Marlene arrived. The star cleaned the apartment from top to bottom and scrubbed the floors. And she cooked the meals.

Marlene packs all her numerous traveling bags herself—tissue paper between garments, at each fold and around each item. During a night's stay at a Beverly Hills hotel a few years ago, her luggage with her stage costumes, etc., was so extensive it was stored in an adjoining room. During the night some thieves managed to remove the luggage to another room. When the maids found the bags the next day, the room looked like a tissue paper factory. The thieves had shaken out every last piece of paper and thrown it about, looking for jewels that Marlene didn't carry.

And her cooking! The delicious odor of a roast met me fifty feet away from her bungalow at the Beverly Hills Hotel one day as I came for her to order some photographs. Inside the front door was a big cardboard box of groceries.

"Cooking your lunch?" I asked Marlene.

"Oh, no," she said, "I'm cooking a roast to take to Rudi." Rudi was her husband who has recently cooled off but at that time lived on a chicken ranch in the San Fernando Valley.

I don't think Marlene would ever let anyone put on her face but herself. And what a

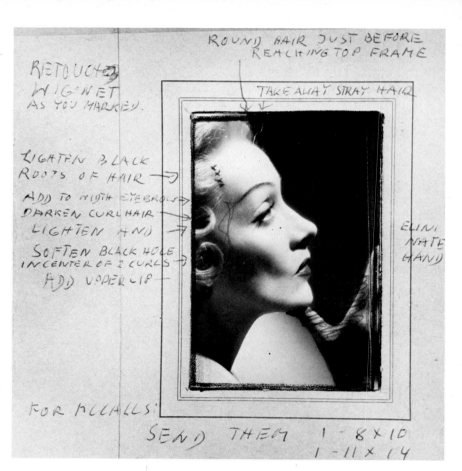

Marlene Dietrich proof,
with her retouching instructions

beautiful job she does! So well blended and powdered you can never see the makeup. But it takes her hours.

And the time she spends on her wardrobe fittings! She has stood for weeks on fittings for one engagement. I don't see how she or the late Elizabeth Courtney could stand the sessions, which lasted from eight to ten hours a day. Jean Louis' invisible nylon armour, made like a body stocking to hold everything in place, was an achievement that ranked with the invention of the wheel and the cotton gin. It was early in 1953 when Marlene walked on the Las Vegas stage in a great Louis dress and created a riot. There were dozens of press photographers in the room to record the incident and Marlene made sure, by exposing a great deal of her bosoms, that every single newspaper published her picture the next day. But her generosity in showing so much only lasted for the opening night. When I arrived a couple of days later to do a sitting for her, a few more beads had been added to her bodice.

Almost every year she made a date for me to go to Las Vegas the night before her show opened. When the preceding act closed its final performance, we'd set up and start shooting about 1:30 in the morning. I'd be out in the audience area—me and an 8 × 10 camera with a 5 × 7 back and tripod balancing on three tables huddled together, and a box of 5 × 7 plate holders. Bill Hennigar, my assistant, would be up on the stage moving the lights for me.

We'd shoot for about two hours and around 4 A.M. go to a darkroom in Las Vegas to process the film. By 7:30 we'd have the black-and-white proofs for Marlene to select and mark for retouching. By ten o'clock we'd be back in Los Angeles, to rush the retouching and printing so her public relations firm would have them in the newspapers the next morning.

We still hear from Marlene when she wants to reorder her old photographs. When her

Marlene Dietrich, retouched photo

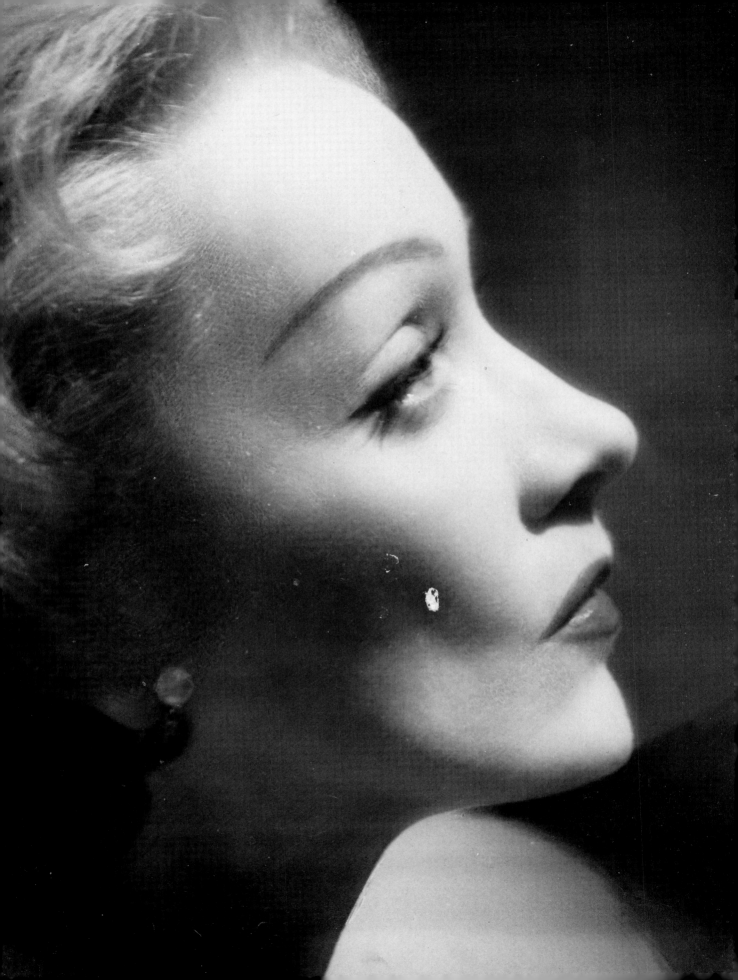

curly hairstyle of the 1950s began to date the pictures, she had Franciene Watkins, who works with me, retouch the hair to the straighter style she has worn since then.

Because Marlene is a perfectionist, she wants everything done correctly—and that means the way Marlene wants it—and every little detail is put in writing in her contracts. For instance, the stage has to be swept with a certain type of brush that will take up all the dirt. Otherwise, her trailing swansdown coat might kick up a not very glamorous cloud of dust. I've heard that Marlene has been seen shaking and cleaning that coat out on Melrose Avenue in front of Western Costume Company in Hollywood.

As strong as she can be at times, Marlene is equally kind and thoughtful. On the set of *Song of Songs* in 1933, she spotted me and asked, "Do you have my record of 'Johnny'?"

"No," I said.

"I'll get it for you. You should have it."

I didn't want her to give me anything, so I said, "Please don't, because I don't have a Victrola. Thanks anyway."

When I returned from lunch that day, there was a portable record player and the record, "Johnny."

■

A friend of mine was Sally Blane—pretty, vivacious and too happy to put up the big fight for stardom. Sally acted in a few movies, but her main profession was posing for publicity pictures, which is how I got to know her. Sally had three sisters at home, all equally beautiful. They were the daughters of Gladys Belzer, who supported them by running a boardinghouse. (For the last forty years this talented woman has been one of the West's top interior decorators. It is nothing to see Mrs. Belzer today on a truck, driving to San Francisco with a load of antiques to install in a mansion.)

One Saturday afternoon Sally came in to see her publicity man. Dragging along behind her was her thirteen-year-old sister Gretchen, pigtailed and so shy she wouldn't open her mouth. A year later I saw Gretchen completely transformed. Now called Loretta Young, she was starting her career at our studio playing Florence Vidor's daughter in *The Magnificent Flirt.* In twelve months her shyness had completely disappeared. The pigtails had been replaced by a low bun in the nape of her neck and the dress had changed from calico to a long sequined affair, with bust pads filling out what nature hadn't gotten around to.

Beautiful Loretta was smart enough to learn quickly the trick of posing for still photographs. But only the important ones—she kept as far away as she could from those silly gag pictures. Soon she was an important leading lady at Warner Brothers. It was seven years before I saw her again, when she returned to Paramount to star in Cecil B. DeMille's *The Crusades.*

Loretta Young, 1940

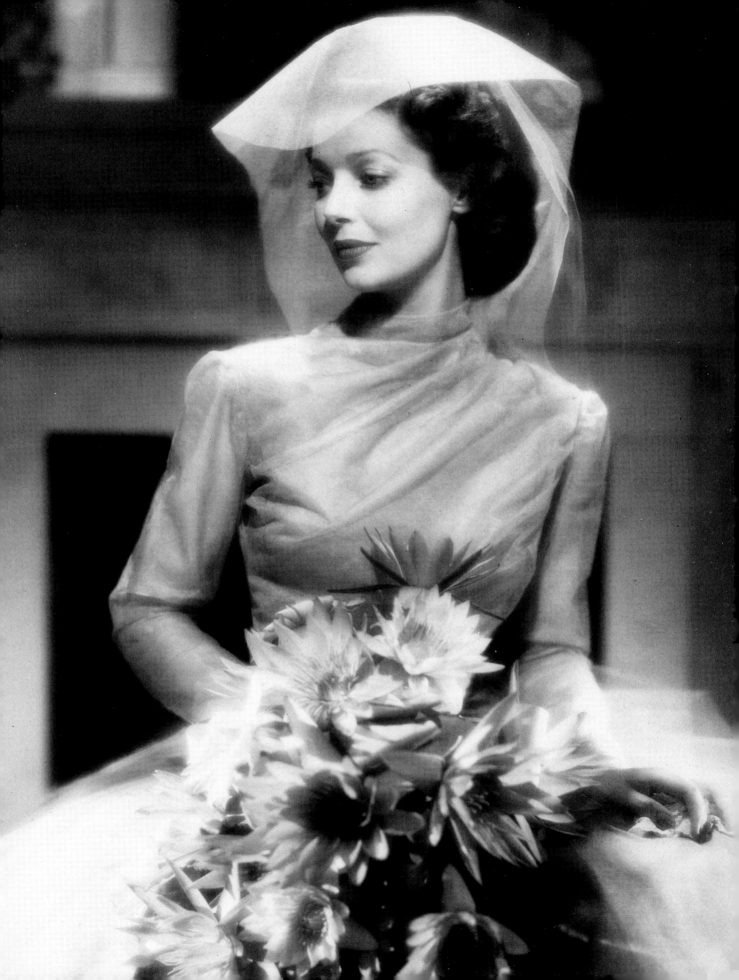

Loretta Young, 1940 *Loretta Young, 1965*

One evening at six o'clock I went to Loretta's dressing room. She was in one of the choice first-floor suites, and when I knocked, she was engaged in a telephone conversation but motioned for me to come in. Her makeup was off, there were shadows under her eyes, and she looked tired. I could not believe her telephone conversation. She was reading the riot act to some studio executive. She told him in no uncertain terms exactly what she would and would not do, made herself crystal clear, and hung up.

I was so amazed by the transformation from the sweet, shy Gretchen to this strong businesswoman, I asked her how she had acquired all this force. And she told me. At Warners, while still a teen-ager, Loretta played leads in one picture after another. The California law stipulates that a minor can only work four hours a day and cannot work after five o'clock, and that a teacher must be present at all times. Whenever one of Loretta's productions was behind schedule, the business manager would ask her to work at night. Eager to be helpful, she would agree. She was told to go back to her dressing room and start changing out of her studio clothes until the teacher left for home. Loretta would then rush back to the set and work until nine or ten o'clock and sometimes all night on Saturday. The reward for these long months of working nights was a complete physical breakdown. In the middle of her hospitalization, a Warner Brothers executive visited Loretta. The man said she was scheduled to start a film the next Monday. He was sorry, but if she couldn't make it she would be taken off salary. And that's what happened. But the long hours lying in the hospital gave Loretta time to think. It dawned on her that it wasn't the old team spirit that motivated the studio executives; it was only money. When she recovered and returned, it was an entirely new girl that drove through the studio gates. As long as she was a minor, she worked four hours and no more; no work after five and a full hour for lunch with no wardrobe fittings at that time. Eventually she managed the right to approve all her scripts, still photographs, and co-workers.

The majority of famous actresses usually come to a sitting with an entourage of anywhere from five to ten people following them around. Whenever she can manage it, Loretta comes alone. She drives up in her Rolls Royce—on time—bringing ten or twelve changes of

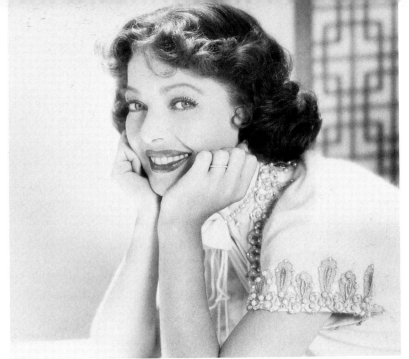

Loretta Young, 1960

clothes, wigs, furs, and all the trappings. She puts on her own makeup, arranges her own hair, and, believe it or not, she can dress herself. It is the intimacy of working alone with the photographer that she enjoys—and the tempo of a sitting uninterrupted by a woman spraying a stray hair or a man dabbing more powder on her nose.

Loretta has a godchild, Marlo Thomas, who has torn out a few leaves from Loretta's book on strength and power, and written a few of her own. From the inception of the idea of her television show, "That Girl," Marlo has been the boss. It could be that she got a few pointers from her father, Danny Thomas, but Marlo hired and fired everyone on her show and signed the paychecks. Obviously, she was right in her decisions because the series was a big hit.

Marlo is a smart one who works hard and gives great attention to detail. She decided at one point that photographs released for covers of newspaper supplements and magazines were to be pictures of her alone. Shooting a session at Mandeville Canyon estate, I asked Marlo to sit on a grassy meadow. After I had the camera set, a big Saint Bernard dog ambled over and sat down next to Marlo and faced the camera. It was a beautiful, lucky shot but Marlo killed it.

With all this power showing, Marlo came in for some criticism. One day during a sitting she was telling her godmother, Loretta Young, the names some people were calling her because of the very definite way she ran her show. "Somebody called me an iron butterfly." [Of course that old phrase had been thought up years ago by some wag at MGM to describe Jeanette MacDonald.] Loretta laughed. "Never mind what they call you," she said. "A Warner Brother's star once told an interviewer that I was a chocolate-covered black widow spider and it was published. But it didn't hurt me."

All those stars of the 1930s were strong—Bette Davis, Irene Dunne, Garbo, Ginger Rogers, Joan Crawford, and the rest. The 1940s also had their share, and one of them was Lauren Bacall. I think she has been a strong lady from the day she was born. I first met her in 1943 when Carmel Snow came west to work with me.

A telegram arrived at my place asking me to look up Betty Bacall and June Vincent. Ba-

Marlo Thomas and Loretta Young, 1972

Marlo Thomas, 1962

Marlo Thomas, 1971

Loretta Young

Bette Davis, 1958 *Bette Davis and Gary Merrill, 1964*

call, seventeen years old, had only been in our town a few weeks and was under contract to director Howard Hawks. For three days we photographed at the Hawks ranch, six blocks from Sunset and Sepulveda boulevards—a hundred acres or more of terrific backgrounds. Betty was so young at the time that we were photographing her in back-to-school dresses. For the first shot of the first day's shooting, the sultry young Betty walked out to the pasture and leaned against the white fence. It seemed impossible to make a bad picture of this girl. My only job was to see that she was in the camera and in focus; Bacall did the rest, arranging her body in a relaxed position and placing her face at just the right angle.

During lunch, Hawks told us how Betty had come to Hollywood. He had been looking for young talent and his wife, Slim, with her keen mind and great taste, kept telling Howard there were many models in New York who were more interesting than the couple of girls he had under contract. She kept harping on this so long that, to silence her, Howard finally said, "All right, show me one!"

Slim lost no time in shuffling through the *Vogues* and *Harper's Bazaars* on their coffee table and slapped her hand on the cover of the March 1943 issue of *Harper's*.

"Now here's a nifty girl."

There was Betty Bacall, seventeen years old. Howard signed her without a test.

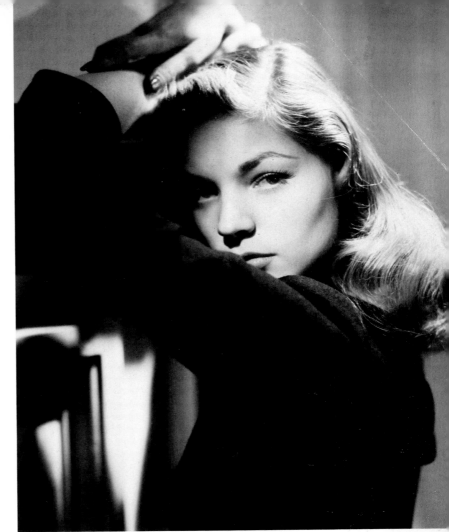

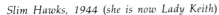

Slim Hawks, 1944 (she is now Lady Keith) Lauren Bacall, 1944

Mrs. Snow smiled and told us how the Bacall face had almost not been used on the cover. Each month several possible covers were chosen and dummied with the magazine's logo over them. From these, the editors of different departments voted on the one to be used. "Betty's picture wasn't the best," said Mrs. Snow. "But it had a patriotic background and that was the deciding factor."

For the next year or so, the only work Bacall did was to pose for me every few weeks for *Harper's*. We did every garment, from shorts to evening gowns, and I can't remember ever taking a picture of Betty that wasn't published. She and her mother and their tan cocker spaniel lived in a little apartment on South Reeves Drive in Beverly Hills. She'd drive over to my house a couple of blocks away in her secondhand Plymouth, and off we'd go in my station wagon to the Hawks ranch.

After a year of this inactivity, I told Hawks I was beginning to give up hope he'd ever use Betty in a picture. "I will when she's old enough for people to take her seriously as a leading lady," he said.

Finally, when she was twenty, she was old enough and the time had come. Betty became Lauren and Hawks cast her opposite Humphrey Bogart in *To Have and Have Not*, without having ever seen a foot of film on her. After signing her, he sent her to make her first test at Warner

87

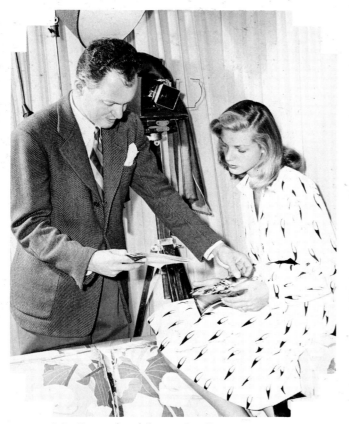

John Engstead and Lauren Bacall, 1946 Lauren Bacall and Humphrey Bogart, 1945

Brothers, the studio that would release the film. An ambitious hairdresser curled her hair and a makeup man put on a typical Hollywood face—false lashes and a reshaped mouth. It was a little out of character for Betty not to raise some hell about this, but I guess she thought Warners must certainly know what they were doing.

Hawks took one look at the test and called me. "I'd like you to make a portrait sitting of Betty at my house. Slim will get the clothes. No makeup. No hairdresser. Just the three of you." And these photographs, with the same face we'd been shooting all along for *Harper's*, were the ones Hawks used to introduce her to the press.

After *To Have and Have Not* came out, with rave reviews for Betty, she and I were still riding out to the Hawks ranch together to shoot more fashions for *Harper's*.

"Now that you're such a big success," I said, "I guess you'll get too important to make photographs."

"I wish you'd let me know if that ever happens," she replied.

During the making of the second Bogart-Bacall movie, *The Big Sleep*, the two fell in love. The only fly in this ointment was Bogart's two-fisted wife, actress Mayo Methot, who wasn't about to give up her sparring partner without a fight. During the filming of the picture there were stormy separations and wild reconciliations between Bogart, his wife, and Bacall. With all this seesawing back and forth, the best emotions were not the ones the cameras caught. When the production was finished, Hawks sold Bacall's contract to Warner Brothers.

There is no doubt that Bacall would have made it even if her picture had never appeared

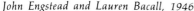

auren Bacall, 1943–46

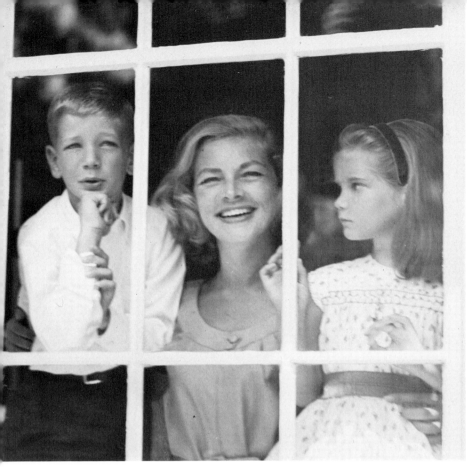

ren Bacall with children Leslie and Stephen

Lauren Bacall and Humphrey Bogart

on that *Harper's* cover. She's a strong, smart lady and she was an absolute brick in the last months of Bogart's illness.

About a week before Christmas in 1956, David Selznick's office called me: would I do a sitting of Bacall and the Bogart children and rush them through? This was the only thing that David Selznick could think of to give Bogart for Christmas.

The Christmas tree was already up in the foyer of the house. We made some photographs inside and then I suggested going into the garden. Of course these pictures were to be a surprise. Bogart's bedroom on the second floor opened out above the patio and garden.

"Can we do this?" I asked. "Won't he hear us out there?"

Betty shook her head, and said quietly, "He'll never know you were here."

■

A friend of mine who lived a couple of blocks from Bogart and Bacall was Claudette Colbert—and I have to tell you Claudette can be a very strong person. She is also a marvelous, intelligent woman. I was completely bowled over the first time I met her in 1929 when a cameraman and I went to the Santa Fe station in Los Angeles to cover her arrival. There was one producer and a limousine to meet her, but it wasn't one of the big-time arrivals, otherwise she would have been taken off the train at Pasadena.

Lauren Bacall, 1968

Claudette Colbert, 1933 *Claudette Colbert, 1940*

At the first look at this young woman, I was in a trance. What vitality she had! What a personality! What a voice! What a body and what a face! When Claudette is "on" and all her cylinders are working, she's got it. Of course, she can't keep up this vitality all the time or, as her first husband, Norman Foster said, "You'll kill yourself—you'll have a breakdown." Despite her vivid personality, Paramount assigned her to roles as the well-dressed society lady with some marital problem. It was dull and not good for the box office either.

I became very fond of Claudette (what guy wouldn't?) and I knew she had many qualities Paramount was not putting on the screen. And I also noted that Irving Thalberg over at Culver City was having great success at MGM making sexy ladies out of his stars, Norma Shearer, Jean Harlow, and Joan Crawford. I suggested to Claudette we try some of Mr. Thalberg's recipe on her. Sick of her boring roles, she was ripe for anything. Perhaps she could change that tight little bob she had been wearing, I suggested, and how about posing in a white satin dress with nothing under it? Claudette agreed.

Claudette Colbert and John Engstead, 1932

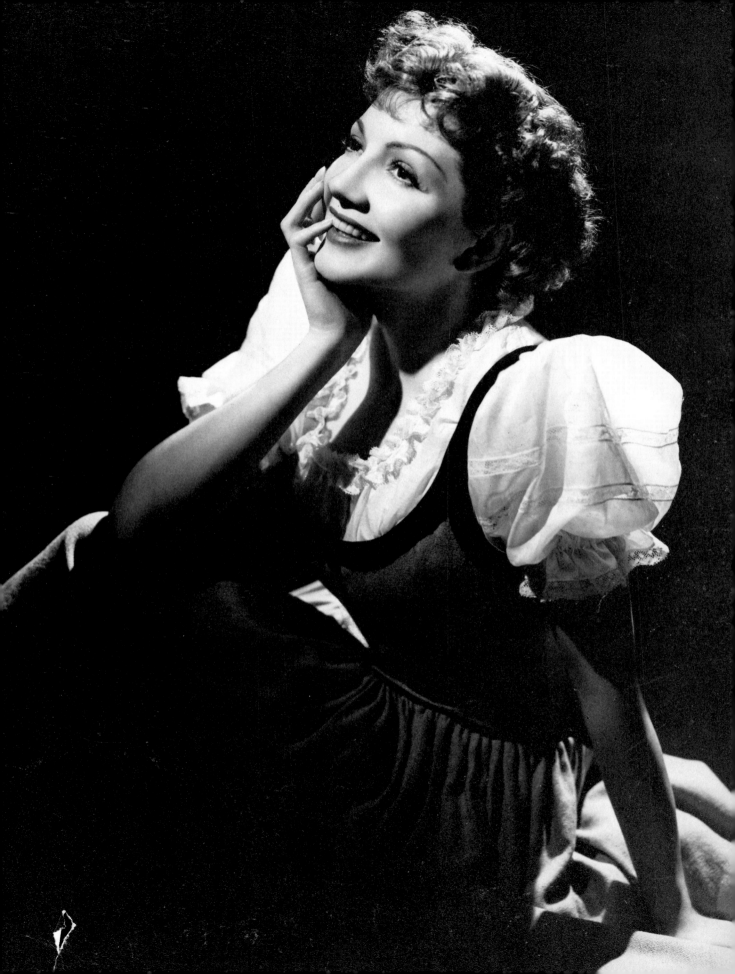

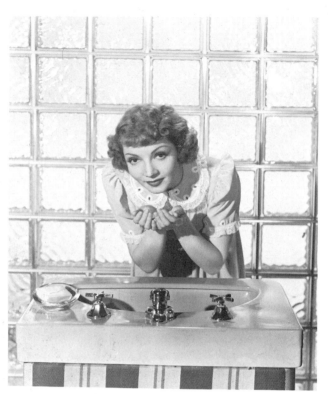

Claudette Colbert, 1940, posing for Lux *soap ad*

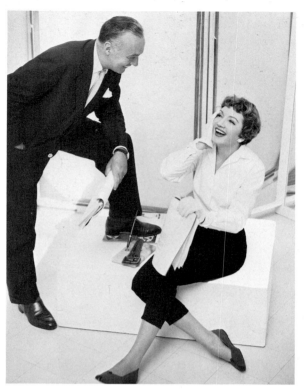

Charles Boyer and Claudette Colbert,
Marriage-Go-Round, *1958*

The day of the sitting, Claudette arrived in the gallery in her white satin dress and her hair cut and softly curled all over her head. So far so good, but when I looked down there was the unmistakable ridge of her underpants showing through the satin.

"Oh come on, Claudette," I said. "You're kidding me. You've got your pants on. Go and take them off."

She sputtered and looked indignant and said, "I can't."

"Go on. That's the whole point of this sitting." I pulled out one of MGM's shots of Jean Harlow to show what I meant. Jean wasn't a prude. And Claudette finally went into the dressing room and pulled off the pants. While Claudette, who was brought up by a strict family, was too much of a lady to project the raw sensuality of Harlow, at least that day a new Colbert began to emerge.

Claudette wasn't around too long before she managed to demand and get approval of her photographs. She was the first star at Paramount to get this privilege and it was all my fault. In 1932 the foreign publicity department sent me a bunch of magazines from South America to be photographed with stars reading them. Claudette and Freddie March were working on one of the stages and they agreed to do this little chore between scenes. I sat them down close together on a couch, each holding one side of each magazine. At this time of his life (did he ever change?) Freddie never let a female come anywhere near him without touching her—somewhere. Having made a couple of pictures with him, Claudette certainly knew about his favorite pastime, but this time she didn't put up a fight when Freddie let his hand land on her bottom. I was running these magazines in and out like a sausage factory and making sure that logo was showing so I didn't notice the fingers on the fanny.

94

Claudette Colbert and portrait of her mother, 1947

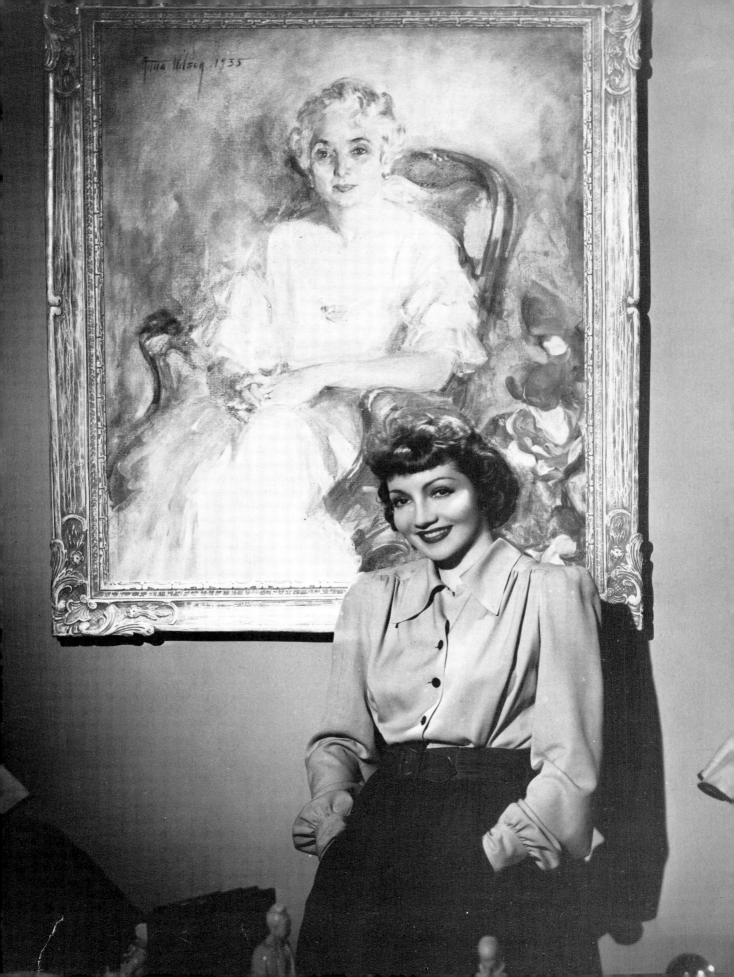

We sent the pictures to South America, but somehow one print from the New York office ended up in the hands of the editor of the *Police Gazette.* He placed Freddie's hand and Claudette's bottom in the margin of the page so it couldn't be missed and the caption read, "Even if the Marines haven't landed, Freddie March seems to have the situation well in hand."

I didn't know Claudette read the *Police Gazette,* but, boy, she saw that picture and went straight through the roof. She raged into the office of studio head B. P. Schulberg and it ended only when Claudette was promised the okay of all her photographs. After her feathers were smoothed and she was about to leave, Schulberg said, "By the way, Claudette, why did you let Freddie put his hand there?" But he got no answer.

When Claudette started to okay her photographs and marked her nose the way she wanted it retouched, she told me that when she was fifteen, a truck hit her on her way home from school in New York. The accident broke her nose and her back. The plastic surgeon would have done a better job on her nose had he known how many millions of people would later view his handiwork. Claudette's husband, Dr. Joel Pressman, was one of the finest surgeons in the country and it would have been easy for him to give her a perfect little nose. She reasoned, however, that she had been seen on the screen for a long time with that nose and it would look silly to appear suddenly with a new one. Besides, a new nose might mean she would no longer have an excuse for having a favorite side of her face.

Perfectionist that she is, Claudette and Wally Westmore worked out a photogenic makeup for her face. After weeks of practice Claudette could do it better than Wally or any other makeup artist. In the mid-1930s Claudette latched onto a hairstyle she seemed to like and has used, with a few variations, ever since. And with her face remaining so remarkably unchanged with the years, it seems her photographs can be used forever.

On the screen and in stills, Claudette knows how she should be photographed—from a high angle, with only three quarters of the left side of her face to the camera. She says the nose goes flat when shot from the right. I myself can't see it, but I know I'd never win that argument.

On only one occasion after she was given still approval did we shoot the other side of her face. During a sitting at Paramount, I said, "It looks very good from this side," meaning the side of her face she likes the least. "Oh, shoot it," she said and the next day she passed the proof. The fan mail department liked it enough to make thousands of prints. But in the forty years since then, I've never photographed that right side again.

Although some performers, like Ingrid Bergman, really don't care which side of their face is photographed, some of them have slight preferences, without being as definite as Claudette. Charles Boyer came in with Claudette one day in 1958 to shoot some publicity photographs for Paul Gregory's stage production of *Marriage-Go-Round,* in which the two costarred. While Claudette was changing, I made a few portraits of Boyer. As we began, I noticed that he instinctively turned the right side of his face to the camera. This was good since it would make it easy to pose him with Claudette, but I was curious to know how he had decided that this side was better.

Boyer told me that his first leading role in an American film was in *Private Worlds* with

Claudette. Since she was the star and she preferred her left side, Charles was forced to show his right side if he wanted to look at Claudette—and that was it. Everyone agreed that Boyer didn't look as good in his next film, *Break of Heart,* as he had in *Private Worlds.* The studio finally saw that it was the constant use of his right side that made Boyer photograph so well, and he's used the right side ever since.

Claudette is one of the most intelligent and self-disciplined female stars of the 1930s and '40s. At the studios she was known to direct directors, instruct writers when they were wrong, guide designers and seamstresses on her wardrobe, and tell cameramen how to photograph her. And usually she was right. Whenever a new cameraman was assigned to her, before the usual test he would assure her that she was so beautiful she could be photographed from any angle and he could do it.

"Try whatever you want but this is not an easy face," she said. "When you finish your way, try it my way and we'll see." In the end they would learn that Claudette was right.

Miss Colbert's knowledge doesn't stop at the studios. She knows how all the chores around the house should be done, and she can do them. If she doesn't like the way the soup tastes, she'll go in the kitchen the next day and tell the cook just how to correct it. She can tell a gardener how to care for her plants. From her late husband she learned enough about medicine to be a registered nurse. Claudette sets all the rollers and pincurls on her head except the small portion of the very back, and then instructs the hairdresser how each curl is to be twisted. She knows better than anyone else.

Claudette's figure stacks up favorably in comparison with all the so-called sex queens of the screen. It's still darned good, and she's always known what's best for it. Against her ad-

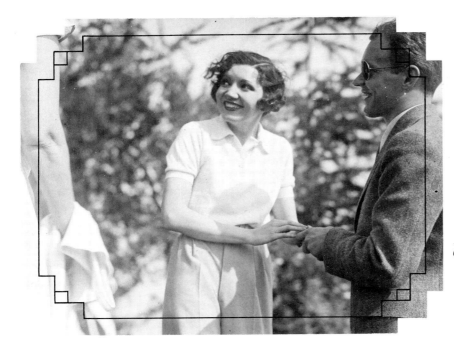

*John Engstead and
Claudette Colbert, 1930*

vice, I once persuaded her to make some bathing suit pictures on a yacht. When we looked at the proofs she said, "I'm too white to look good in a bathing suit. Now in a nightgown or an evening dress, that's another matter." Some of the pictures showing off Claudette's milk-white skin in a bathing suit were published, but it wasn't one of my best efforts.

Her walk is another of her perfections. In a scene from one of her movies I watched her pace a hotel lobby. While others were plodding around, the elegance with which Claudette moved was remarkable. Next time I saw her, I asked how she learned that walk. "I used to watch myself reflected in the store windows in New York and practiced until I was satisfied."

I eventually got used to Claudette's expertise, but I was still unprepared for what I saw one day when I called on her. It was the day before she was to leave for a command performance in England in the dead of winter. I found her upstairs in her dressing room, sitting near a window with one of her wool suits completely apart. The sleeves and the lining were out and the padding was strewn all around—you've never seen a suit in such a condition.

John Engstead and Mae West in Bell of the Nineties, *1935*

John Engstead and Mae West, 1961

"Those damned people at Hattie Carnegie's. I told them I was allergic to horsehair and they went right ahead and put it in. I have to take it all out. This is the best warm suit I have."

I looked at all those scraps and pieces. "Who's going to put this back together?" I asked.

"Who do you think? I will." I saw the suit later and I don't think Hattie Carnegie could have done better.

Claudette had been on our lot two years when another strong personality came on the scene: Mae West. Now, usually a lady has to have a couple of successful pictures behind her before she shows her muscle. In spite of being completely unknown to film audiences, with more years behind her and more weight on her body than her starring sisters, Mae didn't wait a minute to let it be known that she was in charge of everything concerning Mae West.

She is smart and shrewd and has a great sense of humor. In the 1930s she gave me a photograph of herself. On it she wrote, "For Johnny, who knows all the best positions—for the camera." She can come out with some racy dialogue and do suggestive things, but it always comes with a chuckle. Regardless of the image she portrays, there's no familiarity about West. Nobody throws their arms around her; nobody grabs hold of her, and she doesn't touch anyone in public. She doesn't smoke and she doesn't drink liquor and, in fact, not a drop of Los Angeles tap water has ever touched her lips. Only bottled water will do—West is a health nut.

With years of experience, Miss West took complete control of her career from the beginning. She asked for and received permission to okay all her stills on her first picture. When all other actresses were wearing girdles and having their hips retouched off, Mae said, "Nip in the waist and leave the hips." A few years later this became the fashion.

I was a little at a loss to know how to present this woman when I helped prepare Mae West's first portrait sitting. All the rest of the sexy girls in town were in their twenties and Mae wasn't. And the figure wasn't like Harlow's or Crawford's or Lombard's. We had had a couple of actresses about Mae's age—Pauline Lord and Gladys George—but they were playing character parts. The instructions I had received on West were, "Make her sexy."

Mae arrived in the gallery for her first sitting with her manager, Mr. Timony, and a prizefighter. The first thing she did was notice an old-fashioned carbon spot Mr. Richee used as a background light and ask to try this as the main light. It sputtered and sizzled and gave her a white light she liked on her face.

For her first change, Miss West wore a lace negligee with a slip under it. After Gene had made a few heads, I thought we'd better get down to business and try for sex—that's what they said they wanted.

"Is it possible for us to see a little more of your figure?" I asked. I meant perhaps we could pin the slip to suggest a bit more of Miss West's treasures. But Mae had a different and more concrete idea. "Oh sure," she said. And then she wiggled out of the straps of her slip and pulled it down under the lace. Now it was sitting around her stomach. But through the holes of the lace came the hint of Mae's nipples. This didn't disturb her or me because I knew our retouchers

Allan Marshall and Mae West

Mae West, 1962

could remove them. Mr. Richee continued shooting and at the next pause I asked if we could shoot a little lower to take in her hips. I was bolder than Mr. Richee.

"Well," she drawled, "you got someplace I can go for a minute?" Looking around she saw a flat she could duck behind. And in a minute she was back with all the West figure showing very nicely behind the lace. And it was all pretty good too. There were a couple of things you could write home to father about. The only thing that covered Mae now, besides the lace, was a G-string. Next morning, you can bet the publicity boys were impressed with the total beauty of Mae when they saw the proofs.

Although Mae's first role was only a small one in a George Raft film, *Night After Night*, she acted as if she were the star and Raft her leading man. For the special still sitting she again arrived with Timony. The advertising department had given me a sketch of a photograph they wanted to use on the billboards, which showed George surrounded by the women in the story—Wynne Gibson, Constance Cummings, Alison Skipworth, and Miss West. Do you think West would be photographed with three women? Not on your life. She sat in the back of the gallery and said, "No! No! No! I never have any scenes with any of these women and I don't care what the advertising department wants." She posed with Raft for a few heads and told him how to hold her.

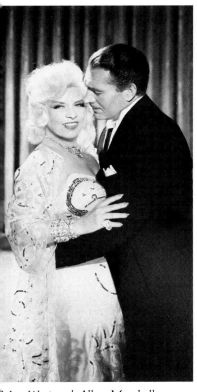

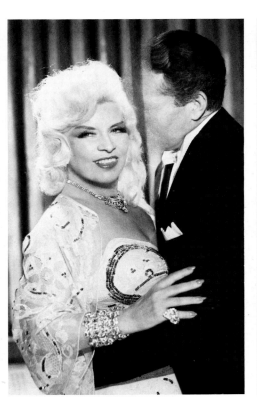

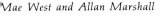
Mae West and Allan Marshall

Mae West, with part of Allan Marshall
retouched out

Mae West, without the late Allan Marshall

Mae was always very considerate and thoughtful of her gentlemen fans. She wouldn't mind on several occasions if we photographed her bosoms to please the guys who clamored for undraped photos. Whenever she got that cooperative urge, Mae would just say, "Lock the doors . . . lock the doors"—she didn't want to give everybody a free show.

Every few years we'd go to Mae's apartment to make some photographs. This place was all white and fringe and in those days, with all the white rubber gladiolas around, it smelled like a rubber factory. I once asked Mae why she didn't move out to Bel Aire or the valley and build a nice house. "I never could be out there where it's so quiet. I like to hear people above me and below me."

Mae was very definite as to the type of women she would allow to appear with her in her films—if she had any at all. (Usually she'd see there were only men, muscles, and more men.) In one of her films she wrote in a sequence with a line of chorus girls. What chorus girls! Not one was younger than thirty, and they were all about five feet ten or six feet tall and hefty! While the curious people around the studio rushed to the stage for a big laugh, West said to me, "Did you see those chorus girls in my picture? Aren't they wonderful?"

There was never a dull moment around Mae West. Being short (just about five feet), she had the soles and heels of her shoes built up to make her look six or seven inches taller. Some-

how she had mastered the technique of walking on these things; it was sort of a slow shuffle. She wore long dresses to cover up these stilt shoes and only once did I see her without them. I was in her dressing room as she made up. Suddenly she needed something the other side of the room, stood up and walked. The top of her head came somewhere around my navel. I was so surprised I blurted out, "My, but you're small."

With her suggestive inflection, she drawled, "That's what they tell me."

We never made any full-length shots of Miss West unless she was standing on a couple of telephone books (besides her platform shoes) which were all covered up by her long skirts. During the 1960s she came to my studio to make some promotional stills with Henry Fonda for a documentary on old Hollywood. Miss West asked for and got still approval. In spite of her telephone books, Mae said she looked too small next to Fonda and killed all the full-length shots.

While some Hollywood girls go for toy poodles and other lap dogs, Mae West goes for monkeys. One was running around the back of her seven-passenger limousine when it pulled up in front of our studio one day. Paul, Mae's companion and driver, came in and informed me that Miss West would like to see me for just a short chat. On this particular day I went out, stooped down, and saw Mae in the back, strapped in, with a long-legged, long-tailed, ring-tailed monkey jumping about. As soon as I leaned my arm on the window ledge, he ran over and jumped on.

"Isn't he cute?" said Mae. He was on a leash and I was happy to see he had on a pair of leather pants.

"Is he housebroken?" I asked.

"Well," drawled Mae, "not exactly. But you know they are great imitators. If I had a man around he could watch, I'm sure he'd catch on."

Mae was so attracted to one of her monkeys that after he died she had him stuffed. "He was so sweet," she told me. "That little face. I couldn't put him in the cold ground."

"What do you do with a stuffed monkey?" I asked.

"Stuck him in my apartment. The only trouble was, the guy stuffed the wrong one. Gave me another monkey. I know my own monkey."

Miss West was always very careful about who posed with her in photographs. A few years ago she made one of her infrequent personal appearances at a Thalian ball. I heard this story from a man sitting at the head table with Mae, Debbie Reynolds, Maureen O'Hara, and others. Miss West was seated between two men, director Arthur Lubin and Francis X. Bushman, one of the early heartthrobs of the movies. As the press photographers gathered to snap Miss West, who was then hovering around the age of seventy, she leaned as far as she could toward the younger Lubin and giving a quick glance at Bushman said, "I'll not be photographed with that old man."

■

Greer Garson and ex-husband Richard Key

Lucille Ball, like Mae West, never lost her sense of humor. Since RKO and Paramount were next-door neighbors, everyone on the two lots was quite friendly. I first saw Lucille one day in the late 1930s. Carole Lombard and I were crossing Marathon Street on the way to the garage and we heard someone a block and a half away let out a scream, "Carole!" It was a tall redheaded girl leaving the RKO back gate. As she waved back and giggled, Carole said, "You see that girl? She copies me." Carole was flattered that she could impress anyone. The redhead was Lucille Ball.

Lucille may have learned from Lombard and her comedy, but it was her own spectacular talent that made her the most popular star of the new medium, television. *Time* magazine asked me to shoot a color photograph of her for a cover in 1952. With the tight rehearsal schedule of "I Love Lucy," the only time to shoot the sitting was after final rehearsal, when she had her makeup on, just before the actual filming of the show. We made the sitting while the audience was filing past us and the crew was making last-minute preparations for the performance. It was a madhouse but it didn't bother Lucy or Desi Arnaz in the least.

When she first came to my studio, Lucy was leery of natural-light photographs. She had been used to artificial light on all her portrait sittings and agreed reluctantly. But when she saw

Lucille Ball, 1972

Lucille Ball, 1970

TIME

THE WEEKLY NEWSMAGAZINE

Chambers v. Hiss (SEE BOOKS)

LUCILLE BALL
Rx for TV: a clown with glamour.

Lucille Ball, on the cover of Time, *1952*

the proofs, she was converted to natural light; since then we have used it whenever possible. We have done hundreds of pictures in her back garden with the sun at her back, lighting her hair, and only a little silver-leaf reflector on her face. It was at her home that we did many sittings to publicize her long-running series on CBS. There were poses of her alone or with her family or with Gale Gordon in various sections of the house and garden. Lucy would be up at 6 A.M. to do her hair and makeup and be ready for work at 10 o'clock. We would shoot all day, with only a half-hour break for lunch. By six o'clock, I was dragging but Lucy looked and acted as bright as she had at 10 o'clock that morning. Finally her publicity man, Howard McClay, said, "How about it Lucy, think we have enough?" I can't think of any other actress who wouldn't immediately have said, "Yes." Lucy's answer was, "Are you sure you have all you want?"

As shrewd as she has to be in her business world, Lucy is a kind, amusing lady offscreen. One of her trademarks, besides the mop of red hair, is the mouth that she paints larger than it is. I thought it was too big on one sitting so I asked Franciene to cut it down just a trifle in all the black-and-white proofs. I was sure Lucy wouldn't notice, but when she saw the retouched proofs, she put a crazy snarl on her face: "John, somebody has made my mouth smaller. You have to put the lips back." Before a recent sitting, Lucy advised, "You'd better be a little more careful with this sitting. Your camera is getting older all the time."

106

Judy Garland

Lauren Bacall

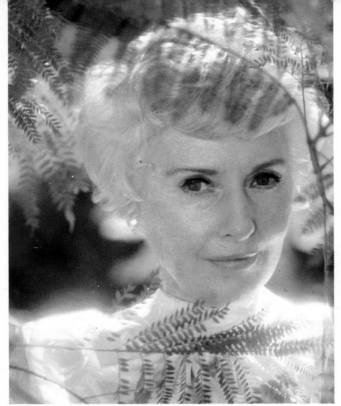

Barbara Stanwyck

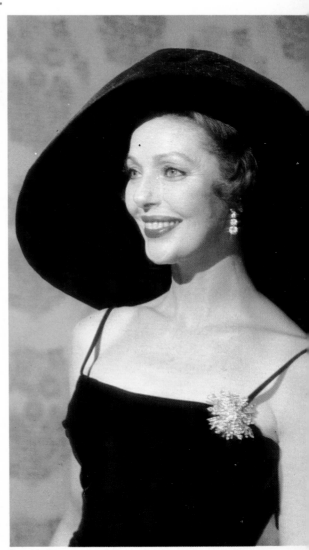

Loretta Young

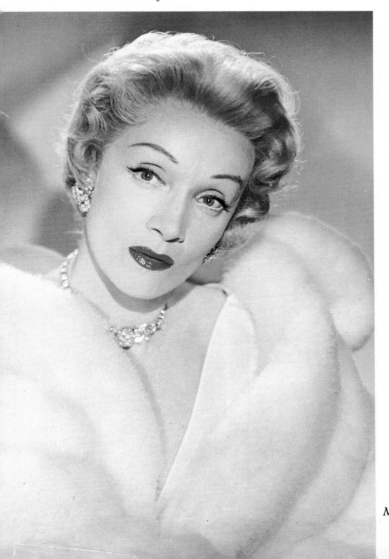

Marlene Dietrich

Clint Eastwood

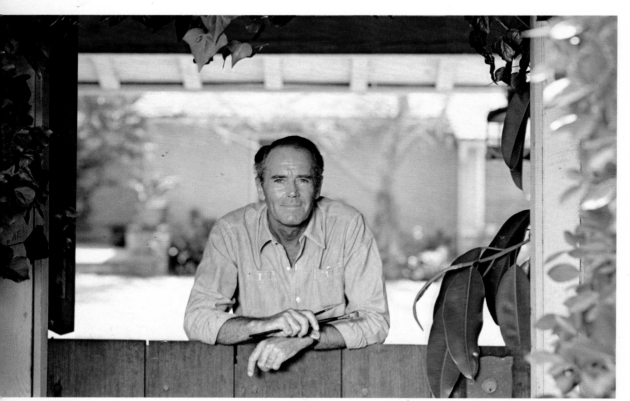

Henry Fonda

Gregory Peck

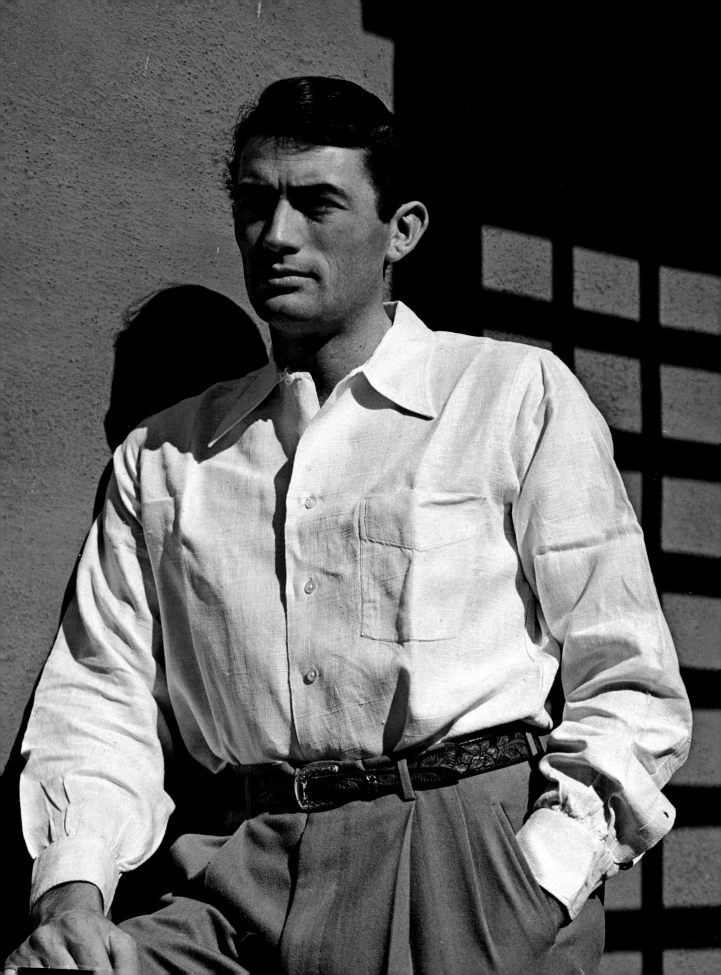

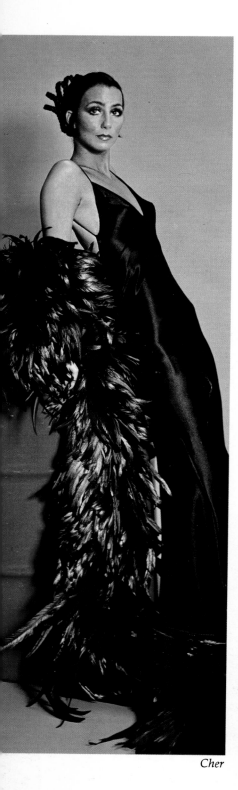

Cher

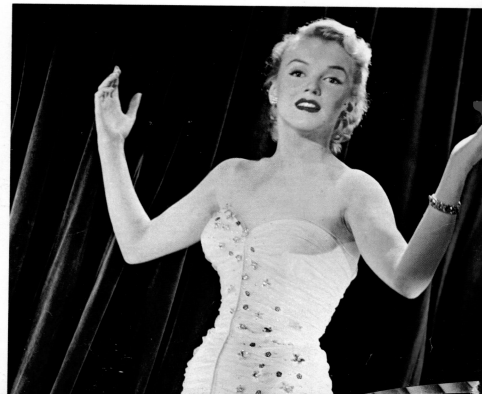

Eva Gabor

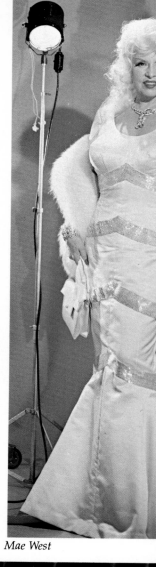

Mae West

Marilyn Monroe

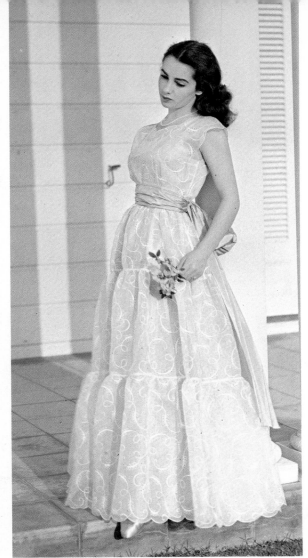

Elizabeth Taylor

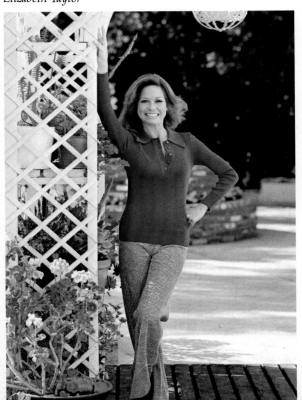

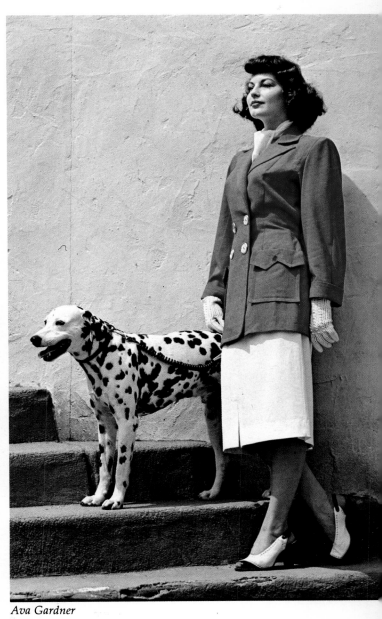

Ava Gardner

Mary Tyler Moore

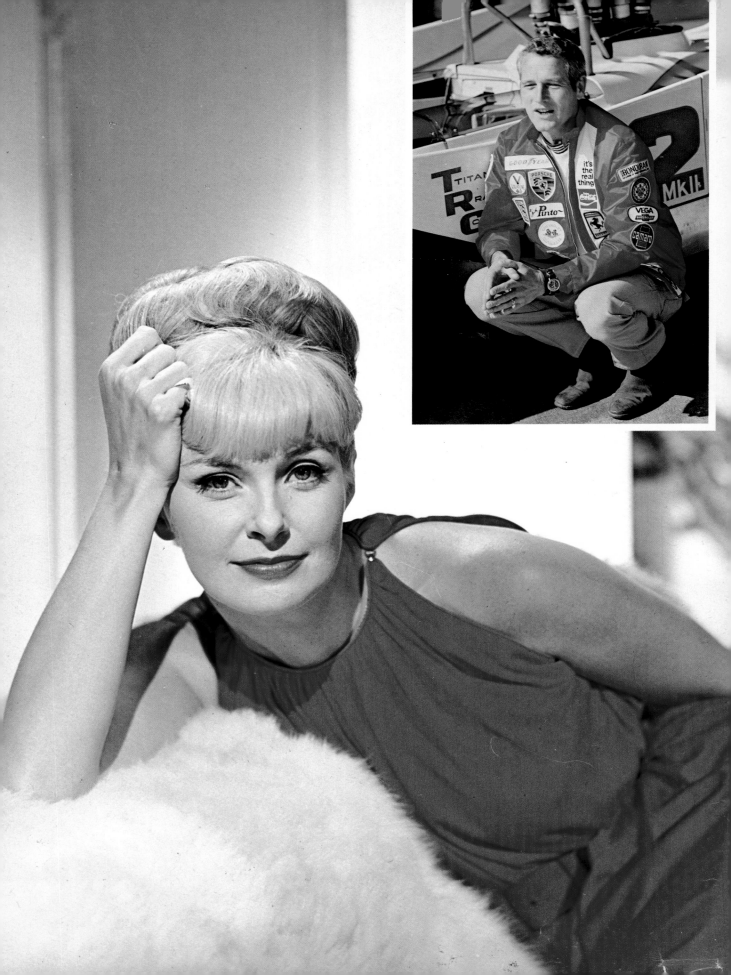

Friends

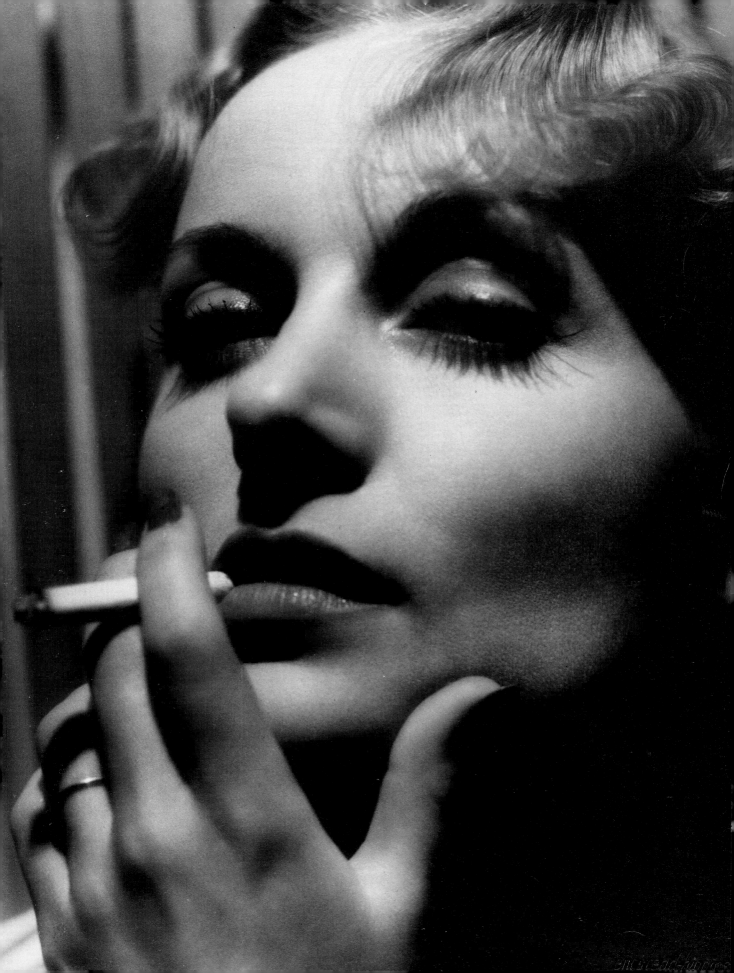

ITHINK YOU HAVE TO LIKE YOUR SUB-
jects to be a good photographer. You should enjoy meeting them, seeing what makes them tick, and giving them all the help you can during a sitting. Because if a person behind the camera is a cold potato and the subject feels indifferent or bored, you might as well call the whole thing off. And this doesn't mean acquiring a phony line of chatter, because a subject can usually pick up insincerity.

I have always found actors and actresses fascinating. I like to meet them and find their best qualities for the camera. Generally I don't make lasting friendships with these people, because neither of us has the time. They come in, say hello, and we go right to work.

During my years at Paramount (1926 to 1941) it was easier to form friendships. The stars were under long-term contracts, and working with them year after year, I came to know some of them quite well. I always tried to be very honest with them and expected that they would be the same with me. I have always tried to tell them what's on my mind, which is not always flattering, but I avoid being unkind.

I have long considered Claudette Colbert a good friend. Over the years we have had dozens of friendly arguments over a particular sitting or a certain photograph I thought we should use. Claudette always had very definite opinions and they were difficult to change. She almost always won in spite of the fact that her mother and husband were usually on my side. But even disagreements with the vital Claudette were pleasant. Today she spends most of her time in

109

Carole Lombard, 1940

Barbados or New York—both a long way from my stamping ground—but I know that when we see each other our relationship will be the same as we left it.

Gail Patrick has been my most constant friend since her first week on the Paramount lot. She is intelligent, hardworking, loyal, and kind. To start out at sixty-five dollars a week and end up a millionairess is pretty good for a girl who always says she was no great actress. Gail's warmth is best illustrated by the party she gives each year on the last Sunday before Christmas. It's a great reunion for dozens of friends in and out of the motion-picture business, including Meredith Willson, Ann Blyth, Jim Jordan (Fibber McGee), Eve Arden, Gene Raymond, Rosita Moreno, Mel Shauer, Harriet Nelson, Tom and Elyse Harmon, Mary Anita Loos, and studio workers she has known since she began.

Little Edith Head has been my friend longer than anyone else in Hollywood. Edie was Travis Banton's sketch artist when I went to work in 1926. During my years at Paramount and after, I always turned to Edith when I needed dresses for a sitting. She was adept at combining various pieces of wardrobe and making old gowns look like new. In those days Edith shunned any type of publicity and whenever we wanted pictures of some actress having a fitting, she'd say, "Oh no, get Travis Banton, get a wardrobe girl, anybody but me." Now, however, she is a master at publicity and is constantly appearing on talk shows. "It's easy," she tells me. "The first two times you are terrified, but after that, it's a snap."

The secret of Edith's long success is that she works extremely hard and lives for the present. We've known each other for fifty years but Edith is not one to reminisce. She's always full of news of a new film she's doing, the stewardess uniforms she is designing, new patterns she's

Edith Head, 1940

creating for *Vogue*, or fashion shows she puts on around the country for charity. From her energy and enthusiasm you'd think she had just started out in the movie business last month.

Anne Baxter is Edith's close friend and mine, too. I met this theatrical granddaughter of Frank Lloyd Wright through Claudette Colbert's brother, Charles Wendling—Anne's first Hollywood agent. Anne was a chubby, sexy, and naive seventeen when I did her first sitting. I can still remember her giggling when I told her to wet her lips. Although she had acted in the theater since the age of thirteen, she didn't know much about makeup and I tried to help her. I still do. A few years ago I suggested a small amount of shading above the eyes. I didn't see her again for three months, but during that time she must have thought that if a little shadow was good, more is better. At the last session, I had to tell her, "Gad, Anne, you look as if you have two shiners!" And off it came.

In the interests of self-preservation, Anne's learned every facet of the film business, but she never "went Hollywood." In between her fifty films, plays, and television shows and an Academy Award, she managed to pursue a very full private life. When she and her ex-husband, Ran Galt, settled in New Mexico in an adobe hacienda designed by Bill Ihnen, Anne asked me to come down for a weekend and do a sitting. When I arrived at the ranch in the middle of nowhere, it was obvious that the glamorous Anne had been barefoot and pregnant most of the time. With no household help, she was taking care of her babies, her husband, and Katrina, her eleven-year-old daughter by John Hodiak. Anne is just normal enough, nuts enough, and loyal enough to be a fine friend.

■

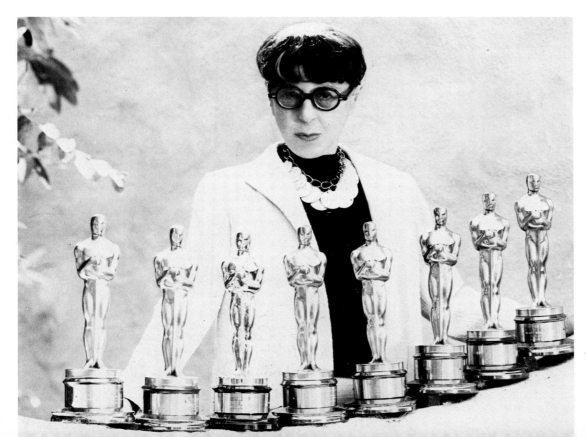

Edith Head, 1976

Anne Baxter, age 17, 1940

Another Annie well remembered by me (and many others in Hollywood) was Ann Sheridan. Originally named Clara Lou Sheridan, she was a big, hefty, happy schoolteacher in Texas when she won a contest and came to Hollywood for a part in a film called *Search for Beauty.*

This happy-go-lucky, sexy girl was anything but the stereotyped schoolteacher. By usual Hollywood standards she was about twenty-five pounds too heavy, although every male on the lot thought those pounds were distributed in very pleasant places. The natural curl in her hair was so tight it was almost a kink and there was a space between her front teeth. Phyllis Laughton, who later married director George Seaton, came to Paramount as drama coach in 1933 and worked to minimize Clara Lou's Texas drawl.

After a couple of small roles, no one at Paramount knew what to do with Clara Lou, so they dropped her from her contract. Five or six months later she turned up under contract at Warner Brothers. She was now Ann Sheridan, a brand-new woman who had lost weight, capped her teeth, and found herself a hairdresser who could straighten her hair. Best of all, George Hurrell made some very sexy stills of Ann and to publicize her, somebody dubbed her the "oomph girl." Ann was on her way. And it couldn't have happened to a nicer person.

I saw less of Ann after that since the Warners staff photographers took her portraits. It was twenty years before I shot her again as the star of her television series, "Pistols and Petticoats." When she arrived at my studio in her period costume, Ann was ill—very ill. She was extremely thin and so weak that she had to be helped to move. As I placed the lights and looked through the camera to focus, I could see her face was gaunt and showing signs of pain. Yet when she heard the sound of the plate holder going into the camera and the slide being removed, she instinctively knew I was ready to shoot. Suddenly all the pain left her face and the old Clara Lou sparkle came back. It was an amazing exhibition of will power. She posed for dozens of black-and-white and color photographs.

When we finally finished, Ann stood up and walked out, supported by her husband, Scott McKay. It was difficult to believe she was in any condition to start a television series. Everyone insisted she would be capable of it. Ann worked on the series for several months until she could no longer walk. Ironically, the Los Angeles *Times* carried our color photograph of Ann on the cover of their television magazine the same morning the front page carried the news of her death by cancer.

Kay Francis was another friend of mine at Paramount who moved to Warner Brothers—finding first great success and later great disappointment. Kay was a smart, classy lady. An un-

Ann Sheridan, for "Pistols and Petticoats," 1966

Sir Guy Standing, Ann Sheridan, and John Engstead, 1936

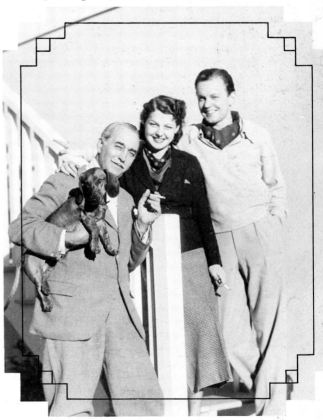

usual, arresting beauty, she stood five feet nine inches tall, wore size two shoes, and consequently was very uneasy on her feet. Once, while filming *Raffles* with Ronald Colman, Kay made an impressive entrance coming down a marble staircase. When she arrived at the bottom, she tripped and fell flat on her face. "Damned little feet," she said.

Almost every day Kay would enter the Paramount executive building, scoop up her mail, come to my office, and plop down in a big red chair that faced my desk. If I had time, we'd talk, or otherwise I'd go on with my work. If she was in a hurry, she'd just say "Hi," glance over the mail, and leave. It was a no-nonsense friendship.

In 1933 Paramount woke up one morning and read in the paper that Warner Brothers had stolen three of their stars, Ruth Chatterton, William Powell, and Kay Francis—so there went my friend. With both of us working at different studios, Kay and I didn't meet very often during the next year. Then, quite unexpectedly, I was summoned into Arch Reeve's office. There sat Ike St. Johns, Adela's husband and one of the editors of *Photoplay* magazine. The J. Walter Thompson agency had put together a Lux ad using pictures of Kay taken for general publicity. She had never believed in product endorsements and always refused to sign a release. Since Lux was one of *Photoplay*'s biggest advertisers, the agency was putting the screws on Ike to use his influence to make her sign. Now Ike was turning to Arch in desperation for help.

"I'd like you," Arch said to me, "to go over to Warner Brothers with Ike and see if you can persuade Kay Francis to sign the Lux release." I had no choice but to go and as we drove to the valley, I mulled over just how I would or could put this to Kay so she would understand. We entered the sound stage when the company was between scenes. Kay came over to me with open arms. "Johnny, what in the world are you doing here?" I hesitated. "Ike wants you to sign this Lux release." With great exasperation, Kay said, "Give me that damned paper. Who's got a pen?" She scribbled her name. "There!" she said. "Now sit down and talk to me."

As we left, Ike tried to slip me five dollars. "No," I said, "send me some soap." And Lux did—a case arrived every month for the next twenty-five years.

■

Carole Lombard once said to me, "If I believed in reincarnation and I could come back as anyone I choose, you know who it would be? Irene. You have to meet her." And so I did. I made a sitting at her home in Brentwood which was the beginning of a long friendship.

Irene, who designed glamorous dresses for Hollywood stars, was a fascinating lady. She was certain proof that all the exciting women of town weren't in front of the cameras. In the 1930s and '40s, every star and social butterfly who would afford her prices went to Irene at Bullock's Wilshire. She was the vital modern heroine of popular fiction—tall, with tawny hair in a windswept bob, tan skin that required no makeup, and a husky voice. The lady dressed simply, swam well, and was expert at skeet shooting.

116

tween the afternoon and evening performances. She and her husband, Richard Halliday, and I had a martini and talked for two hours and have never been out of touch since.

On my way to Paris to photograph the collections for *McCall's* in 1957, I stopped in New York where Richard had asked me to photograph Mary for general publicity. For three days my assistant, Otto Stubbs, and I shot Mary in her two-story penthouse apartment on the East River. (Greta Garbo had the fifth floor of the same building, and as I had become friendly with the elevator operator, I asked the old gent one day, "How is Greta Garbo?" "Well," he said, "like all of us—older.")

Mary had an unbelievably close relationship with Richard, who managed her career. He made the decisions, all appointments, decided how many hours sleep she would have each night, what she ate, and who made her dresses. Mary once said, "It's a great career we have; it's just that I go on the stage and Richard doesn't."

After Richard's sudden death, Mary moved to Palm Springs where she lives near her friends Janet Gaynor and Paul Gregory. I see her more frequently now.

■

Mary Martin, 1957

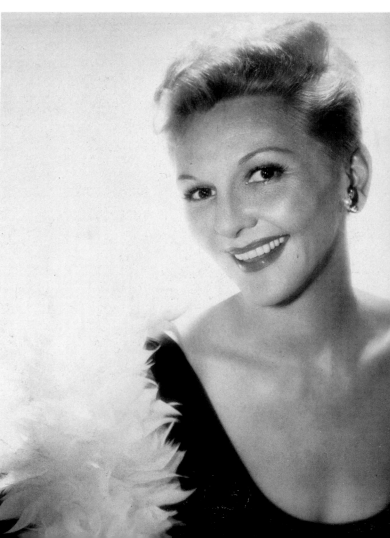

Anne Baxter, 1976

Anne Baxter and Katrina, 1958

Janet Gaynor, winner of the first Academy Award in 1928 for best actress, is one of the happiest persons I have ever known. I met her in 1942 through her husband, Adrian, the brilliant couturier—a shy gentleman completely devoted to Janet. Three or four months after Adrian's business manager had turned down my request to photograph his collection for free, Adrian called me himself, said that Vincent Price had recommended me as a photographer, and offered me the job—for pay.

For the next dozen years or more I photographed two collections a year. Each collection consisted of about 125 dresses from which Adrian would select thirty or so of his favorites to photograph. He always worked with me on the pictures, advising me which points of each dress to feature. We worked for hours each afternoon and I have never seen him become angry or impatient. Janet would come in late in the afternoon from their ranch at Northridge and wait to go to dinner.

Adrian's death in 1959 was a great tragedy for Janet and it took her a while to get over it. But she did because she's such a happy woman. Eventually she married Paul Gregory, a theatrical producer I knew from having photographed his stage productions.

Mary Martin, 1976

Mary Martin, 1957

Now Janet and Paul live in Palm Springs and Janet spends half of each day painting. The showings of her paintings at the Wally Findlay galleries in Beverly Hills, New York, Chicago, and Palm Beach are complete sellouts—and no wonder. Her paintings, mostly flowers, are just like her: full of happiness.

■

The favorite man at Paramount was quiet Gary Cooper. Of course all the girls liked him, but the electricians, the grips, and even all the other male actors looked up to the gentleman who was Gary Cooper. This star was never loud and didn't show off. He didn't need to.

The first time I saw Coop he was playing a glorified extra part in Clara Bow's *It.* They were shooting a scene on the New York street on our back lot. Coop came up to the front door of Clara's brownstone, said a few words, and that was the extent of his part. He and Clara were soon in the gossip columns but this didn't stop all the girls on the lot from falling all over themselves around him. He was certainly catnip to the females—the young ones, the old ones, actresses, secretaries, and fan magazine writers—all had hopes and each one mustered up every bit of charm she had in his presence. After Clara, it was the sophisticated Evelyn Brent who polished up some of the rough edges for a few months; Lupe Velez gave him a couple of hot and hectic years; and then the Countess deFrasso had her innings. She had lost her girlish figure but in its place had a title and money, and she moved Cooper into the cafe society of New York and Palm Beach.

About the time the Countess settled herself in Cooper's life, Paramount assigned him to *The Devil and the Deep* with Tallulah Bankhead, who let it be known far and wide that her first important bit of business in the film capital was to lay Gary Cooper. Tallulah told so many people of her intentions that, of course, Coop heard about it—and he was just as determined that she would not achieve her goal.

The Devil and the Deep was being partially filmed on a submarine in a gigantic outdoor tank on the back lot, so the company worked every night to avoid picking up the sounds of the city during the day. On three different afternoons Cooper agreed to come in early before the night's shooting to make love stills with Bankhead required by the advertising department. Each day Tallulah came in four hours early and sat in her dressing room with the makeup man and hairdresser performing all their tricks to make her particularly beautiful for the stills with Cooper. Each day Richee, Tallulah, and I would wait for Cooper, who would arrive with apologies but too late to make the stills. He would go on the set and Tallulah would go home. I had a sneaking suspicion Coop was trying to tell Tallulah that she wasn't quite the sex goddess she thought she was.

Cooper, with all his girl friends, surprised everyone when he quietly married Veronica

Balfe, an unknown who had come to Hollywood to be a movie star. She was a wise choice. Beautiful and brainy, Rocky, as she was called, kept herself in top form all the time; after all, she was in competition with all these lovely women Cooper made love to on the screen.

Cooper knew more about how to be photographed than any other man I know. The way he handled his face and his six-foot three-inch frame led me to surmise that he must have done considerable homework. Whether he learned by studying himself on the screen or in front of mirrors or a little of each, he moved with the grace of a panther. I don't think he either liked or disliked photographic sessions, but he endured them because he realized that they were part of his business.

One thing that made it easy for Cooper to make stills was his appreciation that cameras photograph the mind. On the screen it is rather simple (if you have any brains at all) to get this eyeball-to-eyeball look when you are reading prepared dialogue and working in a scene with another actor. Coop's trick was that he could create these looks without these crutches.

In the 1930s, when most actors still wore rather heavy makeup on the screen, Coop broke

Gary Cooper, 1955　　　　　　　　　　　　　　　　*Gary Cooper and Maria, 1940*

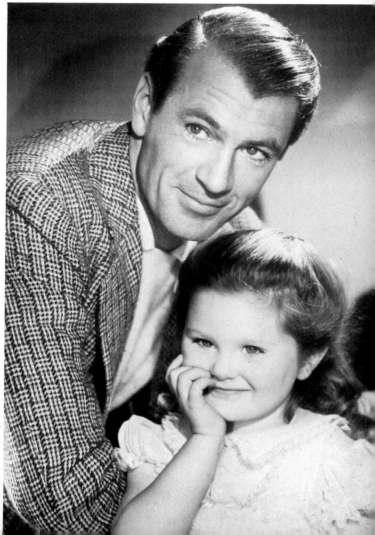

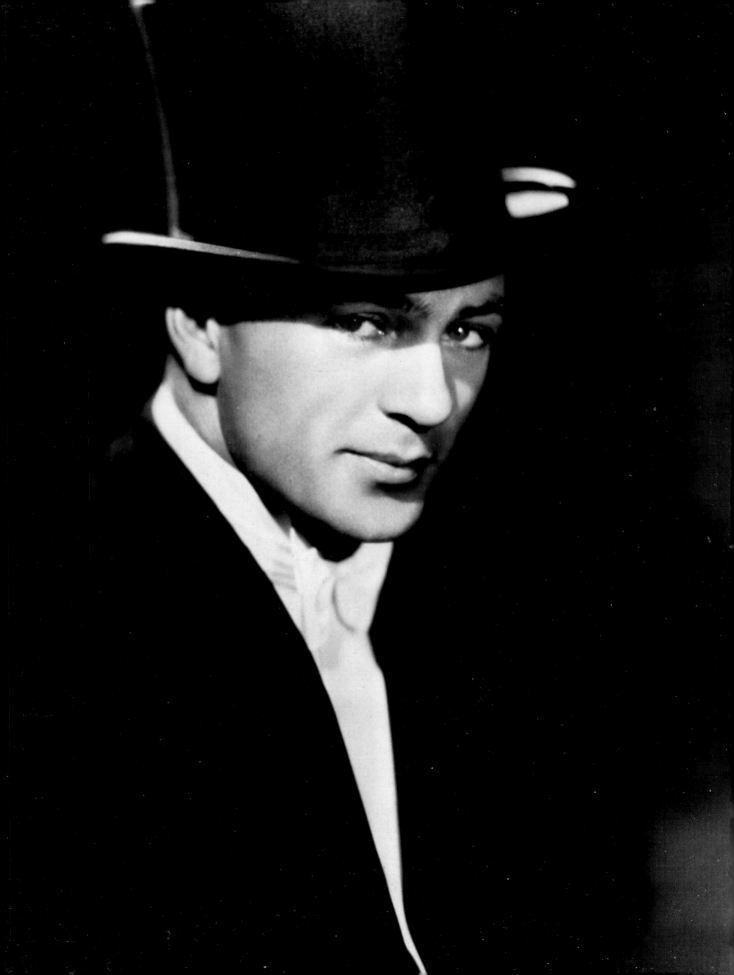

this tradition by maintaining a natural tan. Whenever I had a sitting with him at Paramount, I had an easy job: all I had to do was let him go. It was a pleasure to watch him work in front of a still camera. If I put a chair in front of him on a set and said, "Let's make a picture with this," it wasn't just something to sit on. With many actors I'd have to get in there and find a pose myself and then let them copy me. But Coop would walk around the chair, taking his time, and decide whether it was best to lean on it, sit on an arm, turn the back of the chair to the camera, or sit in it. In a minute or so he'd slide into a pose and make a very easy photograph.

Concentration was another of Coop's talents. I've seen him lean, in his relaxed way, against a wall in the portrait gallery, and, never moving out of position, take out a cigarette case, select one, and look up at an imaginary woman. Through the intensity of his gaze would come a smile. He would do this slowly enough so that at any time a photographer could make an excellent photograph.

Cooper also carried this professionalism to the care of his body, which he kept in top physical condition until his last illness. He came to me to make a sitting just before he went to England to do his final film. When he changed his shirt in the gallery, his lean muscles and washboard stomach were as good as ever. After the sitting we went in the kitchen and had some coffee. We talked of Paramount thirty years before and I recalled the B Westerns with Thelma Todd as leading lady and William Powell as the heavy.

Gary Cooper, Rocky, and Maria, 1961

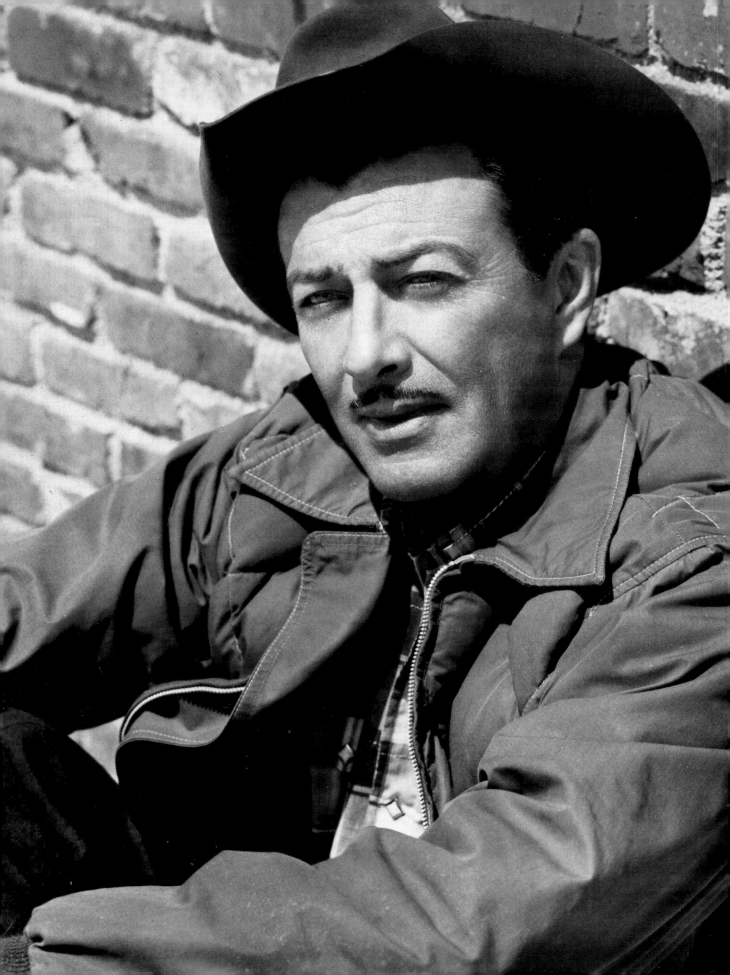

John Engstead pinning a bathing suit for Susan Hayward

Susan Hayward, 1968

Robert Taylor

Susan Hayward, 1945

When the conversation got around to Cooper's father—a man I had liked very much—he said, "Yes, he was a wise old, quiet guy. I wish I'd listened to him. He knew more than all the business managers. He and I went to Palm Springs in the early '30s. We looked at property and decided to buy two sections of land for $70,000. Do you know how many acres that would be? One section was directly behind the El Mirador Hotel and the other was over closer to where Cathedral City is now. We put up a $5,000 deposit. When we returned to Hollywood, my business manager told me to forget it; it would never be any good. We lost the deposit. Can you imagine what the property is worth today?"

My last sitting with him was after Coop came back from England. Rocky called me to make a sitting of Cooper, herself, and Maria, their daughter. When my assistant and I arrived at the house in Holmby Hills, Rocky took me aside and said, "This will be a short session. Gary has been ill and I don't want to tire him out."

We worked for an hour or so. Coop looked pretty good, but there was a strain about all three of them, when I think of it now. I didn't realize the drama that was going on that afternoon.

Usually when we finish with a star, he excuses himself and goes about his business, but this time Coop stayed with us. Maria and Rocky had things to do and left, but Gary watched as we put the camera away, rolled the cables, packed the camera, film, and reflectors. We talked about his paintings, especially the beautiful Renoir he had in the living room. Coop followed us when we carted the stuff out to our truck.

In the driveway I said, "What are you going to do next, Coop?"

"Oh, I don't know," he said. "Guess we'll go to Sun Valley for a rest." We said goodbye.

As we drove out the circular driveway, I looked back and Coop was still standing there. He waved. He knew something that I didn't: that this would be the last time we would see each other.

■

Of all the good friends I have made in this business, Carole Lombard is the one who impressed me the most. Her humor, intelligence, and enormous kindness made her everybody's favorite around the studios.

I think Carole knew every swear word there is—she even made up a few of her own—and used them all around the studios. The crowd that works in the film industry is a wonderful, friendly, lusty bunch, and they loved to laugh at Carole's vocabulary. And with her lively personality there was never a dull moment when she was around. Carole picked up her strong language at the beginning of her career to distract producers who made a habit of chasing this then chubby blonde around their desks. Unfortunately, her talk gave some executives the mistaken idea that her morals were as lax as her mouth.

On the other hand, if strong language wouldn't stop an anxious executive, Carole had a good right arm, which she kept in tip-top condition. She hadn't been raised with two brothers for nothing. And she considered it open season for the fresh photographer at Sennett's. She put

130

Bob Hope and family, 1966

him and his roving fingers in their place with a couple of good punches, and from then on all the other bathing beauties asked her to accompany them on their sittings.

But too much has been written and said about Carole's profanity. Some people have never taken the time to find out that there was a completely different side to the lady. She never swore in front of her mother; her first husband, William Powell; or Clark Gable—because none of them liked it. Travis Banton and Edith Head and the seamstresses who worked on hundreds of Carole's fittings knew Carole Lombard as a lady who never swore—almost! And in the ten or more years that I knew Carole, I never heard her tell a dirty joke.

By the time I met her in 1929 the once chubby girl had slimmed down (and Carole never again gained weight). She had come to Paramount for a small part in *Safety in Numbers*, starring Buddy Rogers. My first experience with Carole showed me just how smart she was. *Photoplay* was preparing a layout of actresses wearing their favorite pieces of jewelry. Carole agreed to pose and instead of bringing one piece of jewelry, as requested, she brought in two pieces and two different dresses. "Let the editors decide which they like," she said. So we photographed both and Carole ended up the only actress with two photographs in the layout.

132

It was Carole's mother, Mrs. Peters, a bug on numerology, who changed the spelling of her daughter's name from Carol to Carole on her first Paramount contract. The studio saw her as a sophisticated glamour girl. It had paid off handsomely for Constance Bennett and Lilyan Tashman, two other blondes, so why not their Carole? For several years she played classy but dull leading-lady roles in films like *Sinners in the Sun, White Woman,* and *Bolero.* William Powell was the star and she the leading lady of *Man of the World* (1931) and *Ladies' Man* (1932) and I presume the two of them liked the arrangement because they soon were married.

People seeing Carole on the screen as the beautiful, cold lady were very surprised to find that in real life she was a lively, amusing woman. I remember sitting around her dressing room with her and the marvelous *Harper's Bazaar* photographer Hoyniguen Huene, after he had photographed her. We talked for half an hour and he was so intrigued with her vitality he said, "Why don't you play yourself on the screen?"

But Paramount executives weren't as aware as Huene that Carole was a comedienne as well as an actress, and in 1933 her career began to go rapidly downhill. After a preview of a particularly dismal film in Glendale, the studio executives stood around the lobby in their usual group trying to fix the blame for their disaster on someone. I moseyed over to learn what the decision was and heard some character say that Carole was "box office poison." Now the Paramount producers were afraid to get mixed up with a loser and Carole sat around collecting a salary of $3,000 a week, without working, for nine months.

Carole's career was saved in 1934 when Gloria Swanson turned down the starring role in *Twentieth Century* at Columbia studios and director Howard Hawks decided that Lombard had

Carole Lombard and John Engstead, 1938

enough glamour and sense of comedy to play the temperamental actress. Of course Paramount was more than glad to get their "box office poison" off the payroll for a while. Carole and her costar, John Barrymore, hit it off well together. She once told me how he would disappear between scenes, and only Carole and the assistant director knew where he went. Most studios have a whorehouse or two in close proximity. There were several such places near the Columbia studio on Gower Street, and that is where Barrymore wandered when he wasn't needed. So when Hawks was ready for Barrymore and the assistant director was busy, it was up to Carole to sneak down Gower and stand out in front and yell for Barrymore.

One of Carole's problems during her first few weeks at Columbia was Harry Cohn, the head of the place. Frequently she was summoned to his office for one reason or another and he

Carole Lombard, 1940's

would promptly make a pass at her. Carole was tired of thinking up excuses and she couldn't use the same technique that worked so well with the Sennett photographer, so she let Hawks in on her problem and the two of them hatched a plot. The next time she had a call from Cohn's office, Hawks followed a couple of minutes later, barging in just as Carole was unbuttoning her dress, saying, "Come on, Harry, let's do it now." (Or, if I know Carole, she probably used a little stronger language!) At any rate, Cohn brushed it off as a gag, but from then on there were no more calls for Carole from Mr. Cohn's office.

Twentieth Century was a success and Carole's career finally shifted into high gear. Paramount executives must have been a little ashamed to have another studio make a star out of their "box office poison," for they scurried around and came up with a comedy, *Hands Across the Table.*

135

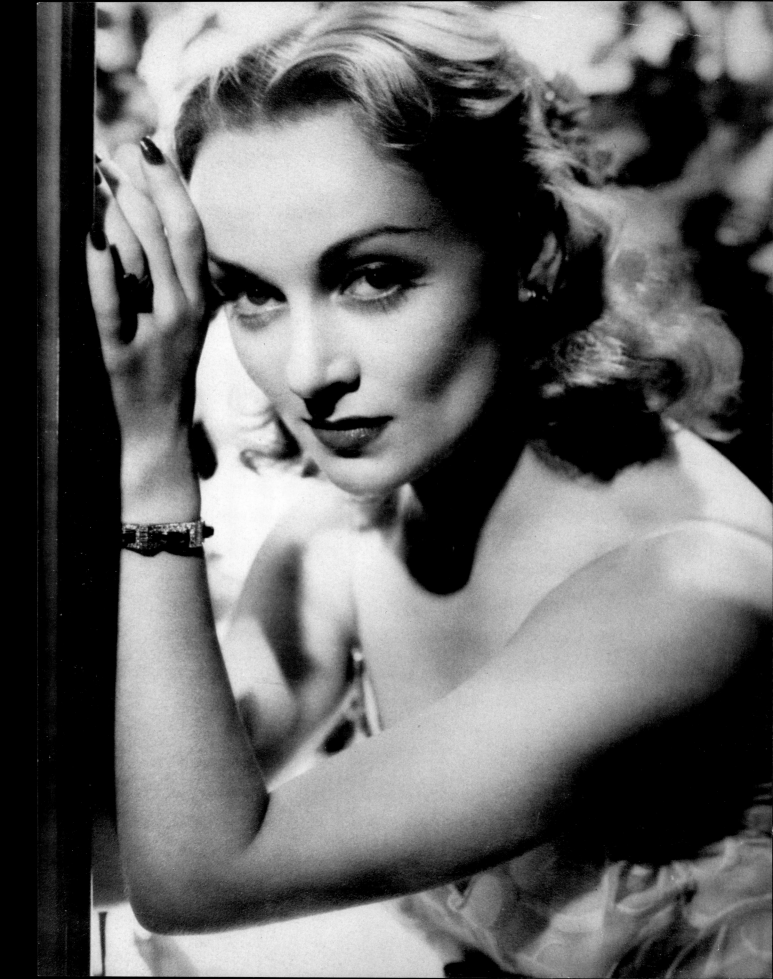

I was in Carole's dressing room late in the afternoon when she returned from making wardrobe tests for the film.

"I'm not going to make this picture," she said. "For the first time on this lot I want to do something good. I only have the first forty pages of the script. How can I build a character when I don't know what happens in the end? I've saved $40,000. I'm going to give my mother $20,000 and I'm going to take the rest and go to New York and do a stage play."

I began to wonder about this girl. "Carole," I said, "have you prepared yourself? Can you handle the great role when you get it?" Was she ready for the world of Helen Hayes, Katharine Cornell, and Ruth Chatterton?

"I certainly can," she said. "I buy every one of the best plays from New York. I study them. I learn the lines. I analyze how the author builds his story. Which are the plot lines. How does he introduce his characters. How does he get them on and off stage. I look for character clues. Laughton once told me that an actor should know more about a character than the author who wrote it. I see good motion pictures two and three times to study the acting and the dialogue. I *am* ready."

Carole cooled down overnight, however, and began *Hands Across the Table* the next day. After she finished this and her next film, *The Princess Comes Across*, both of which did excellent business, her original contract was due to expire. One day she called me and said, "I'll be in my dressing room at 4:30. Can you come over and see me?"

There she was, on time as always, beautifully dressed in a navy skirt, a plaid jacket with bits of red, a navy blue hat perfectly angled, the marvelous legs and elegant shoes—and, oh yes, there was her 152-carat star sapphire on her lapel. "I'm meeting Myron Selznick [her agent]. We're going in to talk contract." She giggled, took six or seven Kleenexes, folded them, and tucked them into the pocket of her jacket.

"What's that for?" I asked.

"I'm making little plans." she said. "I may cry." I walked with her to the executive offices. "I'll call you tomorrow," she said. "And I'll tell you what happens."

The next day I learned the whole story. Present at the meeting were Ernst Lubitsch, briefly the production head of the studio, Henry Herzburn, a fleshy lawyer who helped in production chores, and the usual gaggle of executives and assistants. The meeting went on—Lubitsch outlined big plans for their now popular Carole: the stories they were buying, the directors to be assigned to her pictures, and big-name actors to costar. Then the new contract came up, with Carole's salary to jump to $5,000 a week, which meant that the studio would pay her about $50,000 a film. Well, after six o'clock Myron Selznick gave them the shocking news: Carole wanted no more long-term contracts and $165,000 a picture. This was the girl they had paid $3,000 a week to do nothing for nine months!

Negotiations dragged on. The studio people balked at the money. Then Carole began to put them on the defensive. Nothing was good enough. "Have you ever seen my dressing room? It needs painting and the furniture is all dirty and worn out. You never give me a finished script before shooting. That shit you have as head of publicity allotted me only twelve pieces of film

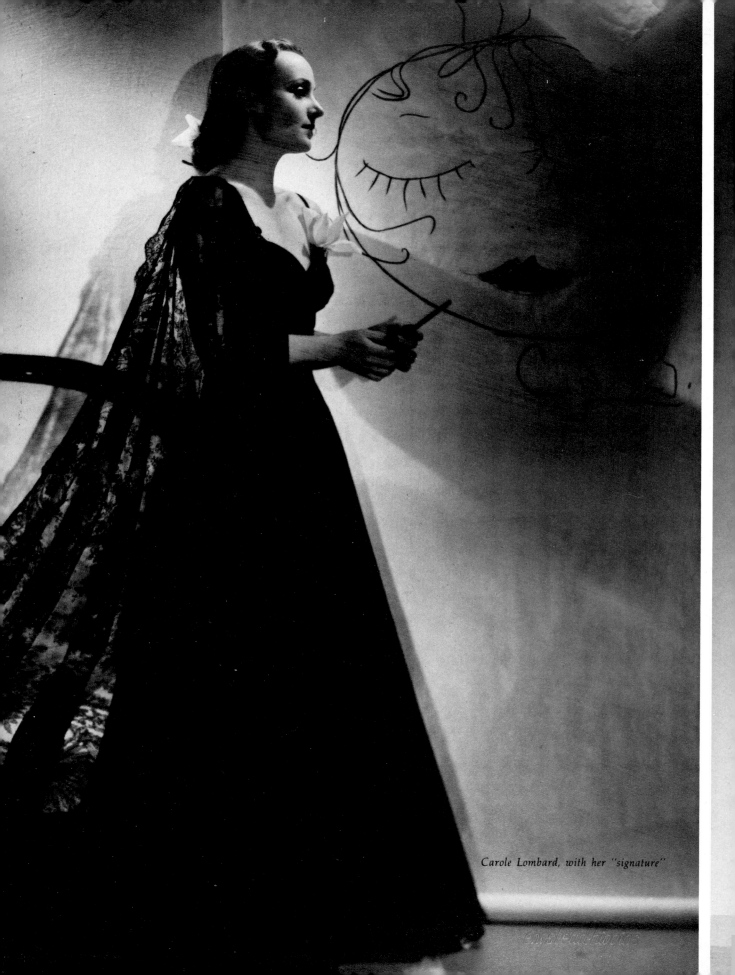

Carole Lombard, with her "signature"

Carole Lombard, 1940

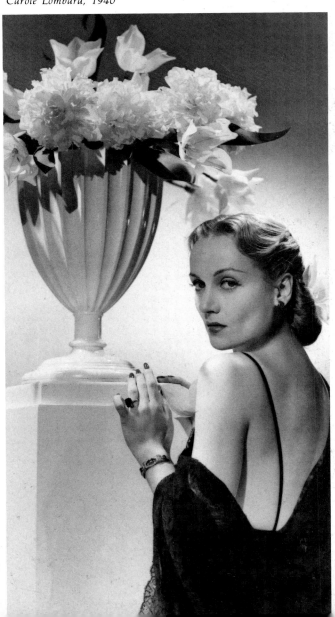

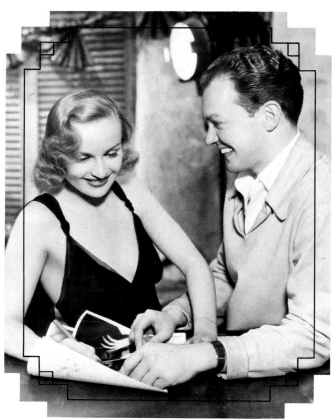

Carole Lombard and John Engstead, 1938

Fred MacMurray and Carole Lombard
(*Photo courtesy Paramount Pictures*)

for a portrait sitting. I'm always on time! I always know my lines! Do I ever cause you any trouble? No! I work hard for you and what do you do for me? *Nothing!*"

Her chin began to quiver. "Nobody gives a damn about me. I feel like I'm alone." Tears were now rolling down her cheeks. Lubitsch came over and put his arm around her. "We love you, Carole." The Kleenex came out.

"No you don't . . . and I can't stand it here any longer," she cried and ran sobbing from the room. Now she had planned to run to her dressing room and lock herself inside as they pounded on the door to talk. Unfortunately, she forgot her key and the key man in charge of the dressing rooms had gone home. The fat Herzburn was running after her but he was no match for the former track star of Virgil Junior High. The best she could do was run around the back of the building and sit on the stairs crying until the winded Henry caught up with her. She got the $165,000 a picture.

As you can see, behind the sophisticated clotheshorse of her early motion pictures, the dramatic actress of *They Knew What They Wanted,* and the scatterbrained comedienne of *My Man Godfrey* and *Nothing Sacred* was a lady who pursued her career with perseverance and intelligence. In a conversation one day Carole gave me a clue to her determination when she said, "You know who was the only person who thought I'd be a star when I began?"

I thought quickly and said, "Bessie" [her mother].

"No, it was me," she said.

Over the years I noticed how Carole took care of herself. She kept her complexion in such good condition that she needed very little base and had her own particular way of putting on her makeup. She attached three or four individual false lashes to the outside edge of each

140

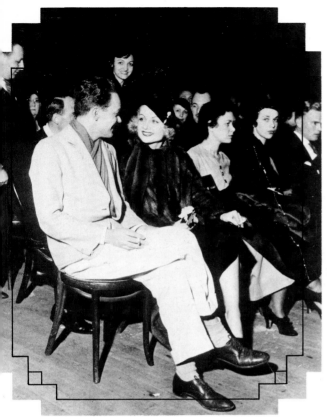

John Engstead and Carole Lombard

John Engstead and Carole Lombard

upper lid. There was a little pot of liquid mascara sitting over a flame. With tweezers she took one or two lashes at a time from a little packet, dipped the ends in the hot mascara, and applied it to one of her own lashes. After three or four were in place, she snipped off the tips with a tiny pair of scissors to make them the desired length. Next she took two kitchen matches and burned the soot onto the bottom of an old saucer. With a small paintbrush dipped in cold cream, she mixed the soot into a shiny black substance which she drew across her upper lid as close as possible to the lashes. And she applied lipstick in a most unorthodox manner. I have watched makeup men and actresses struggle for ten minutes or more to get just the right shape to the corner of a mouth, but Carole didn't even use a mirror. She could be talking to me, stick her little finger into a small circular container of lipstick, daub the red on her upper lip, press her lips together and then rub the lower lip with whatever was left on her finger.

She sometimes applied brown rouge to shade her square jaws and emphasize her hollow cheeks. And using her mind to control the muscles of the face, Carole could sink in her cheeks without distorting her mouth; she could also raise her eyebrows without wrinkling the forehead.

One of Carole's problems was her hair—fine as a baby's and not nearly as plentiful as she wanted. Before each photo session she would wash it to make it look fuller than it really was. Loretta Francel, Carole's hairdresser, whom she called Bucket, would set, dry, and comb it out but Carole would always give it the last brush to arrange it the way she wanted it. There were occasions when Carole would brush too energetically and the curls would uncurl. The session would then end with Bucket applying a hot curling iron.

An automobile accident early in her career left Carole with two scars on her face—one by her eye and one by her nose. We always retouched them out and also cut down her square jaw.

141

After she was well established she said to me, "Everybody knows I have these scars and jaw, so leave them."

During a sitting, Carole always gave a photographer her complete cooperation. She loved good photographs; knew about lighting and how to pose; and bought terrific outfits for her sittings. Quite a few stars come into the gallery with perfect makeup, hair done beautifully, wearing the top of an evening dress over slacks or shorts and perhaps tennis shoes or barefoot. Not Carole. *Life* once wanted one of their photographers to make a head shot of Carole wearing a white evening dress. Even though we knew it would not be a large reproduction and though she was off salary, Carole came in wearing a new white chiffon evening gown designed by Irene, evening sandals, new silk stockings, and two pieces of her best jewelry. With a little daub of perfume she walked on the stage. Without the usual slacks, the photographer could shoot her any way he wanted and she gave him all the time he needed.

When Carole began making films at other studios, she would often arrange to borrow me from Paramount to supervise her photographic sessions. Only once did I ever see her kick up a fuss. I was to help Carole on a Warner Brothers sitting with their French star, Fernand Gravet. The first appointment on this day for Carole was to be a short session with Louise Dahl Wolfe, a great photographer from *Harper's Bazaar.* Carole went to the Dahl Wolfe sitting with great anticipation, expecting to wear some glamorous evening creation. Instead, the editor of the magazine handed her an inexpensive housedress, obviously to please a manufacturer who bought pages of advertising in *Harper's.* Carole refused to wear it and went to her dressing room. I followed in a few minutes and explained that any picture by Dahl Wolfe for *Harper's* was worth doing. She saw the point, and the picture of Carole in the ordinary little dress with her sheep dog hit a full page.

With her keen interest in photographs, Lombard planned every still sitting with almost as much care as she put into a screen role. Perhaps a week before every session, Carole and I would meet to discuss the type of photograph, the backgrounds, and what wardrobe she would need. For our meeting on *Hands Across the Table* I racked my brains to come up with some unusual way to shoot the advertising stills. Finally I had it: action pictures. This was before the days of small cameras and we had to shoot with 8×10 negatives anyway. Our 8×10 cameras that were used on the sets came equipped with focal-plane shutters which could be attached to the back and permit exposures up to a thousandth of a second. They were seldom used because only direct sunlight supplied enough light for the fast exposures. The great noise they made when the shutter was released sounded as if the camera were falling apart. At our meeting I explained the idea to Carole and she thought it sounded great. We would take these against plain backgrounds of the studio and she would dress in evening gowns and furs. One afternoon when the sunlight was at its most flattering, Carole, Fred MacMurray, and our photographer, Bill Walling, went to work. Carole and Fred walked, ran, talked, squinted in the sun, laughed, and mugged for the camera. Although the pictures had been intended only for poster art, the magazines published them and our New York office asked for this type of art on all future comedies. Other studios soon copied our idea.

John Engstead and Carole Lombard *Carole Lombard, posing for* Lux *soap ad*

Carole and I would try to give every sitting a different feeling. To give us new ideas, we would each bring in clippings of photographs we liked. Once we did a sitting of Carole in tweed suits and coats. Another time we photographed at the ranch of Clark Gable's attorney, with Carole feeding horses and actually milking a cow. For this sitting she had Travis Banton design plaid slacks and loose tops, which she paid for herself. Most of her clothes were bought with photography in mind. At one time she returned from New York with a very large, black Lily Daché hat.

"It's marvelous," she told me. "Sits straight on my head and has a thin band of black lace around the edge. I can only wear it for photographs. Pappy [Gable] doesn't like it."

Another time Carole said, "We haven't done any leg art for a long time. Let's do some bathing-suit pictures." Although she was then divorced from Bill Powell, they were good friends and Carole suggested using his pool. Rummaging around his bath house, she found an old white cloth sun hat she'd left behind. The only drawback was that the hat was two years out of style; it had a short brim in front and a long one in the back. Carole played with it, putting it on backward, bending the long brim back off her forehead and over the crown. It looked great, so we photographed it, and the pictures were printed. Whether by coincidence or not, hats with big brims bent off the face began to appear the following season.

In her eight years at Paramount, we released more than 1,700 portraits and countless set stills of Carole.

Strong as she was in the front office, Carole was the exact opposite with her friends and studio workers. Assistant directors never had trouble getting her on the sets on time. After lunch, she would never wait around her dressing room to be called but would walk back to the set at least ten minutes early and joke with the members of the crew while they waited for the

143

director and the rest of the cast. When a wardrobe girl would forget a belt, a coat, or any piece of Carole's outfit, Lombard was quick to say that she herself had misplaced it, to protect the girl's job.

Many studio workers knew the help and assistance Carole gave them. One electrician lost a leg in an airplane crash on route to a location. When he returned to Paramount he was promised a job for the rest of his life but a couple of years later, with the changing of department heads, the man was quietly laid off. Carole got wind of this and marched into Ernst Lubitsch's office. "I know you don't know about this, Ernst, but . . ." and she told him the story. "I'm going to start a picture on Monday and I want to see him on the set. He's not able to go on the catwalks but he's perfectly able to handle the lights on the floor." And the electrician continued to work at Paramount for years, long after Carole died.

One night after the theater we talked until 4 A.M. Carole told me her philosophy of life and love. "Everybody thinks I was wild at the age of twelve," she said. "You'd be surprised how old I was before I had an affair. Never has it been just for a night or a week. I've always been in love with the man. And I've always learned something from each of them.

"Bill Powell helped me with acting, reading plays and biographies. We'd read lines together. He'd coach me on my parts on the screen. With Russ Colombo it was music: I really learned about rhythm from him. . . . You know his mother never knew he died. I'd write letters to her and have them mailed from London. She was a wonderful lady but not well . . . and it would have killed her to learn of the tragedy. From Robert Riskin I learned the most—about writing, construction, and dialogue. I can really discuss a script with a director now.

"I think a girl should give a tremendous amount to the man she loves . . . adapt her life to his. You know I hate to camp out. I'm not the type for bugs and dirt. But if I married a man who liked to hunt and fish, I'd learn about it. I'd take lessons. I'd have the best hunting jackets made and I wouldn't wait for my guy to decide to go hunting. I'd suggest it first."

Two years later, when she married Gable, that's just what she did. When she first started to go with him she said to me, "You'd die if you knew who I was with last night . . . but I'm not going to tell you," and she giggled. A while later she told me and before long she and Gable were in love.

Carole gave very few parties but once or twice a year she would throw a bash that earned her the reputation as one of the town's best hostesses. An invitation to me to one of her parties would always be "Come to my party but don't bring a photographer. I want everyone to come to my house and enjoy themselves and not worry about how he or she will photograph."

Carole once gave one of the largest and most unusual parties Hollywood ever experienced, at the Fun House at Ocean Park. She took over the whole place for one Saturday night. There were two bars, hot dogs and hamburgers, and coveralls for the guests to protect their clothes when going on the rides. She would only allow two Paramount cameramen to shoot, and only if she herself could kill any objectionable photographs. All the newspapers and magazines

were advised of her orders. Many press photographers came anyway, assuming that their pal Carole would let them in, but security guards held their line. The photographers had their revenge the next time Carole and Clark attended a Hollywood premiere. As they made their entrance all the newsmen laid down their cameras, which hurt Clark and Carole because they had always had a very friendly relationship with the press. But the boycott was short-lived, since photographs of Hollywood's two top romantic stars sold newspapers and magazines.

I saw less of Carole once she married Gable, since they lived a very private life on their ranch at Encino. I worked with her on her first big sitting with Clark at the ranch. That was quite a day: photographers from MGM and RKO, where Carole was working, publicity men, wardrobe men, Carole's hairdresser, cars, trucks, drivers, and grips from each studio. I was there to put in my two cents worth for Carole.

In 1940 RKO asked me to do a sitting for *They Knew What They Wanted.* Carole and I had met three days previously and decided on the props, backgrounds, and dresses. Then at seven o'clock on the morning of the session, I learned that Carole had been called to shoot an added scene that morning but would be ready for us at one. Any other actress would have postponed the whole thing until another day, but Carole knew how much anticipation there was for this sitting. She appeared precisely at one o'clock. She had washed and set her hair again and applied new makeup, thus transforming the waitress from *They Knew What They Wanted* into Carole Lombard. With many changes of wardrobe and backgrounds, we worked until seven o'clock that evening, making, I would say, about one hundred shots. In fact, all the portraits of Lombard that appear on these pages were made that afternoon.

In December 1941, Carole called to ask me to come out to see her at the ranch. It was soon after I'd been fired by Paramount and my time was my own.

When I arrived at the ranch, Carole was upstairs in her bedroom. She had been ill and while recuperating she had been making plans. She knew I wanted to be a director and had a scheme she'd concocted with her agent, Nat Wolfe. He would also be my agent. One of the clauses in her next contract was that the studio had to take me along with her, not necessarily to work on her production, but on one being filmed by a director she approved—Hitchcock, Wyler, La Cava, or Capra. I would be called an apprentice director, with no salary, just an expense account (the idea behind this being that if you establish salary in Hollywood it is difficult to increase it). She proposed that after a few pictures as an apprentice, Nat would take me to Republic or some other lesser studio and sell me as a director. Eventually Wolfe would bring me back to the majors.

When I arrived home there was already a message asking me to come and see Nat Wolfe the next morning. He repeated Carole's plans and said he was happy to handle me. But I never saw Carole again, and her generous plan was never put into effect. Less than a month later she was killed in a plane crash. Nat went to war and I kept on photographing.

Other Stars, Old-Timers, and Kids

DURING MY CAREER I HAVE PHOTO-graphed quite a few stars who reached their pinnacle some years earlier, and my respect for these smart professionals grows with every sitting. Screen personalities of the silent era, for example, had to be completely self-reliant. I got a load of Gloria Swanson's savvy when I photographed her with her daughter and granddaughter in 1949. By this time Swanson had gained a few pounds, and the sample evening dress she was to wear had been made for Howard Greer's 105-pound models. There were about three inches where the dress didn't meet at the side. Gloria pinned the dress as best she could, but still there was a bulge showing in front. As we prepared to photograph, Gloria solved the problem by sitting with the good side of the dress to the camera and holding the baby on her lap to cover part of her body.

In the late 1940s, I was asked to do a sitting of Theda Bara, the original vamp of the movies, for a series of "living legends" being photographed for a *Harper's Bazaar* layout. Now the wife of MGM director Charles Brabin, Theda had long ago given up acting those wicked sirens. From the outside, Miss Bara's house appeared to be a nice little bungalow on the good side of Beverly Hills. Inside, though, it was still 1918 Hollywood. Heavy carved furniture, a mohair lounge, deep wine velvet curtains, and at one end of the room was a life-sized painting of Mr. Brabin dressed in riding clothes.

Miss Bara was very cordial and brought out her old stills, including one with her hair

<center>149</center>

*Gloria Swanson (seated), with her daughter
and granddaughter, 1949*

D. W. Griffith, 1946

down over her bare shoulders. She was sulking and petting a human skull as she leered into the camera. "In those days," she said proudly, "we didn't have publicity men and I thought up this pose myself."

Now, for *Harper's*, Mrs. Brabin rolled back the years and her publicity-conscious mind began to work again. She excused herself to change and returned wearing a lace negligee with her long hair hanging loose and seductively around her shoulders. She wanted to be photographed in front of Mr. Brabin's painting. After this was recorded, I suggested a simpler change.

When the magazine appeared, Miss Bara called me immediately. Boy, was she mad! The same layout had a photograph of Pola Negri, and in the caption she was described as the first vamp of the screen. That was when the fat hit the fire. "I was the first vamp of the screen! Pola

Theda Bara, 1951

Zasu Pitts, 1940s

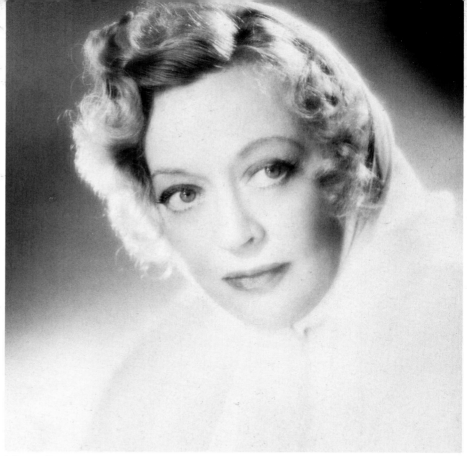

Marion Davies, 1960

Negri copied me. Something has to be done about this. There must be a retraction." I explained to her that I only took the photographs and did not write the captions. Two weeks later she called again, still disturbed at the caption, but to order prints of her photograph for her friends.

The most important star of the silent era was Mary Pickford. Cecil B. DeMille once said that if he could take his choice of anyone as a business manager—and that included Samuel Goldwyn, Louis B. Mayer, and all the brains of the industry—he'd take Mary Pickford. The story was that this little lady would come alone to the business meetings of United Artists, attended by Charlie Chaplin, D. W. Griffith, Douglas Fairbanks, and all their lawyers, business managers, and accountants. But Mary came with nothing but her brain, where she had all the information concerning receipts of her films from all over the country and just what her percentages should be.

I had a taste of her shrewd mind when I did a sitting of Mary in 1954. The telephone rang and a woman's voice asked about my prices. "What's the minimum?" I told her $200 for five poses. The voice said "Thank you" and hung up. A little later the same voice called back. "I'm calling for Mary Pickford. I'd like to make an appointment for her—a $200 sitting." When Miss Pickford arrived she had the same washboard hairstyle she had worn in the 1920s. I figured that was the way she wanted it; anyway, who was to tell the most popular star the screen had ever seen that she was a little out of date. And if I did, how was she going to take the curl out of her hair?

Franciene retouched half a dozen negatives and we made 11 × 14 proofs. When I went to Pickfair to show Miss Pickford the results, she looked at them and after her selection said, "Now when you retouch these, please thin the neck, take a little off the shoulders," and went on with

152

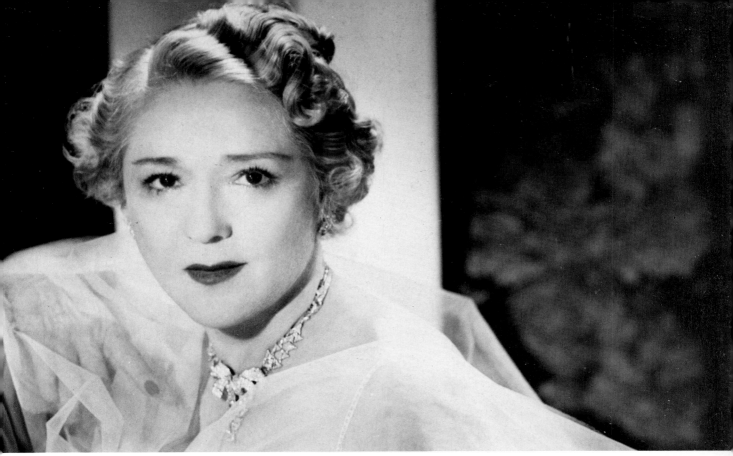

Mary Pickford, 1954

such expert instructions I felt she might be able to do the retouching herself. As I left she said, "I really don't like my hair so curled and stiff—I wish you had told me."

Another star of the 1920s and '30s with the same tight hair was Marion Davies. "She's wonderful and crazy and I'd like you to meet her if she is home," said Carole Lombard in 1935 as we drove to Miss Davies' tennis court to make pictures. Marion wasn't home so our meeting was delayed—for twenty-five years. In 1960 the generous Miss Davies had given part of her fortune to build a wing of a hospital at the University of California at Los Angeles. Because she did not want flash pictures, her publicity representative called me. "Bring all your lights," he said. "We're going to photograph Marion, the Chancellor of UCLA, and Weldon Beckett, the architect."

When we had made the news picture, Miss Davies asked if I could stay and make some portraits of her. She had the same tight hairdress that Mary Pickford disliked six years before. But I had learned.

"Can you loosen your hair?" I asked.

She combed it out the best she could and lightened her lipstick. To be sure not to make a mistake, I asked her to put a scarf around her head. All during the sitting, Marion daubed at the corner of her mouth with a handkerchief. "I'm having tooth trouble," she explained. It was the beginning of cancer which took her life only a year later.

Lillian Gish is from the same era as Mary Pickford and Marion Davies. The only difference is that Miss Gish has been active continually for about three quarters of a century. She's like every true professional—not one bit of trouble. She wears very little makeup, her hair is done simply, and she dresses in very good taste. Her enthusiasm is tremendous.

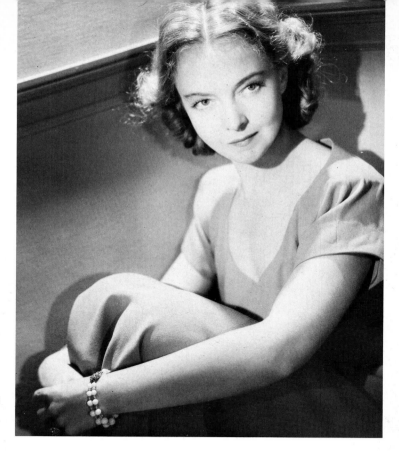

Lillian Gish, 1943

Peggy Lee, 194

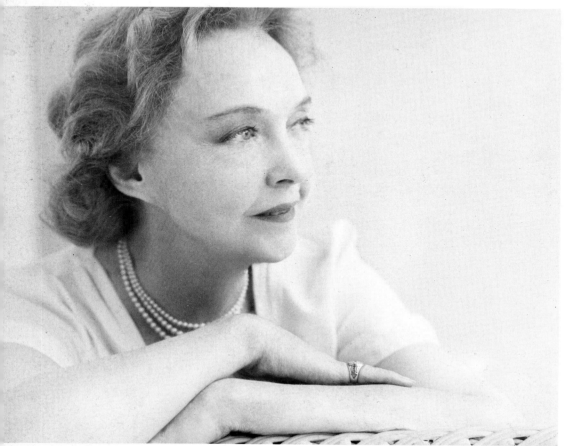

Lillian Gish, 1968

Peggy Lee, 1970

After her first sitting in 1946, Miss Gish sent in her friend, D. W. Griffith. At the sitting I felt a little silly trying to direct the first great director of films. I told him I wanted to be sure to photograph his mind as well as his face.

He smiled, "That's exactly what I used to tell my actors."

■

The camera, of course, is not partial to any age group, and I have spent a lot of time photographing children. After my first difficult sitting, photographing a baby, Judy Lang, with an 8 × 10 camera, I invested in a Graflex, with which I could follow the young ones around and keep them in focus. Any small camera is good for shooting youngsters. When Judy's father,

Margaret Sullavan and her children, 1943 (Brooke Hayward is second from right)

Paramount's ace cameraman, saw the proofs, he gave me a very good tip, to print kids' pictures on the light side—children should always look sunny and bright.

In the 1940s, magazines increased their use of stars and their children, and also layouts with the offspring of Hollywood modeling clothes. At the beginning of World War II, *Harper's Bazaar* thought it constructive to show the substantial family life of the country and Hollywood in particular. And so the first assignment from them was to photograph charming Margaret Sullavan and her three little tots, Bill, Bridget, and Brooke (the latter recently wrote about the saga of the Hayward-Sullavan home life in her successful book, *Haywire*). This time I used my Graflex. For the first photo, Margaret sat down on the side steps and pointed to a bird in the tree and that was the picture that was published. Next they all lay in a line on their stomachs on the grass. Margaret had a great idea for the nanny to put three glasses on the porch railing in front of them. "Now pour Bill's Coke," said Margaret, and those great little faces looked up as I shot. With the pouring of each Coke I snapped another good picture.

Margaret never asked to see the proofs, so I immediately sent the enlargements to

Debbie Reynolds and her children (Carrie Fisher on left)

Charley McCarthy, Candice, and Edgar Bergen

Candice Bergen, 1950

Candice Bergen, 1962

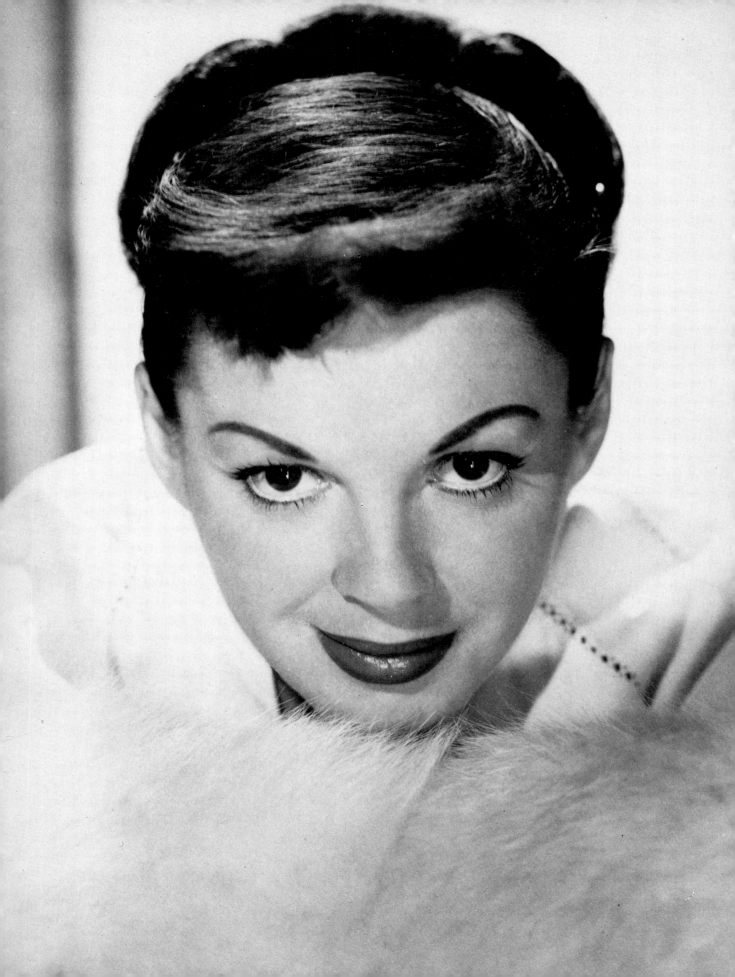

Harper's. That night Margaret called and I told her that the photographs were on their way to New York. This was the angriest woman I ever talked to: "You probably rushed these pictures to *Harper's* because they're no good. You didn't want me to see them."

When she caught her breath, I said, "I have the proofs for you to see."

Half an hour later her driver was at my door, and as soon as she saw them she called again.

"I love them. Use any picture you want," said Margaret. "Can I buy some prints?"

Debbie Reynolds always gave her children enormous personal care. When she called to make an appointment for me to make the first sitting of Carrie, she asked, "What time do you want to do it?" My answer was, "It's not when I want to do it, but it is when Carrie is in the best disposition."

Debbie thought a minute. "Eight o'clock in the morning. Can you be here at that time?"

Debbie was up at six o'clock in the morning to feed and bathe Carrie in preparation for the sitting, and we all tiptoed around because Eddie Fisher was still asleep in the next room. This was a sitting of Carrie alone and that morning Debbie looked like any young housewife without makeup, hair pulled back, and dressed in a short cotton wrapper.

A couple of years later when Todd was born, the fan magazines doubled their efforts to publish photographs of Debbie and the children. The requests became so numerous that she fi-

Judy Garland, 1942

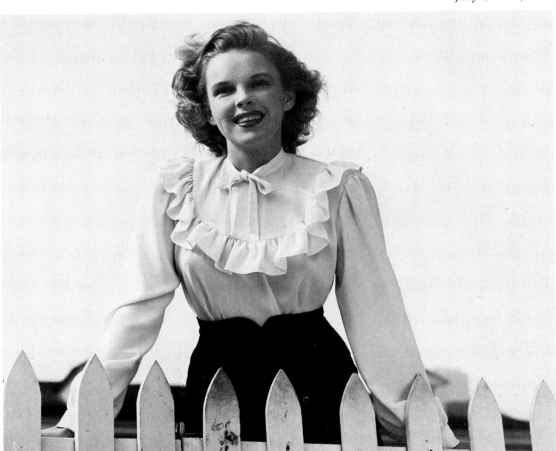

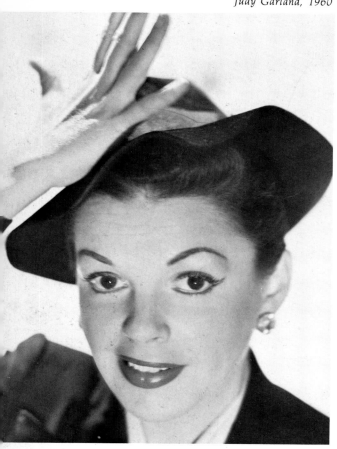

Judy Garland, 1960

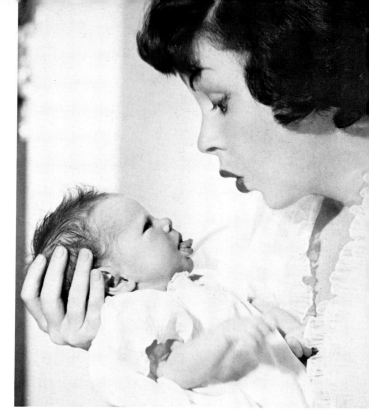

Lorna and Judy Garland

Liza Minnelli, 1951

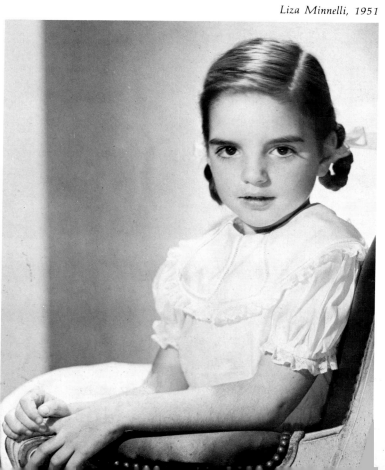

Liza Minnelli, 1967

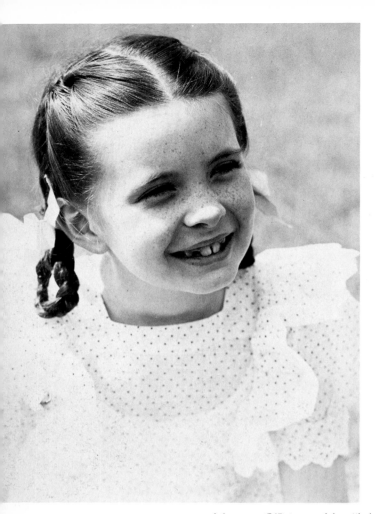

Margaret O'Brien, and her "baby teeth," 1943

nally agreed to have me do a sitting for *Photoplay*. During the shooting, she changed her mind: "I've decided not to give these pictures to the magazine," she said. "I'll pay for them. I want my children to have a normal childhood and not be recognized or asked for autographs when they go to the market, the theater, or anyplace."

Believe it or not, the most naturally beautiful girls I found were daughters of motion-picture people. The children of Ricardo Montalban, Ann Sothern, Hedy Lamarr, William and Margaret Wyler—all were lovely children. Magazines were always returning to the idea of "the children of the stars." I met Candice Bergen, age four, when she modeled for *Mademoiselle*. One year later she posed with her mother for *Ladies Home Journal*. And eight years later I photographed her again for a mural at the entrance to the teen-age department of the Meir and Frank department store in Portland, Oregon. When she was sixteen, Candy began modeling as a profession. She came to me to pose with her face loaded with makeup, copying the most sophisticated New York models. She is much better with almost no makeup and has a great talent for moving in front of a camera. To promote a commercial for Celanese Corporation, *Seventeen* used as its frontispiece three Hollywood teen-agers: Mia Farrow, Tisha Sterling, and Liza Minnelli. We all met at a designated hill in Elysian Park, near downtown Los Angeles. Liza, shaking and trembling, was the most nervous of the group. During the lunch at the Brown Derby with the

Margaret O'Brien

editor before the shooting, Liza was full of enthusiasm and confided in me that she was going to be an actress. I wondered how this plain-looking little girl would ever make it. But did she! This proves how hard work and belief in yourself can bring success.

I remember the first time I saw Liza's mother. Every Sunday night at the Trocadero was beginners' night, when talented unknowns came to do what amounted to an audition because on that night the place was filled with producers, directors, and actors and actresses. I happened to be there the night Judy Garland sang. It was 1935. She came out with pigtails and a jumper dress and when she finished her song the applause, the whistling, the stamping were tremendous. It was all Joe E. Lewis, the master of ceremonies, could do to introduce the next act.

It was seven years later that I photographed that little girl for the first time. Mrs. Snow was determined to have this young superstar on the pages of *Harper's* and arranged a sitting with her at Metro. It followed the usual MGM pattern. We were allowed twenty minutes of Judy's time, told that Judy would wear her own dress, and also informed that we could photograph on the *Andy Hardy* street on the back lot.

The next sitting, at Judy's request, was entirely different. I was allowed all the time I wanted. At least all the time Liza would allow, because this was a 1946 sitting of Judy and her first baby, for *Photoplay* magazine. Young children can screw up their faces, start crying, and

June Allyson and her son, Ricky Powell, 1952

June Allyson and Ricky Powell, 1970

James Mason with Portland and Pamela

plainly tell you it's time to pack it up. The sitting was at Judy's home and there was none of the MGM entourage around—only Dot Pondell, Dietrich's makeup wizard from Paramount, who at that time was working with Judy. Dot was in great form: singing, laughing, throwing pillows about, rolling on the floor and keeping Liza and Judy in a happy mood.

It was six years before I did another sitting of Judy, and every one of those years had added more problems to the life and career of this troubled star—until MGM finally released her from contract. After a cooling-off period, Judy regained her confidence, pulled herself together, and began a tremendous second career on the stage of the Palace Theater in New York. And to let the film industry know firsthand that she wasn't down for the count, Judy brought her SRO show to Los Angeles. At that time she came to me for a sitting.

"Look at me," she said as she came in, "a fat old lady." She *was* fat, but still only thirty

Jennifer Jones and sons

years old. She wore the sparkling wardrobe she used in her act but there was nothing to use for informal shots. So I brought out a couple of blouses—inexpensive things I kept for emergencies. Judy took such a fancy to one two-dollar blouse that I gave it to her; the way she carried on, you'd have thought it was the Hope diamond.

From then on we did quite a few sittings together, one to publicize *A Star Is Born* and several for her concert tours. She was always agreeable and almost always happy. There were the usual postponements, late arrivals, and loud music. At one session her favorite of the moment was a Frank Sinatra single, "All of Me," and she had it played all afternoon with the hi-fi turned to full blast. It was so loud that Judy couldn't hear me talk from four feet away. When I wanted her to change position or expression I had to go up and almost yell in her ear.

During each sitting with Judy, she became happier as the afternoon progressed. There

Jennifer Jones, 1956

Henry Fonda, 1962

Charlie Chaplin and family, 1948

Henry Fonda and family, 1948 (Peter and Jane in tree)

Chester Conklin, 1952

was the usual grapefruit juice and vodka between changes, but she would stay as long as necessary to do a good sitting.

We did a few sessions with the family at her home. Judy loved her children and enjoyed doing sittings with them. At the end of each photographic session at our studio, she'd usually call home and have Lorna, Joe, or Liza brought down for a few shots.

One day the telephone rang: "It's Judy. . . . I'd like you to come over on Saturday to make some pictures of me and the children." I had other plans for Saturday so I said, "Can't we make it some day during the week?"

"No, please come Saturday. Liza is home from school . . . Please . . . Please . . . Come at 1:30 . . . Please." So Bill and I loaded up the truck with lights, strobe, and the works and drove to her house on Saturday.

I rang the bell and the maid came to the door and gave me one of those what-are-you-selling looks.

"We're here to make some pictures of Miss Garland."

oan Bennett and her daughters

Chester Conklin, 1965

"Well, she's not here."

"Are the children here?"

"No. They're all away."

"We're supposed to make pictures at 1:30."

"Nobody's here except me. When did you make this appointment?"

"Last Tuesday."

"Oh, that's it." She rolled her eyes heavenward. "She can't remember. You should have talked to her yesterday or she'd never remember."

We went home and Judy never remembered and never called. It was another year before we made the next sitting.

At the lowest point of her career, Judy owed me $800. The bills were ignored; there was no use suing Judy when she was already plagued by lawsuits of designers, hotels, and restaurants. She had no money and I wouldn't add to her bad luck. But I never could forget this cute little girl in the jumper dress at the Trocadero that Sunday evening.

174

On Photography

TO BEGIN WITH, I NEVER PLANNED TO be a photographer, and I certainly never thought I'd get tied up in the fashion end of the business. But after my photographs began to appear in *Harper's Bazaar* in 1942, there were so many assignments coming my way for fashions and advertisements that portraits had to take a back seat. And because I never wanted to limit myself to any one type of photography, I was encouraged when *Life, Look, Collier's,* and *House Beautiful* asked me to do sittings of personalities.

Because a photograph is a permanent record, I feel that it is important to present subjects at their best. You can look at a portrait for an instant or for an hour; you can study the pores, the lines, and the blemishes that are not nearly so noticeable in reality, when the face is warm and animated.

It wasn't long before friends would say, "I saw the portrait you took in the newspaper and I could tell it was yours without seeing the credit." This bothered me for a while because I thought I was falling into a rut. But later I realized that this is a compliment, because the characteristic feature of my work that people noticed was the soft beauty I would highlight when photographing women. I am against showing every wrinkle in the name of "realism." I prefer to have certain imperfections softened by retouching—but not so much as to take all the character out of the face. It should not look as if it had been lately plastered (and I don't mean drunk).

The retouching of negatives requires an expert and I have had one for thirty years

Annabella and Tyrone Power, 1942

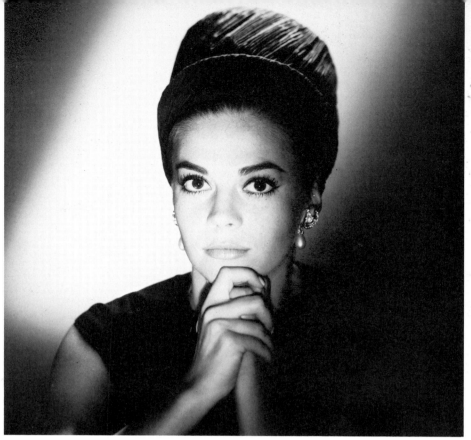

Natalie Wood, 1958

in Franciene Watkins, who can do such careful corrections that no one can tell the face has been touched. She uses a fine point on a retouching pencil to lighten the dark spots of blemishes and a few wrinkles with infinitesimal additions of lead. To darken any area of a negative requires etching with a knife—carefully scraping the emulsion from the dark areas. Dirty teeth can be cleaned or a tooth can be put in or straightened; eyes can be matched up if one is larger than the other; and crepy, wrinkled necks can be uncreped. It is also amazing that babies have pimples and lines their mothers want removed.

In order to permit this type of retouching, I use 4 × 5 and 5 × 7 film—the tougher the subject, the larger the film—and this requires larger cameras. Soon after I began to shoot pictures seriously, I had two cameras that required tripods: the 8 × 10, which could be adapted with a change of back to accommodate 5 × 7 or 4 × 5 holders; and a Graphic view camera. On many sittings I carried a Graflex. The Graflex, a hand-held camera approximately 8″ × 8″ × 8″ and weighing nine pounds, is seldom used today, but in the 1920s and '30s it was the standard camera for all sports photographers. On the back of each Graflex was a magazine with either twelve or eighteen very thin metal film holders that were manually slid in place for each shot. The film could be exposed for periods of from half a second to one thousandth of a second. This was great to use for following children and for action shots, and unlike the tiny spools in today's small cameras, the 4 × 5 film was large enough to allow corrections.

One of the first things I learned was to choose the appropriate camera to maintain the right tempo of a sitting. June Vincent, a New York model then under contract to Universal Pictures, educated me. When we were preparing to shoot an evening dress in a garden, June suggested that I use the portrait view camera on tripod because it was a slower camera to manipulate and this would give her time to find the best angle of the dress and a quiet pose. And

178

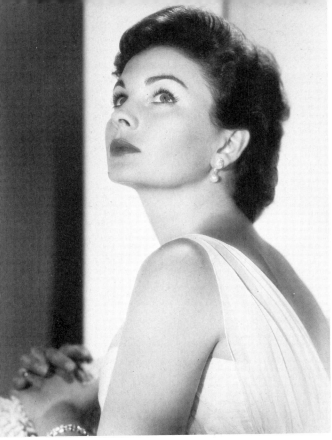

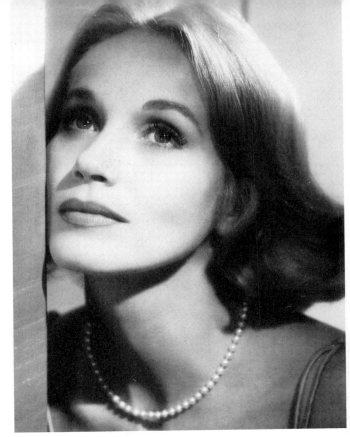

Jean Simmons, 1959 *Eva Marie Saint, 1958*

when June wore tennis shorts or bathing suits, we used a Graflex to speed the tempo of action shots.

At the beginning of World War II, film was rationed, which meant that I could buy more 4 × 5 and 5 × 7 film than 8 × 10—and not too much of them, either. I would do four or five exposures for a fashion shot and perhaps a dozen for a portrait sitting. Color was coming into wide use and I began to use Kodachrome film, which had one third the speed of black-and-white. I had to find poses in which the subject wouldn't move during the one-fifth and half-second exposures. And these were fast compared to the ones of the first color photographs of the early 1930s. At that time, three separate negatives, recording the three primary colors, had to be exposed. I remember one character, a former Sennett photographer, who invented an amazing contraption to make color pictures. I had to trot our stars up to his studio so their faces could be on magazine covers. He actually put the head of Claudette Colbert in a metal clamp. On the back of his enormous 8 × 10 camera he had a big wheel about four or five feet in diameter. As Claudette tried to look fetching, with her head in this vise, the photographer would yell "Still! Still! Still!" while he rotated his big wheel and brought each of the three color plates in position, exposing each one. It was the damndest thing you ever saw.

The quality of the early Kodachrome film varied from one batch to the next. With each new emulsion number, we'd make tests and if one series turned out to be too blue or too yellow we'd either send it back to be replaced or use a correcting filter. Eastman, who made the film, had technicians who would argue that our studio was causing the color change. But whether I shot on location in New York or Texas or in a star's home, the same undesirable tones would appear. Finally Eastman developed an improved color film, Ektachrome, which was consistent—i.e., without color shifts.

179

Indoor or Type B Ektachrome is exposed with the subjects lighted by 3,200-Kelvin lamps, the same lighting technique that I use for black-and-white film. Daylight Ektachrome was designed for natural light and, in the 1930s and '40s, was used with flashbulbs for instantaneous exposures. The drawback to flashbulbs was that I usually used three or more sources of light and these blistering hot bulbs had to be changed (with gloves on) between each shot. Worse than that, sometimes they exploded. During a Shirley Temple sitting, I had a flashbulb four feet from her face. When I pressed the cable release it sounded as if a bomb had exploded. Fortunately the shattered glass flew only a few feet, and Shirley went on with the sitting after she caught her breath and I moved the bulbs back away from her face.

I find that one of the most interesting aspects of photography is proofing and printing after a sitting is over. It is always interesting to watch the prints of photographs come up in the developing fluid in the darkroom. It was at Paramount, about 1934, that I began to learn something about printing photographs. Whenever I wanted some special effect—perhaps combining two or three negatives on one print, I would go into the darkroom and work with the printer. Later, during my first months as a photographer, all my negatives were not perfect exposures and Christy and Shepherd's good-natured old printer would throw up his hands at the tricks he had to perform to save some of my negatives.

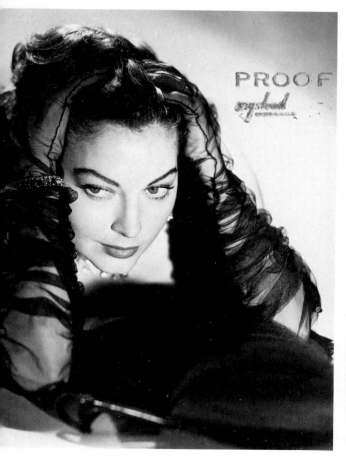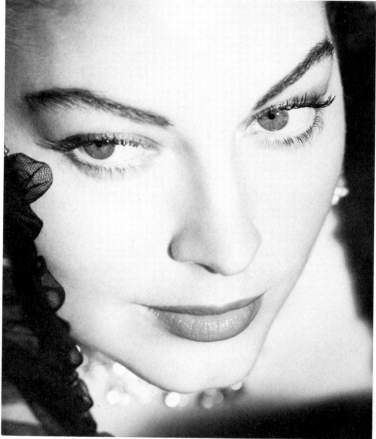

Ava Gardner, 1951, and same photograph enlarged and cropped

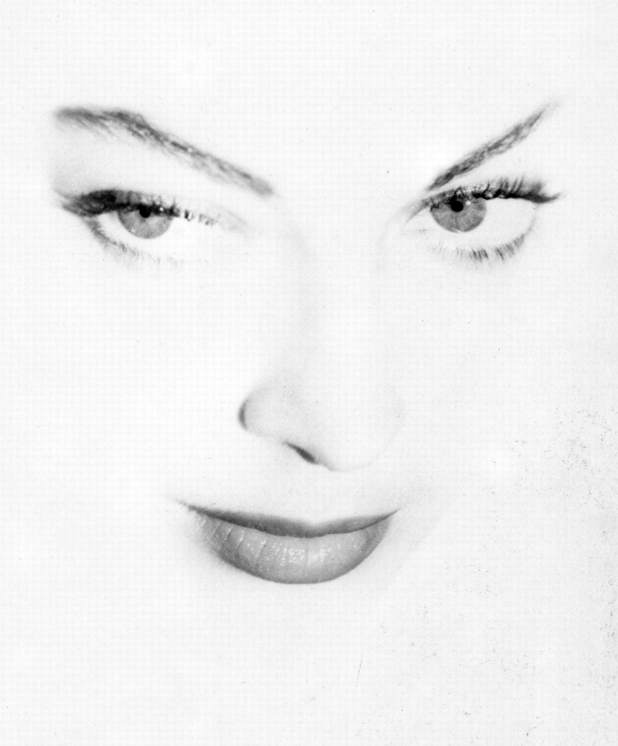

Once I began to print for myself, in 1945, an 8 × 10 Saltzman enlarger was an important purchase. This massive nine- or ten-foot-high steel contraption has a rigid table with an enlarging apparatus above it that accommodates anything from a 4 × 5 to an 8 × 10 negative. I hired a full-time printer when I began to work almost every hour of the day (and some nights). Now my staff consisted of Franciene; the printer; Otto Stubbs, to take care of the office; Bill Hennigar, to assist in the gallery; and another man to develop negatives and dry prints, etc.

If my photographs have an individual stamp, it could be the result of the way we print. In my darkroom we always try to give a creamy texture to the faces of women. Part of this is the product of the reflections of a white gallery, and part is obtained by slight diffusion in printing—holding for a short period a ring of net or even a piece of crumpled cellophane between the lens and the paper. Selecting the right contrast paper helps. I also learned the trick of dodging—holding various-shaped pieces of cardboard attached to wire handles over parts of prints I want to lighten. For instance, many times the area around a woman's mouth, chin, or nose photographs darker than the rest of the face. If this happens I hold the darker section back. When highlights are too bright (most often in the hair) I give this extra time in printing to bring it down to the density I want.

The greatest invention since the camera, in my book, was the development of the strobe light. In the early 1950s I had an elaborate setup of power packs and lamps sent from New York.

Paul Newman and Joanne Woodward, 1961

Joanne Woodward, 1960

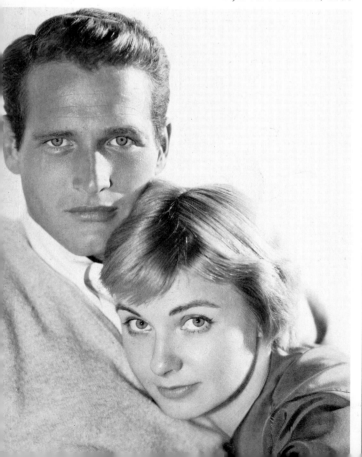

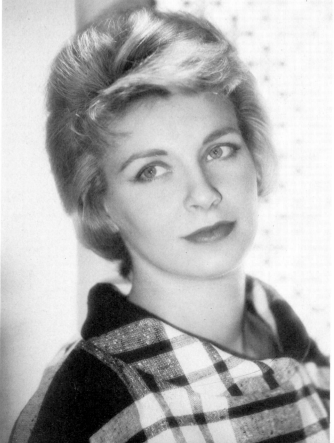

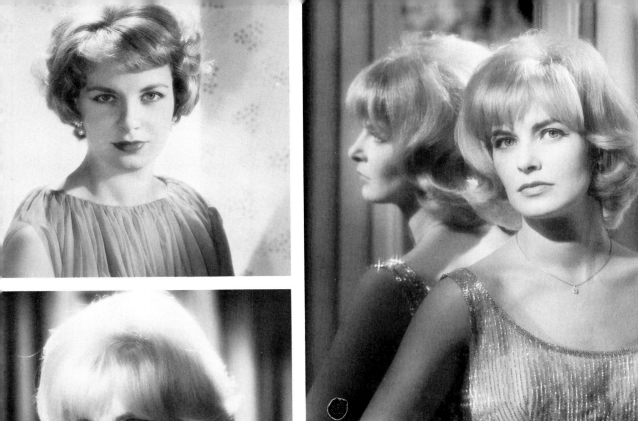
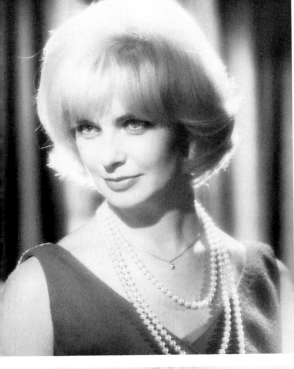

Olivia de Havilland,
The Snake Pit, *1947*

Olivia de Havilland,
1965

Claude Rains, 1935

The advantage of this big strobe was that its electronic flash went off at about a ten thousandth of a second, which meant that I could catch Fred Astaire flying through the air. The two drawbacks of this equipment were the very loud bang when I shot, which would startle the subjects, and the fact that after each exposure you had to wait about thirty seconds for it to recharge before you could make another shot. In that long pause the excitement of the sitting would frequently evaporate and I would have to start all over again to build up the tempo. Within five or six years engineers had developed a smaller and more portable strobe. Today I can shoot this about as fast as I can change the plate holders. This is great for groups of people and for catching spontaneous expressions during portrait sittings. Many photographers use only this type of light. But I think sticking to one type of lighting tends to make for too much uniformity in photographs. It's almost as if you had your lights nailed to the floor (and I've seen this done).

Today the majority of professional work is done with small cameras because the lenses have greater depth of focus, the film requires less light, the exposures are faster, and the photographer can follow the subject. Traveling with a 35-mm or a Hasselblad camera requires a minimum of equipment and gives you freedom to shoot loads of film. When it comes to making any corrections on a face, retouching will show from work done on the small film and a generation of quality is lost in the transference to a large negative to permit corrections. Sometimes airbrushing is done on an enlargement and then this has to be copied, but again quality is lost if any number of prints are made.

The 35-mm cameras are used exclusively on motion-picture sets today because they can be shot at the same time a scene is being filmed; the difference between these fantastic action pictures and the old posed shots is like that between night and day.

185

Olivia de Havilland, 1976

Elizabeth Taylor, 1943–48

I shoot 2¼ × 2¼ film with a Hasselblad camera for children's pictures and for certain advertising jobs, but when the public relations people bring their actors to me they usually want larger transparencies to impress the photo editors of newspapers and magazines, who receive an abundance of 35-mm slides.

With the requirements of television companies to supply various newspapers around the country with original color negatives, hundreds of pieces of film are exposed during a sitting. With an assistant handing me plate holders, I can shoot twenty or more in a minute. That is, if the subject can stay in the same place! And that's the rub with the big camera. A slight change of position, forward or back, and he'll be out of focus. If he shifts a little to one side, half his face will be out of the picture, so he has to remain still. This takes a little self-discipline. Stars of the 1930s and '40s quickly learned this technique; they had to if they wanted to be photographed.

Paul Newman and Joanne Woodward made a sitting together at their home in the late 1950s. Neither had any problem sitting for a 4 × 5 camera. Joanne was always easy about this and got better at it as time went along, but the reverse was true of Newman. In the early 1970s he was signed to do a racetrack special for Coca-Cola. It was to shoot an 8 × 10 color photograph of him to be blown up to life size for retail outlets across the country. The large negative was required by the art director because of the enlargement. Moving around, Newman said he hadn't been photographed by a camera on a tripod since 1961, and the executives said to me, "Just keep shooting. We'll get something." Eventually we did, but it was a struggle to get two of the thirty exposures in focus. I feel that an actor or actress who receives good money for a film commercial shouldn't be uncooperative about posing for a still to sell the product.

Grace Kelly, 1950

In order to do advertising photographs with ease, I built my own studio in 1948. Magazine editors who have worked with photographers in Paris, London, and New York have told me that it is the best studio in the world. It was designed by Casper Ehmke to take advantage of California's sunlight. The shooting room is 38 by 40 feet with an 18-by-28-foot skylight. Along the south side there are 25 feet of 18-foot windows. When the curtains are open, a tremendous amount of light floods the room. The floor, ceiling, and walls are all true white.

When a subject comes into my studio, I try to make sure that the first impression is instantly a good one. The acoustics of the large, high-ceilinged room are marvelous, so I have music playing.

I usually begin a sitting with natural light. The communication is easier when the entire studio is light and the subject can see me. Only for certain photographs of men, when I want strong shadows, do I use direct sunlight on the face and then infrequently, because it is a rare eye that can take these intense rays. Sunlight coming down from behind a subject gives beautiful highlights on the hair. With blonde women I usually soften this back light by placing large scrims above the head so the light hair doesn't photograph completely opaque and become difficult to print with texture. We spread black sheets on the floor between the subject and the camera to kill the unflattering reflections from the white floor below. Light from white cardboards or a reflector is used to illuminate the face. With natural light the exposures are fast—many times a fiftieth of a second, which permits me to catch a spontaneous laugh or a fleeting expression. Some sittings, such as the ones we do with Cher, are done entirely in this light. Her eyes are strong and can take almost any light.

In order for an actress to get the most out of her sitting, I advise her in advance to be able to change her hair as many times as possible and to bring different types of clothes. And when I vary the backgrounds and the lighting, no one can tell that all the pictures were taken at the same time. A good example of this is the recent sitting I did of Olivia de Havilland. Edith Head had arranged for us to have at least a dozen changes of wardrobe. Part of the sitting was done with natural light, part with incandescent lighting, and another part on location at Edith Head's home.

To change from natural to artificial lighting, I close the awnings above and pull the curtains. Few photographers today use incandescent lighting. The trend is to strobe lighting because it is easier and more foolproof. It takes a little experience to learn how to blend the degree of light from floods and spots on a subject and a background, and this is one of the techniques you see used on the screen today. The other is light reflected from white screens.

I learned very early that economy of light is most important. One key light correctly placed or reflected on a face is sometimes all that is necessary. A small light about a fourth or fifth of the intensity of the key light, aimed at the subject from just below the lens, softens the shadow from the main light. Most often I used a high key light on Marlene Dietrich and Carole Lombard to accentuate the bone structure. With a full-length mirror beside the camera, these experienced ladies would check me and the elevation of their face so the shadows on the bone structure were right. Claudette Colbert, who also has fine bone structure but a wider face, always wants a lower key light so as not to draw attention to what she calls her apple cheeks.

John Garfield, 1948

A light on an extension boom is used behind and above to highlight the hair. Most actresses know too well what happens when any backlight comes around the face and hits the cheeks or the nose. They are careful to see that it doesn't. A good example of this was the lighting done on Diahann Carroll for a television special a few years ago. Diahann has a very clear skin and is extremely careful about her makeup, but just as she was taping this show, she developed makeup poisoning. (This rash can occur when an actress uses greasepaint for a long period of time. It is easily cured by having a doctor prescribe a nonallergenic makeup.) The male singer with Diahann gave her a big buildup; the set was beautiful; and the music was great as Diahann glided down the elegant staircase in her glamorous gown. Then came a close-up where the cameraman had used a backlight across her cheek, highlighting every abrasion. That's why one superstar today has a mirror beside her motion-picture camera—to see that no more mistakes are made on her.

Flat lighting, where the key light is as close as possible to the lens, is very flattering. It takes out the shadows and is easy on the lines. When there is a ridge to the bag under the eye, the key light has to be just high enough so it will light down into the ridge and wash it out. Crosslight on some men, and occasionally on women, produces strong character studies, depending upon the type of face and how the two lights are blended.

Very often I use the smallest spots available; these have been named inkie-dinkies by motion-picture electricians. Inkie-dinkies throw a small beam and I can make it smaller with the use of Masonite pieces with various-sized holes cut in the center of them. These fit in front of the inkie-dinkies. I use one for lighting a woman's face and another across the bosom, sometimes to make a small situation appear to be something it isn't. If someone's arms are big or she has a stomach that shows, I leave these in shadow and light what I want to photograph. After this, the background is lighted. The execution should be fast indeed. Using a stand-in for the star, a motion-picture cameraman can take half an hour or an hour to arrange the lights; a television cameraman takes fifteen minutes. But the portrait photographer must do it in no more than three minutes—or he has a tired star on his hands.

Josef von Sternberg taught me the importance of creating the roundness to a face by lighting. He showed me how to have a spot fall off and shade very slightly the top of a forehead to show that it is not flat. Von Sternberg also said that a good photograph has tones of pure white and black and all the shades of gray in between. Once, while he was arranging a full-length shot of Miss Dietrich in the Paramount gallery, I noticed some dirt on the floor and asked if he wanted it cleaned before he shot. His answer was, "If anybody looks at the dirt instead of Miss Dietrich, none of us are any good."

The height of the camera can make worlds of difference in a subject's face. A high camera angle can minimize a big chin or thick lips but it is hell on a bald head or a long nose. A low angle makes the figure look tall. With all the rather short actresses in Hollywood who would almost rather be tall than have big bosoms, none of the photographers I worked with knew how to use the swingbacks of the 8 × 10 cameras to add height to a subject. The fronts and backs of these cameras tilt forward and back as well as sideways. Most often these tilts are used to keep

all the sections of the subject in focus. I learned this lengthening process from Norman Carlson, a *Ladies' Home Journal* camera assistant who was working with me on a sitting in Washington of Marjorie Merriweather Post (mother of Dina Merrill). Mrs. Post was not very tall and wasn't "model-thin," which, because we were doing fashions, posed a problem. We were lined up for a shot on one of the walks of Mrs. Post's estate when the editor whispered to me, "Stretch her out." I didn't know what she was talking about. I was at a low angle as it was. Again she said, "Stretch her out." Then Norman came to my rescue and tilted back the top of the back of the camera and did the same with the front lens board. Mrs. Post grew from five foot three to five foot seven in about ten seconds.

Later, I was using this new knowledge of mine on a Marlene Dietrich sitting at Las Vegas. As usual, most all our shots were full-length. The camera was at the level of her head which was the best angle for her face. And I was stretching her out.

"Don't you think you'd better get the camera low?" she asked.

"No, Marlene," I replied. "This is better for your face and I can make you look taller in the camera." She looked skeptical but didn't insist. I knew from her troubled face she thought she'd come out looking like a big-headed midget. But when she saw the proofs she realized that I had made her look four inches taller than she is. No questions from then on.

Every single photograph of Marlene Dietrich that Josef von Sternberg had anything to do with was diffused. The Paramount publicity department could swallow a few portraits of a sitting being diffused, but not every last photograph of one of its major stars. To complaints, von Sternberg would reply, "They will either publish diffused photographs of Marlene Dietrich or

Van Johnson

Sterling Hayden, 1940

special "look" and knew exactly how to turn on the faucet and control the muscles of the face for the best effect. Some looked sweet, some smiled, some looked virile, and some looked tough. No one, for example, ever caught a smile on the face of the first vamp, Theda Bara. Valentino had a trick of flashing his eyes and dilating his nostrils to drive the women wild. Raft modified this same look in the 1930s. Gable found that wrinkling his forehead, squinting his eyes, and smiling produced a devastating look. Joan Crawford concentrated on intense eyes and a wide mouth. Gary Cooper used jaw muscles to show strength and found a little amusement in the face worked wonders. Through Bogart's face came tough strength mixed with some of the "little-boy" look. Tracy had that amused twist to his strong features. Garbo smoldered. For sophistication, Lombard took in her cheeks and raised her eyebrows. And sex rolled out of Marlene's eyes. One thing that all the greats had in common is that they all did some thinking in front of the cameras. The well-trained face of the proficient actor performs as he or she thinks the part.

The technique that most stars have developed for making photographs is to react ever so slightly to an imaginary person when the film is exposed. And I have found that if I ask a person to "think about a smile," it does wonders for producing a pleasant expression that is neither a smile nor a laugh.

Joanne Woodward hadn't mastered posing techniques for stills when she came in for her first sitting soon after she won the Academy Award for *The Three Faces of Eve*. A nonegotistical, intelligent lady, Joanne hadn't spent hours in front of mirrors studying her face. I explained that each star has her own particular aura, which is what I wanted to photograph. I remember her asking, "What is Joanne Woodward?" We all did our best, and with every sitting since then, Miss Woodward has shown greater assurance in front of the camera. Today she is, of course, a pro.

Another star who came to me before she had learned how to project her image was Marilyn Monroe. When half of my work was photographing fashions, all the girls who had come to town for a stab at pictures would drop into my studio to see if they could pick up a few bucks modeling while waiting for their break. They were all beautiful, but usually they were a

Sharon Tate, 1963

Ingrid Thulin

little too cute and a little too fat to fit the model outfits I received from manufacturers, and Marilyn was one pretty blonde I turned down.

A couple of years later, *Photoplay* magazine sent me a sketch for a two-page layout to be photographed with an unknown actress. There would be velvet draperies in the background and the starlet would stand in an elaborate gown with her hands outstretched with an isn't-it-wonderful expression. The caption was to be "How a Star Is Born." The magazine selected Marilyn—at that time under contract to Twentieth Century Fox—to pose for the photograph. The studio set up the background in their photo studio and the head designer, Charles LeMaire, took the top of one strapless evening gown and the big skirt of another to concoct the outfit.

Marilyn came in exactly on time, hardly said a word, put up her arms, smiled, and that was that. Her pretty face was all that impressed me and I still wonder what transformed this sweet young thing into the superstar and sex symbol of a generation.

I also remember well the first Hollywood sitting of Ingrid Thulin. MGM, who imported her to play the lead in *The Four Horsemen of the Apocalypse,* told me she was an excellent actress, interesting looking but difficult to photograph—so naturally I felt challenged to produce some topnotch pictures. She came into the gallery followed by Metro's usual entourage of six people. The studio wanted her sexy, but with an actress of her obvious intelligence you don't play games. I told her I wanted to photograph her mind and I told her what to think. During one of the big close-ups, I talked to her softly, "I want you to feel the presence of a man. He's very close to you. Feel him . . . take hold of you."

She thought a second and murmured, "Where?" The sitting was a success and she was beautiful.

Fredric March had a method of stimulating a woman's passion or hatred. Posing for billboard stills, Freddy liked to repeat lines from the script to his screen lady love. For a romantic photograph with Rose Hobart during a session for *Dr. Jekyll and Mr. Hyde,* he breathed to her, "My love for you is uncontrolled as the earth." The feeling was there and we photographed some powerful love stills. For a drama he would grab a startled leading lady, draw her to him, shake her, and growl some raging dialogue. Sparks flew again.

Over the years, Elizabeth Taylor has learned the tricks of being photographed as well as anyone in the business. From the moment magazine editors saw Elizabeth in *National Velvet,* there has been a constant demand for her photographs. For me it started when she was twelve years old and Carmel Snow made arrangements to photograph her feeding a goat at the Howard Hawks ranch. During the next several years I shot her at her beach house, at her home in Beverly Hills, with her girl friends, with her boyfriends, with dogs, horses, and squirrels, at the MGM schoolhouse, taking piano and singing lessons, and modeling for fashion pictures. Later there were pictures with her mother and her second husband, Michael Wilding. Other photographers must have had as many requests for her as I had, and boredom inevitably set in. Sometimes it was difficult to arouse much animation from her face. Even so, she made marvelous photographs—under all circumstances. I remember seeing a news picture of Mike Todd and Miss Taylor arriving in Mexico City. She was very ill and on a stretcher—the only person I know who could look beautiful when she was half dead.

On Hair
and Makeup

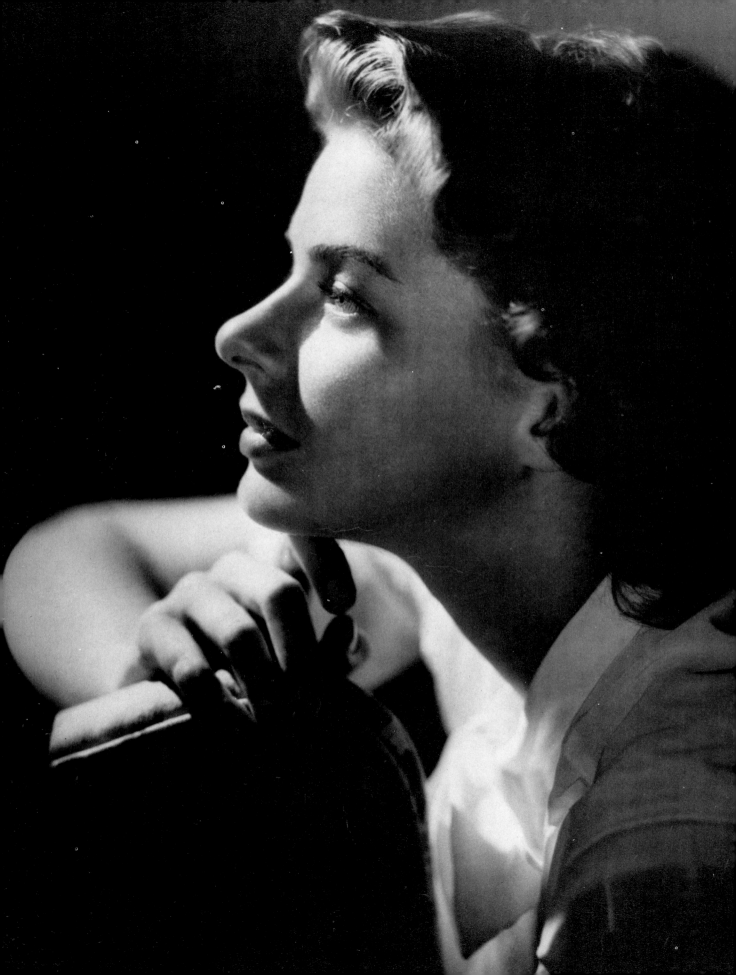

IALWAYS REMEMBER MRS. SNOW'S words: "Keep everything simple." And I soon found that this applies to everything. "When I send you a dress to photograph," she said, "and you don't know whether or not a model should wear a bracelet or a necklace, leave it off. That way you can't go wrong. The girl should wear little makeup, dress her hair simply, and wear no false eyelashes." (In the 1940s the editors of *Vogue* and *Harper's* felt that false lashes were only for hussies.)

How many times have I been asked the question, "What should I wear for the sitting?" I say, "Show your good points and hide your bad ones." If you have a good neck and shoulders, show them. If you have a fat face, use a V neck to give length and don't wear earrings that are too ornate, which tend to broaden the face. If you have a fat fanny, don't wear stripes around it or tight pants. Remember that a smashing red dress, in black and white, photographs just plain old dull gray. A woman who is not an actress, and will therefore not be having frequent sittings, should avoid the newest and most spectacular evening dress. I prefer something simple so that a couple of decades from now, the kids won't say, "Remember when Mom wore those funny clothes?"

Norma Shearer, the shrewd queen of MGM in the 1930s, once said to me, "A woman should wear less and less makeup as she ages." But how many women, young and old, are lured by the startling ads of the cosmetic companies and by ambitious salespeople who plug the bizarre colors, shadings, oils, lashes, and lipsticks invented by technicians. How many women use

Ingrid Bergman, 1943

blue, purple, or green eyeshadow which places all the attention on the eyelid instead of on the eye itself, where it should be? When you look at a girl, you should see her face first and not what she is wearing—and the eyes are the first part of the face you should focus on, and not the makeup around them. A few years ago women would paint white stuff on their lids and below their eyes that made them look like owls. The white lipstick of the same era was just as unnatural and ugly. More recently we have "blush-on" rouge which is supposed to make a woman look as if she had hollow cheeks; more often the stuff makes her look as if she had a high fever. Old ladies with teased, sprayed heads are a perennial reminder of the folly of artificial "beauty" aids.

A woman should look at her undressed face when she gets out of the shower—analyze her features and do what's best to make a distinctive and conservative face. She should find her look and keep it. Of course every woman has to make very slight changes to her makeup as the new styles come in. Lips can lighten, eyebrows can be a trifle thinner or wider—but the allover look should remain the same. Compare the photographs of Sophia Loren in the last fifteen years. Her eyebrows have slowly changed and a new shading around her eyes has evolved as she matures. But it is basically the same face and basically the same makeup. The real beauties of the world don't need far-out fads.

One lady who knew her face was Ingrid Bergman. In 1944 William Perreira, then assistant producer to David Selznick, called me. "We're going to change Ingrid Bergman's image," he said. "We're going to glamorize her . . . a new makeup, a new hairstyle, and a new wardrobe, and we'd like you to photograph her."

The star dressing room suite on the Selznick lot was a small two-room affair. I set up my camera and lights in the little front room which measured about 12 15 feet, a very limited area to photograph a great star. Behind the closed door of the second room, Ingrid was being "transformed." Eventually the hairdresser and makeup man came out. "She's changing," they said. "She looks great. I changed her eyebrows, added false lashes, and shaded the face. She'll be out in a few minutes." The few minutes stretched into half an hour, but finally the door opened and out she came. As far as I could tell, it was the same Ingrid Bergman I'd seen before. There were a few cautious glances around the room.

"I don't mind trying something new," said Ingrid. "But I think I know what is best for me and this glamour makeup is not right. I look better with nothing on my face." She had wiped off all the makeup and combed her hair loosely. That's the way we did the sitting. She proved to be right, for because of those photographs I received a call from Perreira and Ray Clune, Selznick's production manager, saying that Selznick wanted to sign me as a motion-picture cameraman. He wanted me to transfer to the screen what I did in the stills. (We worked out the contract and all was arranged, but unfortunately the studio couldn't get me into the union—a closed shop—and I stayed with the still side of photography.)

Every actress should be as knowledgeable as Miss Bergman. Those that sit in the makeup chairs and nap through the application don't seem to mind if they have a different face at every new studio—or even if they are almost unrecognizable.

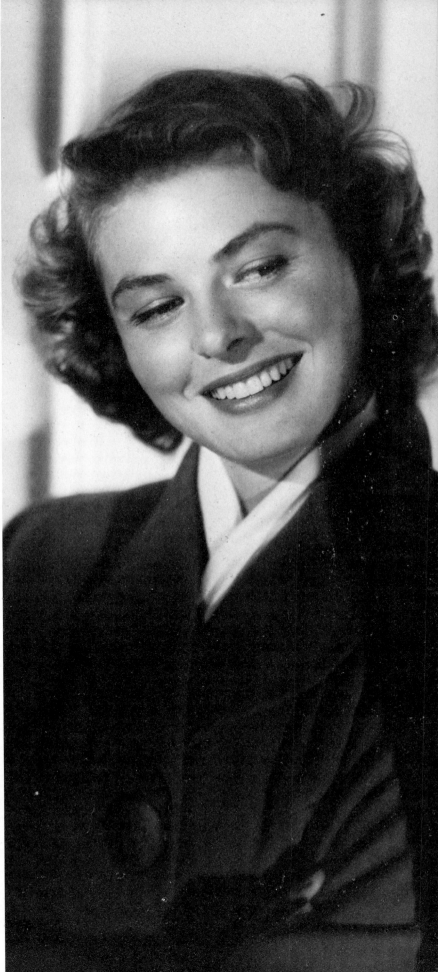

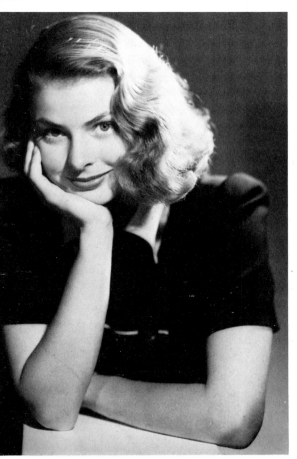

Ingrid Bergman, 1938

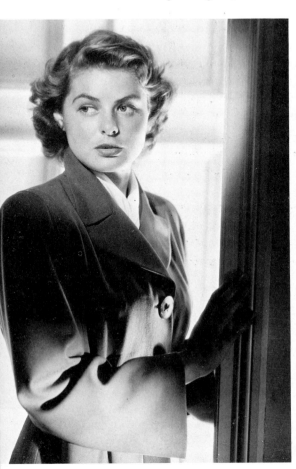

Ingrid Bergman, 1943

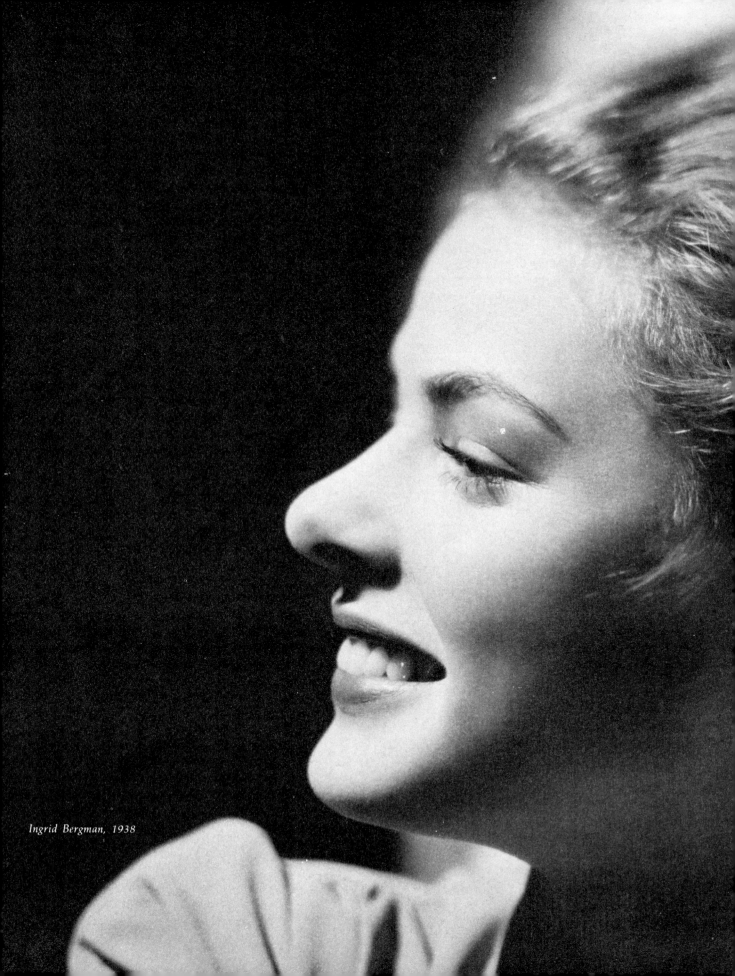

Ingrid Bergman, 1938

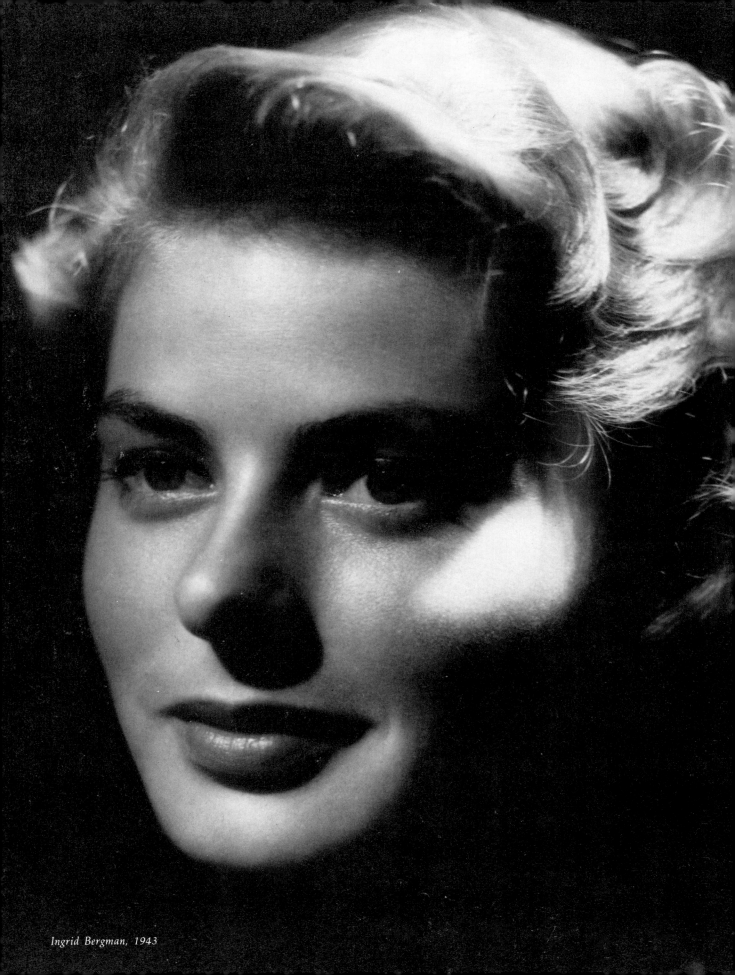

Ingrid Bergman, 1943

I was called to the home of Joan Fontaine when she was for a brief period the queen of Universal Studios. In the group that gathered there to discuss the new sitting were her husband, Bill Dozier, her publicity man, her secretary, and myself. It was to be decided what would happen on the day of the sitting. The program included the hairdresser at 7 A.M., makeup man at 8, followed by her body makeup woman for her neck and arms, and the wardrobe girl. I looked around the fully furnished living room where the sitting was to be made. In this room, with all these people, with my lights and camera, we'd be falling all over each other.

I asked if we had to have all these people. "Can't you put on your own makeup?" I asked.

Joan didn't answer me. When the silence of the group continued, I thought I might as well spill it all out. "Please let me tell you something Myrna Loy told me. When she began in pictures there were few makeup men. She put on her own face and always did, even at MGM. But she used to see all these young actresses—Judy Garland, Lana Turner, and others—drag themselves to the makeup department, plop down in a chair, and lean back and snooze for forty-five minutes while their faces were applied.

"In the early forties Myrna was off the screen for two years, married to John Hertz and living in New York. At the end of that little cycle, when she returned to MGM, Louis B. Mayer suggested a test to be sure of makeup, hairstyle, etc. Now Myrna decided to let the makeup man do the work while she relaxed. When they saw the test the next day, the director and Mayer said, 'Who is it?' Myrna had never known that her eyebrows were not even, her lips not straight, and that her nose was not perfect. And with all these things corrected, it was no longer Myrna Loy.

" 'Better put on your own makeup, Myrna,' said Mayer."

When I finished, Joan rose. "This bores me," she said as she left the room. We never did the sitting.

Jolie Gabor, 1965 *Eva Gabor, 1940* *Eva Gabor, 1965*

The many faces of Zsa Zsa Gabor

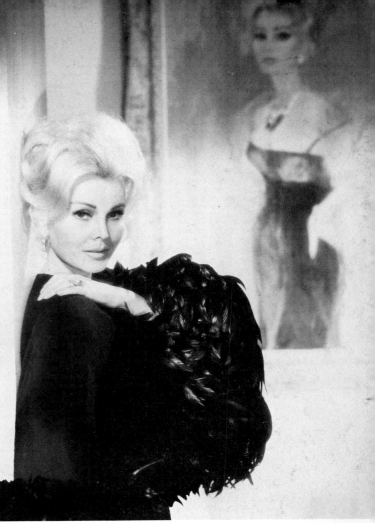

Not all actresses can afford to go without makeup. It was never possible for me to stop Miriam Hopkins on the lot on one of her days off and arrange a quick still. Her face needed careful work before she became the intriguing charmer of those Ernst Lubitsch films. With her light blue eyes, blonde hair and eyebrows, and light, pale lips, she looked, as Travis Banton once said, like a rabbit. It was like photographing a blank wall. But this doesn't mean that Miriam wasn't a volatile star offscreen. Her ex-husband, Austin Parker, once said that the only way he could get any peace when he was married to her was to go in the bathroom and lock the door.

I am amazed by the big stars who say they don't know how to put on their own makeup. Betty Grable was an extremely nice person, but never moved by burning ambition. After making a group of B movies at Paramount, her future was not too bright, but one publicity man, who thought Betty was the greatest thing since Mary Pickford, devised a campaign in which various authorities on different parts of a woman's anatomy would come to the studio each week or so and proclaim Betty the owner of this or that perfect part. A sculptor said her legs were the most perfect (of course we all knew this); the leading chiropodist in Southern California claimed she had the most perfect feet; one week it was an optometrist who said she had the most beautiful eyes; then a painter said her neck and chin were most perfect; and the head of the Hairdressers League of America said she had the most beautiful hair. Of course, pictures of all these old goats and the luscious Betty always landed in the newspapers—no thanks to the goats!

In spite of these efforts, Paramount eventually let Betty go—only to have her turn up as the big star of Twentieth Century Fox and the pinup girl of World War II. After years of success, followed by a decade as a Nevada housewife, Betty was persuaded to return to show biz to play one of the leads in a Las Vegas revival of *Guys and Dolls.* A call came asking if I could do a few rush pictures of Betty Grable that very day.

The only time I had available was after work, so Betty came in that night at six o'clock. She wore no makeup and had none with her, although at this point in her career she needed a little help. I found some makeup and lashes, and she left their application completely to me. It was difficult to believe that after all these years Betty had never learned how to fix her face—or would trust the job to me. I have always thought that it is as important for an actress to know how to put on makeup as it is for a plumber to know how to clean out a drain.

Knowledge of makeup has never been one of Shirley MacLaine's strong points. A representative of Mike Todd sent her to me (without a makeup man) in 1956 for a sitting to publicize *Around the World in Eighty Days.* Then in her twenties, Shirley didn't require much makeup for the usual corny negligee art that was wanted. But when we started to photograph her as the Indian Princess we could have used a makeup man. Shirley didn't know what to do, so I struggled with shading, a liner, and managed to stick on some false eyelashes.

Fifteen years later I went to New York to photograph Miss MacLaine for her television series, "Shirley's World." By the look of her face I knew she had been spending more time writing books, dancing, and going to China than she had on her makeup. She came ready to be photographed with only two big black lines under her eyes and nothing on the heavy lids above the eye where a little shading would have worked wonders. We managed to rub off part

Lana Turner

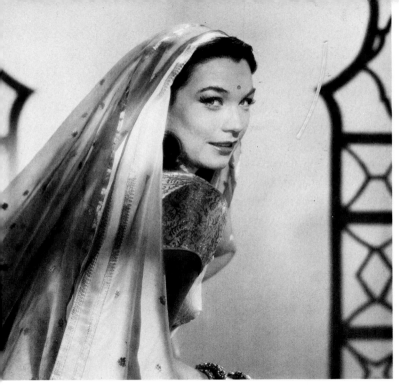

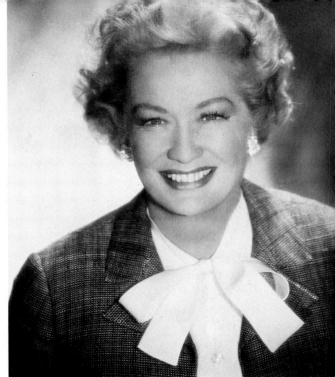

Shirley MacLaine

Miriam Hopkins, 1957

of the stubborn black under her eyes, and we searched the rented studio for makeup. Finally we settled on using an old lead pencil.

Some actresses, of course, overdo their makeup. A cute redheaded actress named Nancy Carroll was starring at Paramount in *Abie's Irish Rose* with Buddy Rogers before Marlene Dietrich came on the scene, and evidently it was difficult for Nancy to swallow all the publicity generated by the arrival of the sexy German. For Nancy's first portrait sitting following Dietrich's initial splash, I couldn't believe what walked into the gallery. Here was a round-faced, Irish version of Marlene Dietrich—or as close to it as Nancy could manage. Her hair line had been shaved to give her the high forehead. The eyebrows were entirely plucked out and painted on nearly an inch higher than where God put them, and they seemed to be floating on her forehead. Shading had been applied between the eyes and eyebrows to give her the heavy lids. There were false eyelashes and the hair, teased high, was wild and disheveled. We made the sitting and Nancy used this same makeup in one film: After all the alterations she'd done on her face, it was the only way she could look.

Marlene herself knows more about face makeup than the Westmores, Elizabeth Arden, and Max Factor put together. But once in a great while she makes mistakes, too. During one sitting at my studio in the late 1930s, she came out of the dressing room with one eyebrow painted on much higher than the other, which resulted in a very peculiar leer.

"I get bored with my face," she said. "Let's try something different." Of course it was so different we had to kill all the photographs.

If you are not Cher or some other exotic creature, a simple hairstyle is best so as not to date the photographs. Ninety percent of the wigs that women wear are bad because they have too much hair and enlarge the head. Mary Costa's hairdresser was so enthusiastic at one sitting that he put two wigs on her at the same time, one on top of the other—and both teased! The result was so startling that Mary came back the next week by herself to do more pictures—with no wigs.

Audrey Hepburn, 1953

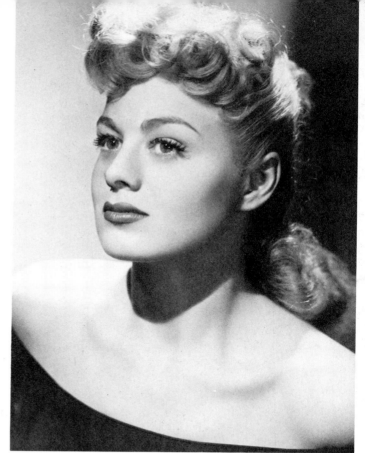

Shelley Winters 1948

Shelley Winters, 1977

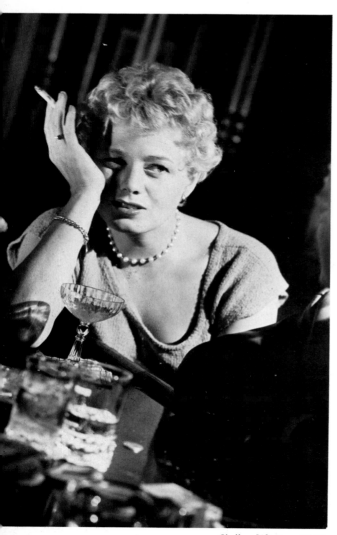

Shelley Winters, 1950s

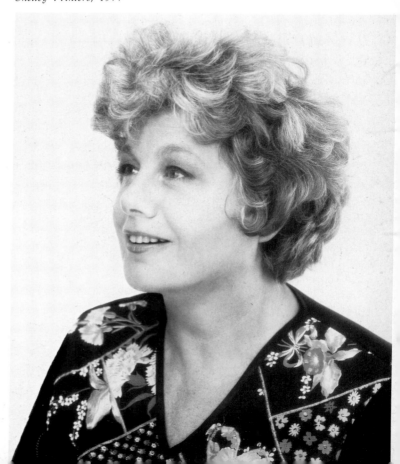

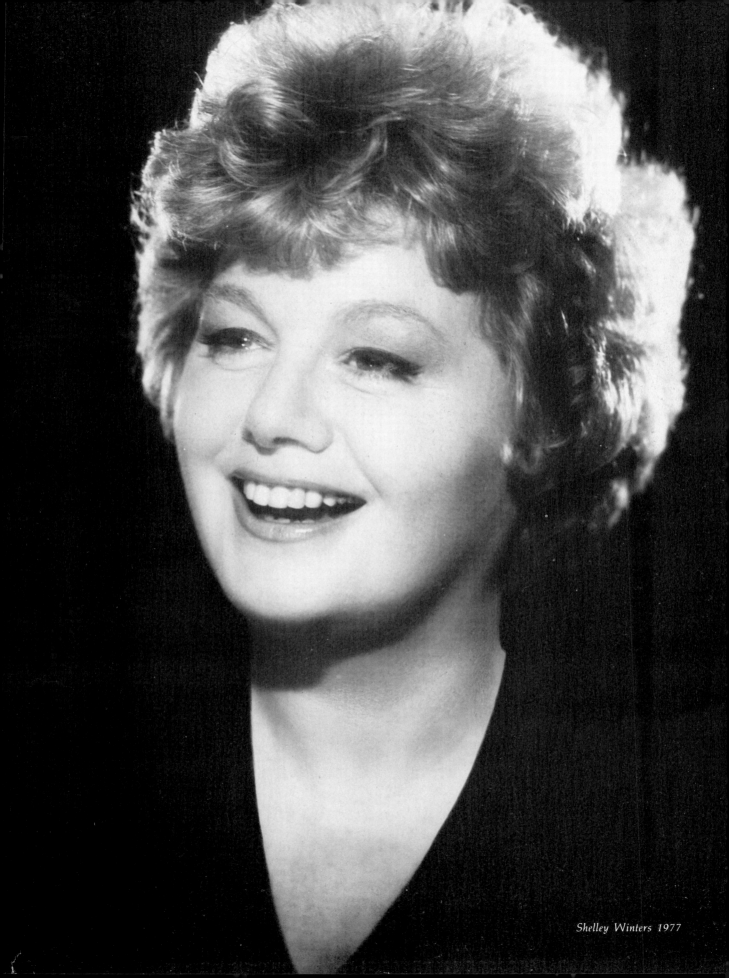

Shelley Winters 1977

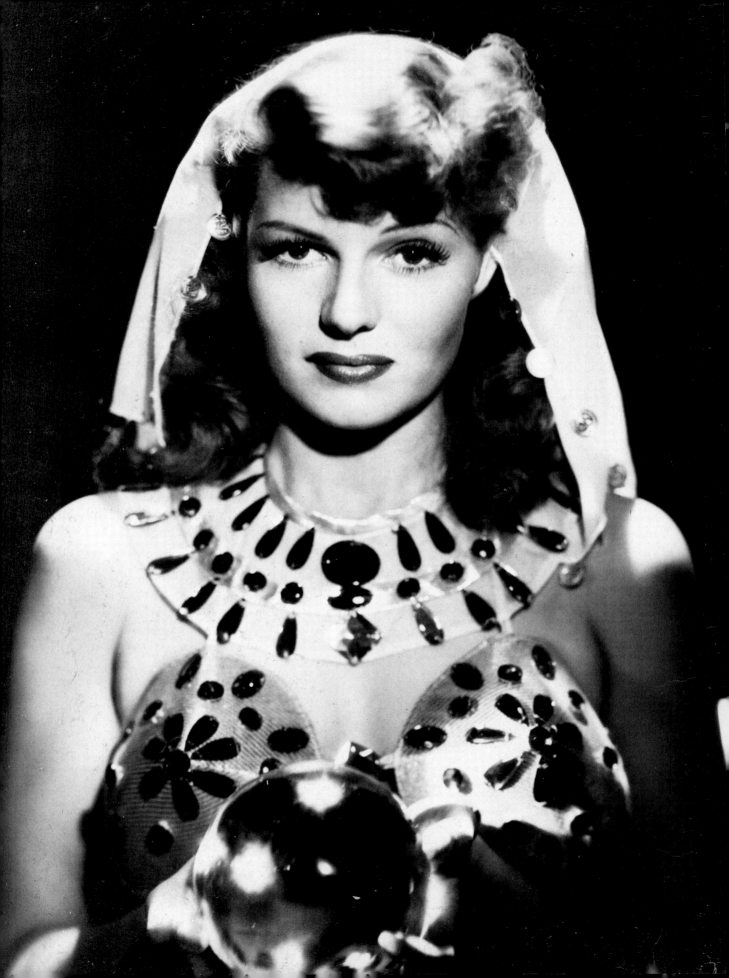

Claudette Colbert wore wigs in a couple of her films because her own hair is such a dark shade of brown that it photographs without highlights. Later she began to dye her hair a lighter reddish brown to accommodate the cameramen. However, she disliked the lighter shade so much that as soon as a film was completed, she would dye her hair back to its natural shade.

Once Claudette was having her hair dyed by her usual operator, with the same dye as usual, when all of a sudden she heard a loud gasp from the hairdresser.

"My God!" cried the operator.

Claudette quickly looked in the mirror to discover that she had green hair.

It wasn't the girl's fault, but, as Claudette told me, "She had to bleach my hair blonde to get out all the green, and then dye it back to brown. Thank God I have strong hair or I would be bald today."

Lana Turner has had every shade of hair from white to black and has ended up today with a very good natural blonde color. For every portrait sitting, Lana arrives carefully made-up and with her hair curled, set, and lacquered in place—not a stray hair anywhere. It is pretty but there is no freedom to the look. At every sitting I say, "Let's comb your hair out and get a casual look."

My persuasion worked only once: during the sitting for her television series, "The Survivors." "Let's make some pictures to look as if you just got out of bed," I said. She understood

Rita Hayworth, 1958 *Rita Hayworth, 1966*

The many faces of Betty Furness, 1950-76

that and disappeared into the dressing room for half an hour. But half an hour is a long time to comb out a stiff set. And I anticipated exactly what came out of the dressing room—an arranged disarranged look.

"No, Lana," I said. "I really want a natural easy look. Just take out any pins you have in there and lean over and shake your head and come up." She did, and that's the shot reproduced in this book.

Lana isn't the only lady who is stuck on the way she wears her hair, and sometimes it's just about impossible to persuade an actress to discard an old style. It takes some of them a year or so to come around to correct fashion in clothes, makeup, and hairstyle and twice as long to drop a look when it's become old hat. Knowing what to select and adapt to your face and body takes more than just guessing.

Alexis Smith is a tall lady and when she arrived at the Town House pool in Los Angeles in the 1940s to make a bathing-suit photograph with her hair piled about a foot above her head, curled, swirled, and sprayed, plus high heels, she was more than six feet tall. The hairdress would have been great for Academy Award night, but we were making this picture for *Charm* magazine and the editor made no bones about saying that it was wrong around a swimming pool.

In Miss Smith's entourage were a hairdresser (who obviously had spent hours working

Joan Fontaine

Katherine Hepburn in
Dragonseed, *1945*

up this contraption), a Warner Brothers publicity woman, a wardrobe girl, and a makeup man. They all pitched into a great arguing session with the editor, but she was a tough one who could stand her ground.

Alexis entered the fray, too. "I know that good fashion is wearing what's good for me. This hairdress is becoming to me and I will always wear it!" she said. We made a few photographs and the magazine never published them. Miss Smith's "always" wasn't too long because a year later I noticed that she had her hair smoothed down flat.

Shelley Winters kept her high pompadour in spite of hell and high water at Columbia studios where she was under contract. She was a very determined young lady in 1947 when she was sent to me by Howard Hawks to make a sitting, after she had finished a bit part in *Red River*.

I had it from the horse's mouth—the editors of *Harper's Bazaar*—that high hair was a thing of the past, and I didn't want Shelley left with a group of dated photographs she couldn't

Julie Newmar, 1958 *Veronica Lake*

use. I soon found out that trying to swing Shelley away from high hair would be like altering the course of the Colorado River.

"Columbia studios wanted me to change my hair . . . everybody wants to change it, but this is what's good for me," said Shelley.

She was paying for the sitting, so—what the hell—I let her have her way. But at the end of the sitting, I said, "Now we are finished. But I have four pieces of film and I'd like you to make a couple of pictures for *me*. Now go in and take your hair down all the way . . . I would like to try it." Shelley gave me a wicked look, laughed, and went in and took down her hair and we made the last four shots. To my amazement, she ordered one of these poses.

Several months later I read in the paper that a Shelley Winters had been given the leading role opposite Ronald Colman in Universal's *Double Life.* Could this be that same blonde? It took only a couple of months for me to find out. I was on the Universal lot when Shelley spotted me,

Cyd Charisse, 1945

Cyd Charisse, 1970

Deborah Kerr, 1944

Dina Merrill

ran over, threw her arms around me, and told me the story. George Cukor, the director of *Double Life*, had seen all the film on her—all her pictures, all with the frizzy pompadour—and decided against her. Then her agent came in with our sitting and Cukor, looking at the picture with her flat hair, said, "If she can look like that, she can have the part."

We've been friends ever since. She lives two blocks from my studio and I bawl her out regularly for not keeping her body as trim as her mind.

Among the male actors I've worked with, the one who did the best makeup for stills was Gary Cooper—and all in two minutes. He would take an eyebrow pencil and make a few dots at strategic places around his eyes, a quarter-inch line at the end of the eye, and then smudge it until it didn't photograph as makeup.

Deborah Kerr, 1960

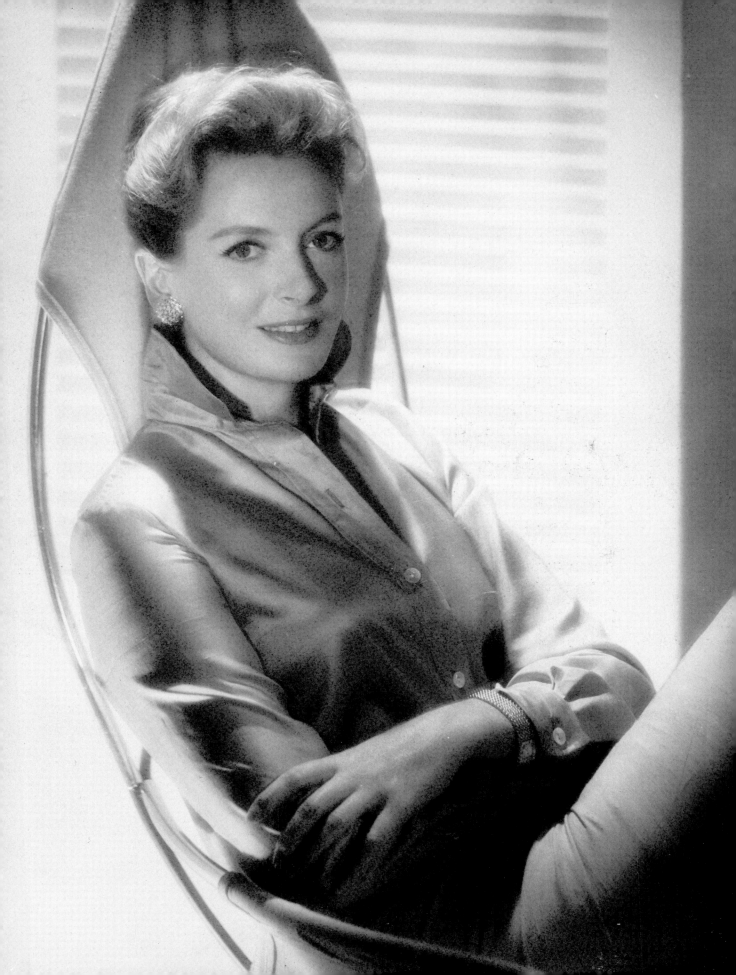

With Gilbert Roland it was the hair on his chest that got the attention during his sittings. Roland, the companion of numerous superstars for the last fifty years, keeps himself in perfect physical condition. Years before Burt Reynolds revealed his hairy body in the *Cosmopolitan* centerfold, Roland knew that a hairy chest was catnip to the females. A mirror beside the camera during his sittings enables him to check and arrange the hair on his chest to the best effect for every pose, with his shirt opened three or four buttons.

When I was a kid, there was one old dame named Fannie Ward who was a star on the Orpheum circuit simply because at the age of eighty she looked like a girl of fourteen. She couldn't do much except stand there and have all the other women, who had dragged their husbands to the show, stare at her and wonder how the hell she did it. Although there were rumors of operations to pull out the wrinkles, Fanny would never tell.

Today some ladies have their faces pulled up and smoothed out almost as often as they have their teeth cleaned. I first had my eyes opened to this face manipulation in the late 1920s as I watched Clive Brook, the elegant middle-aged leading man for Pola Negri, Evelyn Brent, and Marlene Dietrich, have some of the sags pulled out of his face by the makeup department. Pieces of fish skin covered with hair were attached to the temples on either side of his face and strings on top of the head pulled up the face to any age he desired. Fortunately, Clive Brook was partially bald so his wig could cover the tape. This is a little more difficult if you have a full head of hair.

Some of the actresses on the lot got wind of this invention and whether or not they needed it, many longed for the face pull-up job. These women forgot that anything you pull up will sag just a thousandth of an inch more when the pulls are released.

Gene Hibbs, makeup man extraordinary, has worked his considerable talents on many motion picture stars including Eva and Zsa Zsa Gabor, Bette Davis, and Rosalind Russell. Some stars have also found that he is a master at the "face pull," and have had decades removed from their faces with his tapes and strings. Other stars, like Zsa Zsa are proud of the fact that they have never gone this route. She will shove her hair back at the drop of a hat and show any disbeliever that there are no scars behind her ears—the telltale sign of plastic surgery.

Some enterprising actresses have kept their eyes open as Hibbs worked and learned to do this little job themselves. For one sitting, a legendary aging star came to me so carried away with the face-pulls that she looked like a blonde Japanese. I might add this one knows all the tricks. She made the mistake of raising the back of her hair in the dressing room. There, in the back of her neck, she'd taken a great hunk of loose flesh, pulled it back, lapped it over, and taped it down so that the front of the neck looked lovely.

Permanent face-lifting is fine if you find the right plastic surgeon and you're not overanxious. If it's all done at once—the great overhaul—the end result can take twenty or thirty years off a woman's face, but many times the big question is then "Who the hell is she?" Smart actresses have little pieces nipped and tucked at various times, so they never lose their identity and the changes are never so radical that their husbands don't recognize them.

Changing Times

WITH THE ARRIVAL OF TELEVISION IN
the early 1950s, everything changed in Hollywood—including my work. I had had the best of
two worlds, fifteen years at Paramount and more than a decade in business for myself, when I
found that suddenly a large part of my work was photographing promotional sittings for televi-
sion shows. In 1971 I decided to begin spending half my time in Hawaii and return a few times a
year to photograph.

For television shows, the summer is the hectic period when everybody is preparing for
the fall season. The players usually pose for two photographic sessions, one for the network and
one for the sponsor; and there is frequently a third sitting for *TV Guide,* the bible of the industry.
Color transparencies appear mainly in the Sunday supplement television guides, the little maga-
zines that list the programs for the coming week, published by virtually all the major newspa-
pers across the country. They can use 35-mm or 2¼ × 2¼ shots, but a 4 × 5 or 5 × 7
transparency gives a sharper image and is closer to the size the art director will have in his maga-
zine. These larger negatives can also be retouched, which is sometimes necessary.

The photographs for the sponsor and the stills for the networks are distributed by differ-
ent publicity representatives, sometimes to competing publications in the same city, so we make
sure that our sittings are different in ideas and backgrounds than those done by the network. A
good photograph can be duplicated for various sections of the country, but each newspaper de-
mands an exclusive photo for its territory.

231

Cher

From the beginning, television has been a good medium for women. In the 1950s Ann Sothern was right up there with Lucille Ball and Loretta Young on the popularity polls. Ann knows everything there is to know about posing and is great to photograph in spite of the fact that she put on extra pounds and never took them off. Fat or thin, she is an excellent subject. She puts on a careful makeup with expert shadings. When she knows I am ready to shoot, an amazing transformation takes place. Ann pulls her head up from her shoulders by stretching her neck, the cheeks go in a trifle, the eyebrows are raised, and there is that Sothern face. The face gives no clue that it is attached to a large body.

A few top stars of television today are as careful with their appearances as the movie stars of the 1930s and '40s. Cher, Ann-Margret, and Mitzi Gaynor have excellent makeups. This wasn't always true of Mitzi. In the early 1950s, Russell Birdwell brought Mitzi to me for a "white fur and bosoms" sitting. The makeup was slapped on, the hair had a bad permanent, and there were twenty extra pounds on her body—absolutely not the Mitzi of today. It could be the help from her manager-husband, but suddenly all Mitzi's mistakes were corrected.

Mitzi Gaynor *Mitzi Gaynor, 1962*

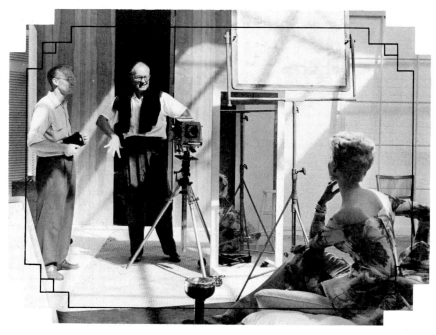

Mitzi Gaynor in
John Engstead's studio

Actresses with definite likes and dislikes are easier to work with than the ones who have no opinions at all. Diahann Carroll had one request when she called to make an appointment for her first sitting in 1959: Would I see her perform at Mocambo nightclub before our session? When the lights dimmed and she began to sing, I knew I'd heard that voice before. Then I remembered the voice on the record of *The House of Flowers* that Jane Powell had given me.

Since then I've done five sittings of Diahann to promote her television shows. There is nothing careless about this handsome woman. Everything is done to perfection—her hair, makeup, and wardrobe. And to make a sitting a pleasure, she has a fine sense of humor.

■

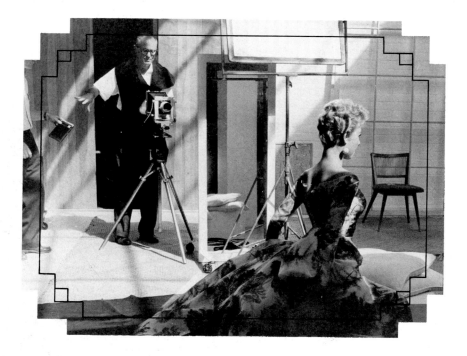

Diahann Carroll, 1959

When the TV people made the appointment with me, they said that wonderful Pearl Bailey was hard to photograph, was difficult to hold still, and talked all the time. Whenever any woman comes to be photographed at my studio, professional or nonprofessional, the first thing she asks is, "Where's the dressing room?" Then she goes in and spends anywhere from ten minutes to three hours doing all the things women do to get their wares in shape. But Pearl Bailey came in one afternoon, hung up a dress on a rack in the studio, and looked at me. She had a scarf covering her hair and over that a slick little snap-brim hat set at a rakish angle. She didn't ask me where the dressing room was, so I said, "There's the dressing room."

"What for?" she asked. "I'm ready. What do you want me to do?"

Heeding the advance advice, I said, "Can you hold still for photographs or would you rather that I use strobe light?"

"Why of course I can hold still—however long you want. Whatever you want, tell me."

"There's the camera," I said. "Sit down in front of it."

And with almost no makeup, no powder, and no primping, we made photographs for the TV show. One she used on an album cover and another on the cover of her book.

■

I met two cooperative performers in one afternoon—Carol Burnett and Julie Andrews—in preparation for their television special in 1972. The only trouble with a superstar of Carol Burnett's magnitude is that there are too many demands on her time. She and Julie had already made a network sitting for their special when the sponsor wanted more photographs. Carol had only one hour between three and four in the afternoon. I anticipated that the stars would come late as usual and that we'd have, at best, fifteen minutes. But on that afternoon, Miss Burnett arrived five minutes early and both ladies changed in five minutes—and we ended up with a really good sitting. At four Miss Burnett apologized and left, but we had what we needed.

■

Some of the shows I have photographed have been "Andy Griffith," "Gomer Pyle," "Hogan's Heroes," The Odd Couple," "Bewitched," "Dark Victory," "The Jean Arthur Show," "Eleanor and Franklin," "The Ghost and Mrs. Muir," "I Dream of Jeannie," "Get Smart," "Petticoat Junction," "Gilligan's Island," "Julia," "Sonny and Cher," "Tennessee Ernie Ford," "Johnny Cash," "The Last of Mrs. Lincoln," "The Brady Bunch," "The Partridge Family," "Gunsmoke," "Mayberry," "Lassie," "The FBI," "The Fugitive," "Marcus Welby," "Father Knows Best," the Fred Astaire specials, "The Big Valley," "The Rookies," "The Real McCoys,"

236

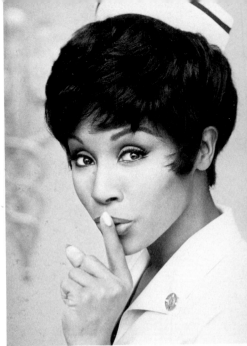

Diahann Carroll, 1965

Diahann Carroll, 1976

Diahann Carroll

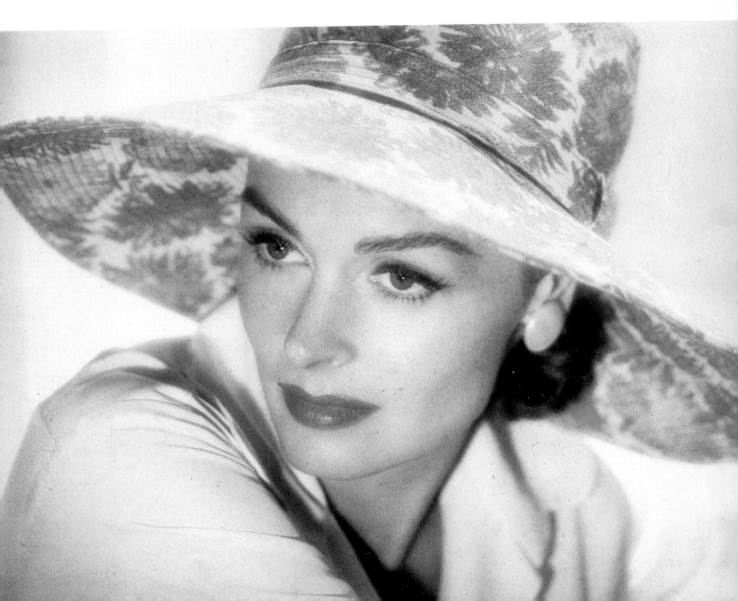

"That Girl," "Danny Thomas," "Bonanza," "Rifleman," "The Courtship of Eddie's Father," "My Three Sons."

■

The Hollywood of television and motion pictures today is more real, more vigorous, and more inventive than ever before. But the fairy-tale beauty and glamour I knew in the 1930s will probably never happen again. In that era the actors were more handsome and the women more beautiful than most actors and actresses making it today. The films were more romantic and upbeat, shot on sets that sometimes took up two enormous sound stages put together. The marvelous clothes were designed by the likes of Travis Banton, Edith Head, and Adrian, and dozens of seamstresses would often work for a week preparing one dress.

But all the eras of Hollywood were good and provided opportunities for those of us working there. I feel the movies have always been and always will be wonderful. I would like to have been working when the films were sowing their first oats in 1915; and I wouldn't mind starting out right now, with the limitless opportunities in photography, writing, directing, and acting, outside the big studio system.

Ann Sothern and daughter Tisha *Ann Sothern, 1977*

Today only Universal hands out a few long-term contracts, and all the "smother love" lavished by the major motion-picture studios on their stars; the work to sustain careers in high gear for at least a decade; the schemes to keep the scandals out of the press—all this has disappeared with television. In the old days of film it was no catastrophe if a star appeared in one lousy film; in fact, the studio would work all the harder to make sure the next one was good. Today, particularly in television, it's everyone for himself or herself. Each star with his or her manager scrounge around to find a good part. ABC felt that "Charlie's Angels" could survive even without its star sensation Farrah Fawcett-Majors. Since it behooves all actors today to promote their own shows, very few television performers give any static about posing for stills or making personal appearances to publicize their shows. In the 1930s and '40s an actor or actress felt put upon if they were asked to leave their Beverly Hills mansions to make an appearance. Film studios placed their stars on thrones and always kept the public at least twenty feet away. All the stars, even the featured players, had their hair fixed and were made-up before any appearances or photographs were made. By contrast, many of the television women today don't want makeup at all. This is fine if God was kind to them, but some of those plain Janes who are good actresses can use help. It used to be that models and actresses with pimples went to derma-

Pearl Bailey, 1971

Carol Burnett and Julie Andrews

tologists, but today the attitude is "what the hell."

Movie actresses in the old days learned how to take care of themselves, photographically and financially. They would watch the height of the camera, the lighting, and would want to know how much of them was in the picture. And they wouldn't mind telling you if they thought you were wrong. I don't think the average television performer today knows these things. From the photographs I've seen of Farrah Fawcett-Majors, for example, she must surely be a lively beauty. But on one magazine cover was a photograph with lighting coming from below. This is great for Dracula but can ruin a beautiful face—and it did hers.

As for photographs today, it is usually "shoot 'em as they are": show the wrinkles and the pimples; shoot them in jeans and off-the-rack dresses instead of sequins and chiffon. Maybe, though, people are beginning to get tired of this realism—Cher is doing all she can to start a trend, with her exotic styles and exciting wardrobe. When they go to the movies I think people sometimes like to see people not as they are but as we would like them to be. There are signs that there is a trend in this direction.

I have found stars of all eras—whether lovable or monsters—interesting to work with. After years of trying to find out what makes these entertainers tick, I decided that their ability to

Cloris Leachman, 1958

Lily Tomlin

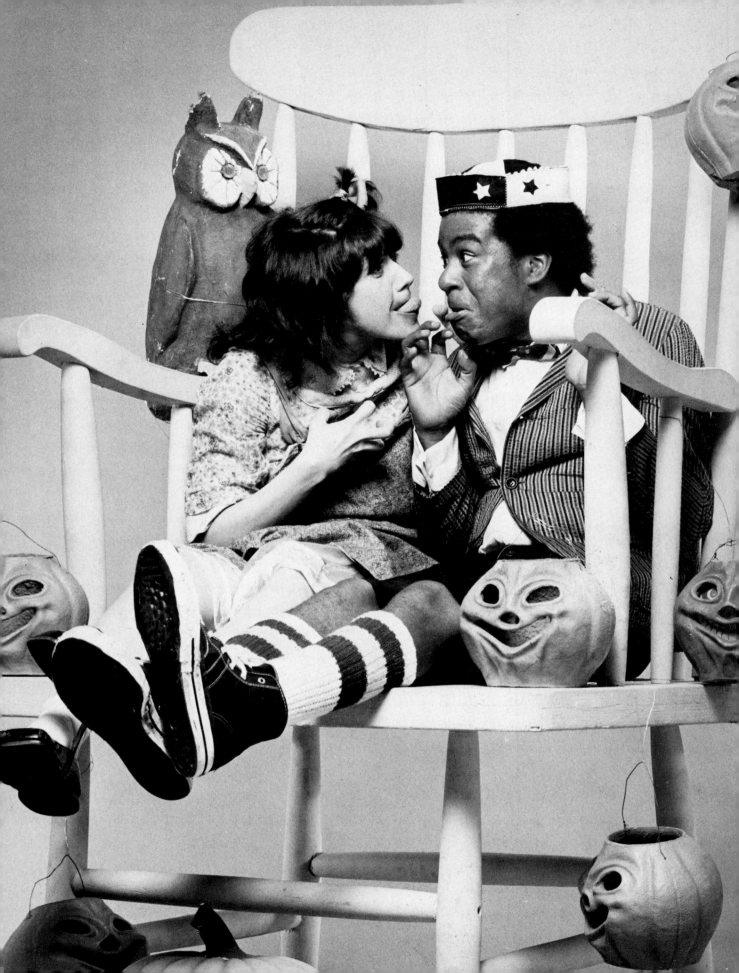

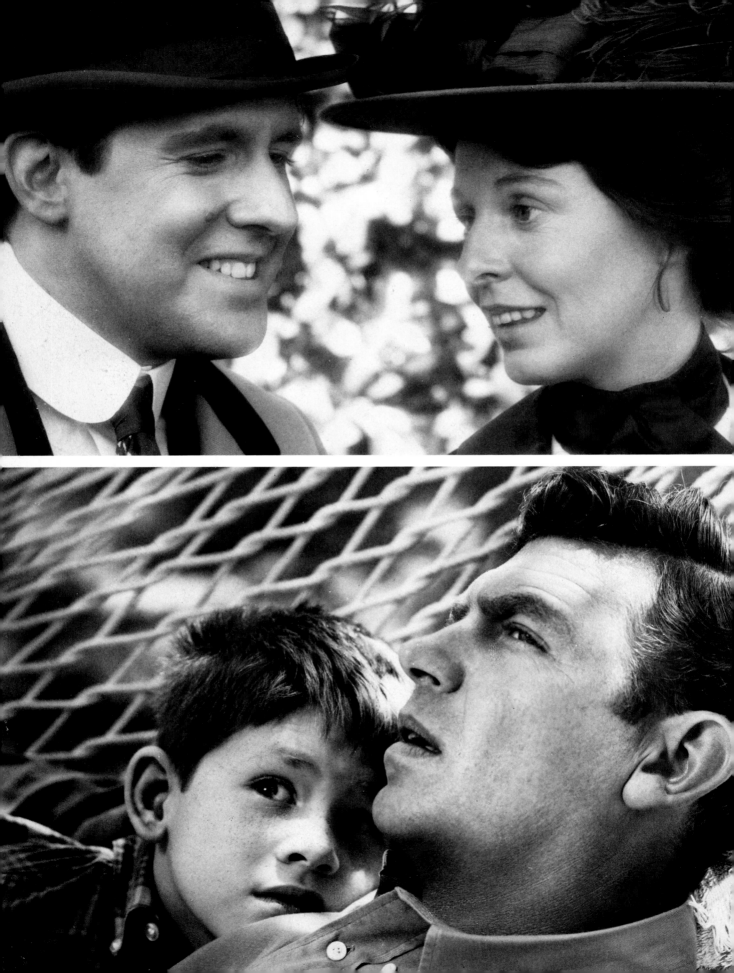

Ed Herman and Jane Alexander
s the Roosevelts, 1975

Ron Howard and Andy Griffith,
"The Andy Griffith Show"

Diana Ross, 1975

Marisa Berenson, 1977

James Arness

The Fifth Dimension in John Engstead's studio

Richard Benjamin and Paula Prentiss, "He and She"

Mikhail Baryshnikov and Gelsey Kirkland, 1977

use their head and work like hell to fulfill their extroverted ambitions does not, most of the time, remove them from reality. Sooner or later, they have to face it, just like the rest of us. Theda Bara, certainly the wildest and most bizarre of almost any era, came down to earth and in later life turned out to be a fairly typical Beverly Hills matron. Others, of course, do not fare so well—and level-headedness is a big help to stars, and ex-stars, just as it is for all people everywhere.

As for that elusive thing called star quality, who can say what its ingredients are? Most of us, though, are pretty sure we know it when we see it. In many ways I think my pictures tell it better than I can myself.

Index

Page entries in bold type refer to illustrations.